T0340775

HISTORIC HOUSES AND BUILDINGS OF RENO, NEVADA

HISTORIC HOUSES AND BUILDINGS OF RENO, NEVADA

An Architectural and Historical Guide

Holly Walton-Buchanan

Photography by Robert E. Blesse

THE BLACK ROCK PRESS
University of Nevada, Reno
2007

ISBN 978-1-891033-35-3
Library of Congress Control Number: 2007927052

The Black Rock Press
University of Nevada, Reno Reno, NV 89557-0044
www.blackrockpress.org
Printed in the United States of America

Designed by Robert E. Blesse
Cover Image by Loren Jahn

Photograph acknowledgments:
Jack Hursh, Jr., page 99
Chris Castel, Ph.D., page 58 - Wanamaker/Mapes Chateau
All the other historical images in the book are courtesy,
Special Collections Department
University of Nevada, Reno Library

⤳ CONTENTS ⤳

ACKNOWLEDGMENTS

This book could not have existed without the dedication of preservationists in Reno who have worked tirelessly to save what is left of "old Reno." Very few important, architecturally significant structures would have been saved if it were not for their activism and concern for Reno's history and its legacy to future generations. Many historic buildings, schools, and houses were threatened as downtown Reno began to grow rapidly in the 1960s. Unfortunately, a wide swath of Victorian and Craftsman/Bungalow houses near the University of Nevada was demolished in 1974 to create the Interstate 80 corridor. More recently, the 1940s-era Mapes Hotel was torn down in 2000, and the old Mizpah Hotel burned in an arson fire in late 2006.

I grew up in Reno and attended Mary S. Doten and Central schools, two historic structures that were demolished years ago. Since then, I have despaired at the destruction of the city's beautiful old homes and historic structures when they were in the way of "progress," and at the loss of lush ranchland to make way for tract homes.

Fortunately, beginning in the 1970s, Reno preservationists pressured the City of Reno to protect our architectural legacy, and managed to save several buildings from certain death. The Lake Mansion was moved not once, but twice to avoid demolition. Mount Rose School and McKinley Park School were restored and fitted to modern earthquake safety standards. The Riverside Hotel barely escaped the Mapes Hotel's fate, becoming a national example of adaptive re-use by housing the Artist's Lofts.

When I joined the Historic Reno Preservation Society (HRPS), founded by my friend and colleague Pat Ferraro Klos in 1998, I met people who had organized expressly for the purpose of saving Reno's architectural and historical gems. During the many fascinating tours and walks led by Pat and the other HRPS volunteer tour guides, I realized that a surprisingly large number of Reno's historic buildings have been protected, thanks mostly to their owners, who lovingly maintain them and actively work toward their preservation. In addition, much credit goes to several city council members and staff, who listened to the concerns expressed by preservations, artists, and cultural activists, and passed laws protecting historic structures and facilitating their historic registration on city, state, and national registers of historic places.

As a result of participating in the HRPS tours, it became clear that a permanent record of the city's most historic and significant houses and buildings was needed. I envisioned a book with self-guided walking and driving tours that would not only enhance the ongoing HRPS tours, but would also give the owners of the structures a permanent record of their house's history and architecture. This book would publicly recognize the owners, with a salute to their costly efforts over the decades to preserving their house or building for future generations.

Helping me in this endeavor were several local historians, including Mella Rothwell Harmon, formerly of the State Historic Preservation Office and now with the Nevada Historical Society, and Jack Hursh, Jr., who co-founded Truckee Meadows Remembered with Loren Jahn and Jack Sutton. Hursh's documentary photography—plus Jahn's murals and drawings—have inspired

a movement to preserve historical barns and ranch out-buildings from Reno's once-ubiquitous ranches. Hursh, Sutton, and Jahn can be credited for the fund-raising and creation of the historic ranch outbuildings exhibit at Bartley Ranch Regional Park.

Pat Klos has guided me in this project from the beginning, steering me in the right direction on the focus and content of the book.

Bob Blesse, Director of Black Rock Press at the University of Nevada, is the publisher and designer of this book. He also photographed all the houses and buildings found in the book and obtained most of the historical images. His Black Rock Press intern, graduate student Kyhl Lyndgaard, assisted with proofreading.

Historical photographs and maps in this book came from the Special Collections department of the University of Nevada, Reno, Library. In particular, I wish to thank Kathryn Totton and Jacque Sundstrand in Special Collections for their assistance.

I also wish to thank others who have donated funds for the publishing of this book. During the initial fund-raising effort in 2005, Tom and Tonya Powell of IntoHomes Mortgage Services, who had just bought the Gibbons/McCarran Mansion and restored it to its previous grandeur, stepped forward with a very generous donation. The Robert Z. Hawkins Foundation soon followed with another large contribution, while other funds have come from several historic buildings' owners as well as advance sales of the book.

The information contained in this book has been gleaned from a large body of research, found at the State Historic Preservation Office in Carson City, the University Archives and Special Collections department at the University of Nevada, the Nevada Historical Society, and the Internet. The documentation included nomination forms for placement on registers of historic places, newspaper and magazine articles, books, pamphlets, newsletters, Internet web site postings, archival documents, and personal interviews.

Historians Mella Rothwell Harmon and Jack Hursh, Jr., edited the first edition and along with Guy Rocha, Neal Cobb, and Jerry Fenwick, provided corrections for the second printing. I apologize in advance for any inaccuracies or errors that might remain overlooked in this publication after careful editing and review.

Holly Walton-Buchanan, Ph.D.
August , 2008

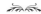

Photograph Credits

Jack Hursh, Jr., page 101
Chris Castel, Ph.D., page 58 -
Wanamaker/Mapes Chateau
All the other historical images in the book are courtesy,
Special Collections Department
University of Nevada, Reno Library

❧ THE UNIQUE HISTORY ❧ OF AN UNCOMMON TOWN

Introduction

Are you a tourist who has just arrived in Reno and would like to know more about its history? Or are you a current resident, curious about an interesting old house you've been driving by for years? Whatever your reasons for choosing this book, you will soon appreciate the rich heritage of this 138-year-old city on the Truckee River. You will learn the history of many old buildings and houses and how to identify their diverse architectural styles. You will also learn about the prominent Reno architects who designed them. By using the walking/driving guides in this book, these traces of Reno's past can easily be located and studied.

Seeking Out Traces of "Old Reno"

Confronted with the proliferation of shopping malls and new homes all over the Truckee Meadows, the first-time visitor to Reno might well wonder what could possibly remain of Reno's past. Amazingly, despite this rampant growth, much of "old Reno" can still be found in the historic center of the city and surrounding areas. Historic homes, most still used as residences, can be spotted on tree-shaded streets just steps from the casinos' neon and glitter. Other older houses have been converted to offices, a process known as adaptive re-use. Chapters 1-7 feature houses and buildings in and around the historic downtown core.

Outside of the downtown area, the lush pastures of the Truckee Meadows were once dotted with prosperous cattle ranches. Today, most of the ranch land is filled with commercial and residential structures, but a precious few of the ranch houses have survived, carefully preserved among industrial parks and shopping centers. Four of the most significant ranch houses are highlighted in Chapter 8.

Reno's Unique Past

Those who follow the walking and driving guides in this book will quickly realize that Reno is truly a unique city. Other Western cities typically have a blend of historic and modern buildings. Not so in Reno: Much of its historic center was transformed into clubs, casinos, and hotels. Most of the original office buildings, banks, and stores were demolished or drastically remodeled, as gambling establishments filled the downtown area. All of this began in the early 1930s, when Nevada legalized two highly controversial "sinful" businesses: gambling and "quickie divorces." As a result, today's modern Reno barely resembles its early 20th century appearance. And because the "biggest little city" seems to enjoy re-inventing itself every so often, many of those casino-hotels are now being converted into luxury condominiums, once again transforming the historic center of town.

Here are some quick looks back into Reno's unique history:

Reno Was America's First "Sin City"

When the 1931 Nevada Legislature allowed six-week divorces and legal casino gambling, Reno was instantly reviled in the nationwide press for its blatant marketing of those "unpardonable sins" and was called a "blot on Civilization," a "vicious Babylon." Undeterred by its critics,

Reno welcomed the crowds of divorce seekers pouring into town for "the cure" or "Reno-vation," as columnist Walter Winchell called it. The combination of new casinos downtown and a steady supply of customers brought much wealth—and quite a bit of notoriety—to the bold little town on the Truckee River. The occasional sighting of a famous gangster such as Baby Face Nelson—as well as mobsters from the East Coast, hanging around downtown casinos did wonders for Reno's image as a racy, exciting place to be. It was not until the 1960s that the casinos were finally cleansed of the influence of the powerful Detroit and Chicago mob bosses who had long claimed Reno casinos as their turf.

Harolds Club, 1940s.

Reno Invented the Hotel-Casino Industry

In 1931, a newly legalized business called the "gaming industry" emerged from Reno's illegal speakeasies in back alleys. World-famous Harolds Club (now gone) and Harrah's Club invented the hotel-casino industry as we know it today. Well-lighted, clean, and safe, Reno's new clubs and casinos featured top Hollywood and Broadway performers, exciting games of chance, and 24-hour fun. The first high-rise hotel completed in the world after World War II was the 12-story Mapes Hotel (also now gone), built in 1947, long before the 15-story Fremont Hotel and Casino opened in Las Vegas.

Reno Was Marketed Directly to America's Millionaires

In the 1930s, wealthy real estate owner Norman Biltz contacted 200 families worth more than $10 million each, convincing more than 60 of them to take advantage of Nevada's unique status as a "haven for the tax-weary."

Lured by a national advertising campaign touting Nevada as "One Sound State," these newcomers built fine mansions in Reno, Washoe Valley, and Lake Tahoe; acquired vast tracts of ranchland; and took a personal interest in the cultural and educational foundations of their adopted town. Among Reno's new millionaires were E. L. Cord and Major Max C. Fleischmann, both of whom contributed large sums of their personal wealth to the cultivation of the arts in Reno, and to buildings and programs at the University of Nevada. Biltz was largely responsible for cleaning up Reno's image and improving the quality of its community members. The site of his large "Gentleman's Ranch" along Kietzke Lane is still occupied by a working cattle ranch and equestrian center, now known as Rancharrah.

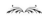

A Short History of Reno

The town of Reno was founded in 1868 as an important stop on the new Central Pacific Railroad. One of Reno's first hotels, the Lake House, was built in 1870 on the current site of the Riverside Hotel, just south of the Truckee

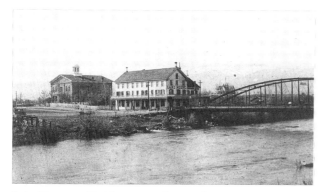

Lake House and bridge across the Truckee River, ca. 1880s.

River on Virginia Street. Earlier hotels around the valley had served freighters and travelers on the Emigrant Trail and the road to the silver mines in Virginia City, but the Lake House marked the location of the future site of downtown Reno. The toll bridge across the river at that point proved to be the safest, most dependable place in the Truckee Meadows to cross the often-treacherous river. Today, the Virginia Street bridge and the Riverside Hotel are considered the historic heart of Reno.

Working on the Railroad

Reno's initial economic success stemmed from its fortunate location, first as a major stop on the Emigrant Trail and later on the transcontinental railroad, the Lincoln Highway, and then the Victory Highway, and now Interstate 80. Typical of a railroad town, Reno's first commercial buildings faced the tracks along Commercial Row. The downtown area near the railroad grew rapidly, filling Virginia, Center, and Lake streets with banks, stores, and office buildings.

Ranching in the Truckee Meadows

The well-watered pastures of the Truckee Meadows supported large ranches that supplied beef, mutton, butter, fruit, and vegetables to the busy silver mines in nearby Virginia City as well as neighboring Eastern California.

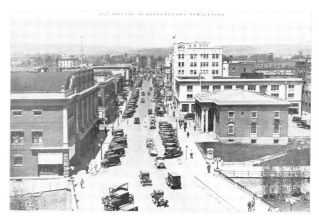

Virginia Street, 1920s.

The arrival of the Central Pacific Railroad in 1868 helped extend the transport of these products to markets on both the East and West Coasts.

Several ranches from the late 1800s still exist, four of which are highlighted in Chapter 8: the Peleg Brown Ranch on Old Virginia Road, the Longley/Beidelman/Capurro Ranch off Longley Lane, the Buscaglia/Bartley

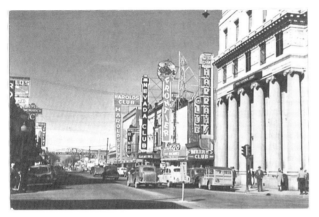

Corner of Virginia and 2nd Streets, 1940s.

Ranch on Lakeside Drive, and the Caughlin Ranch on Mayberry Drive. These four ranches are excellent examples of late 19th century ranch architecture found in Nevada.

Legalizing Gambling and Quickie Divorces

The closure of many of the silver mines in Virginia City in the 1870s and a nationwide economic depression in the 1880s caused thousands of residents to flee the state. Despite the rush of gold miners to the new mines in Tonopah and Goldfield in Central Nevada in the early 1900s, eventually the ore played out and thousands left the state for better opportunities elsewhere.

Reno's struggling economy by then depended mostly on the rising popularity of Nevada's liberal divorce laws, which required no embarrassing questions from the judge and a mere six months' residency at that time. High profile divorces, such as British Lord and Lady Russell's in 1899 and the Coreys' (United States Steel tycoon) in 1906 were putting Reno on the world map as the divorce capital of the world. The Hollywood connection became well-known with silent film star Mary Pickford's divorce in 1920 in Minden, 45 miles south of Reno. Her attorney, Patrick McCarran, who rapidly became well-known in the nation's press, eventually became one of Nevada's most prominent leaders.

In 1927 the legal residency requirement was lowered to three months, and the divorce business was in full swing when the Great Depression hit in 1929. By 1930, Renoites knew they needed more than three-month divorces to bring in people. In 1931, Nevada lawmakers decided to drop the divorce residency requirement to just six weeks, a drastic action spurred by the fear that pending actions in other states would undercut Nevada's three-month requirement.

Then the Legislature passed another law at the same time, which was destined to change Nevada forever. In an effort to attract more revenue to Nevada, as well as stem the outward flow of money from Reno's numerous illegal gambling dives, the 1931 Nevada Legislature legalized casino gambling.

No other city dared to follow Reno on its journey to infamy and eternal damnation. Reno became known as "sin city," internationally famous for its wide-open casinos and quickie divorces, activities banned in virtually every other state for decades to come.

Soon Reno was flooded with thousands of tourists and divorcees. By December 1931, over 4,000 divorces had been granted, but, surprisingly, the number of marriage licenses surpassed that number. Lonely divorcees often found comfort and companionship as they "did their time" in Reno with others in the same situation; many did not remain single for long.

Dealing with Gangsters

Although Nevada legalized gambling in 1931, the state was still wide open to criminals and their shady business practices. In gangster parlance of the 1930s, Reno was

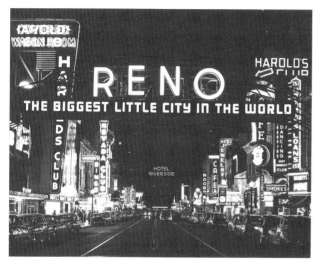

Downtown Reno, 1940s.

known as the "big store," meaning it was a good place to "launder" money that had been collected illegally in other states by mobs in New York, Chicago, and Detroit. The local criminal element also had a tight grip on illegal liquor sales and prostitution. But because local authorities were often corrupt, major crimes went unpunished until the Federal Bureau of Investigation stepped in.

The FBI figured that two local scoundrels were responsible for most of the corruption, William Graham and James McKay, whose friends—Baby Face Nelson, and other such killers—were welcome in their speakeasies and brothels. Both Graham and McKay had been involved in

illegal gambling, brothels, and bootleg liquor since the 1920s, first in Tonopah and later in Reno. Graham was involved in a shoot-out at a bootlegging bar in Douglas Alley, in which he killed Blackie McCracken, ostensibly in self-defense.

Most importantly, Graham and McKay were very close associates of George Wingfield, a powerful politician who owned most of the banks in the state. Money laundering was assumed to be a common practice in Wingfield's banks, and the FBI was ready to hear testimony from one of Wingfield's bank tellers, a Mr. Roy Frisch. When he disappeared into thin air one night near his downtown Reno home, McKay and Graham were prime suspects in Frisch's disappearance.

Frisch's body has never been found, making it one of Reno's intriguing unsolved murders. The FBI eventually got MacKay and Graham on mail fraud charges in New York, and they spent six years in the Leavenworth federal penitentiary. Nevada's powerful Senator Pat McCarran persuaded President Harry Truman to grant each a full pardon in 1950, after which they once again became involved in the Reno gambling scene.

By the 1960s, after years of Congressional investigations into the influence of the New York and Chicago Mafia families in Nevada casinos, and resulting crackdowns by Nevada lawmakers, casino gaming became highly regulated, virtually off limits to those with connections to known gangsters or mob members. A famous example of the state's official "Black List" of unwanted visitors was the Frank Sinatra case: Sinatra lost his gaming license after he allowed a New York mobster to stay at his Lake Tahoe hotel.

Reno Begins to Grow

Reno began to grow when the hotel-casino industry modernized after World War II. In the early 1950s, the transcontinental highway over the Sierra Nevada was greatly

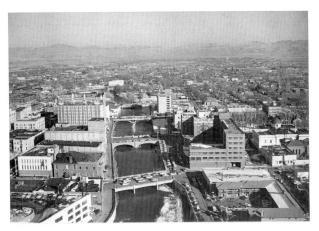

Aerial view of Reno and the Truckee River, 1955.

improved, attracting California motorists in their spiffy new cars. Survivors of those vibrant days of automobile travel can still be seen on the streets of Reno during the annual Hot August Night classic car celebration.

The Reno airport expanded its facilities to accommodate wealthier travelers coming in by air, with a new air traffic control tower built in 1954. Visitors also arrived daily on the numerous passenger trains and buses from California and the East Coast. When the Olympics were held at nearby Squaw Valley in February, 1960, Reno became the point of arrival for the thousands of attendees (many of whom liked Reno and Lake Tahoe so much that they stayed and put down roots).

Reno made headlines again in 1960 when Marilyn Monroe and Clark Gable were in town filming *The Misfits.* Movie workers and hangers-on filled the hotels and bars downtown, while crowds surrounded every local shooting scene. Especially memorable was watching Marilyn practice on the steps of the Washoe County Courthouse, rehearsing the part of a divorcee on her way to court.

Interstate Highway 80 was completed through Reno in 1974, providing a dependable, all-weather passage over Donner Pass. By then, the Reno Chamber of Commerce had set up a hotel reservation desk in San Francisco and the Reno Fun Train was making regular weekend runs from the Bay Area to the ski slopes and downtown casinos.

In 1940, Reno's population was 21,317, but by 1950 more than 32,000 people were counted, an increase of 52.4% in just ten years. By 1960, the population skyrocketed again, by 58.4%, to 51,470. Reno's rapid growth was based mostly on the hotel-casino industry as well as on light manufacturing and warehousing (Nevada became a tax-free "free-port" destination in the 1950s). Las Vegas, meanwhile, only had 8,422 residents in 1940, but by 1960 its population burgeoned to over 64,000, and Reno lost its status as the largest city in Nevada. Reno's population by 2000 was 180,480, compared to Las Vegas' 478,434.

Downturns and Upturns

The national recession in the early 1980s, as well as the competition from the new, larger casino-hotels on the outskirts of Reno, caused several downtown casinos to close, including the Mapes Hotel, the Riverside Hotel and the Money Tree. The historic heart of Reno suffered from unsightly shuttered stores and casinos for nearly a decade.

Members of the local arts organizations began a campaign to revitalize the downtown corridor. By 2000, dramatic changes had occurred: Although they had failed to save the Mapes Hotel from demolition, the Riverside Hotel was remodeled into artists' lofts, and downtown Reno was engaged in a revitalization that continues to attract visitors and residents to the historic corridor along the beautiful Truckee River. Long-closed hotels are now being turned into luxury condominiums, and vacant lots are filling with new movie theaters and restaurants.

Reno's Architectural Styles and Building Materials

Many styles of architecture are found in Reno. The Appendix describes the most prominent styles in detail, with addresses of local examples. The most common materials used were wood from the forests of the Sierra Nevada, native river rock and stone found in abundance all over the valley, and brick from companies such as the Reno Press Brick Company.

Lumber

The abundance of pine and fir trees in the nearby foothills provided Reno construction companies with plenty of lumber for the first houses and buildings. Some expensive homes (such as the Lake Mansion) were even built of redwood, hauled up on the railroad from the Pacific Coast.

Victorian house designs of the late 1800s emphasized carved wood as decorative trim, as in the Queen Anne, Carpenter Gothic, Shingle, and Stick styles. Wooden balustrades, spindles, columns, shingles of various shapes, and geometric designs formed by half-timbers decorated these Victorian houses. While the bulk of the houses were constructed of local lumber, much of the so-called "gingerbread" trim was crafted in other parts of the country and shipped in on the railroad.

Rocks and Stones

As you drive around Reno, you will notice many older homes that utilized river-tumbled cobblestones for foundations and chimneys. Sometimes stone was used for the entire house, as in the Hill/Redfield house and several others located nearby on Mount Rose Street and Plumb Lane. Colorful rocks of all sizes and shapes are found in abundance across the Truckee Meadows alluvial plain, hence their common use even today. As local artist and preservationist Loren Jahn wryly observed, "You can't plant a shovel without hitting a rock" in the Truckee Meadows, thanks to the meanderings of the Truckee River and to the alluvial wash of stones flooded out of the Sierra in streams into the meadows.[1] Rounded stones are more difficult to work with than flat and split rock, because more mortar must be used to ensure a stable and strong wall. The massive Hill/Redfield Mansion on Mount Rose Street is a testament to excellent masonry skills needed to stabilize the round rocks in its high walls and to support the roof.

Quarries near Carson City and on the outskirts of Reno supplied sandstone and granite for foundations of many houses and public buildings, especially for the state government buildings in the capital. Native American stonemasons, trained at the Stewart Indian School in Carson City, most often created the elaborate decorative

stonework on upscale residences in Reno and built many beautiful rock walls and fences around those homes.

Decorative stone hauled in from central and eastern

Stone construction, Hill/Redfield Mansion.

Nevada quarries such as marble and aragonite from Tonopah was used in many fine homes and churches for fireplaces and church altars.

The most common building material in Reno after the 1880s was brick, largely because of its resistance to fire. A disastrous blaze in 1879 had leveled many blocks of buildings and houses in downtown Reno. Local brickyards supplied the majority of the brick used in commercial buildings and houses, operating until the 1960s.

Italian masons, highly skilled in bricklaying and creating decorative patterns with various sizes and colors of brick, built and embellished many of Reno's brick homes and businesses. The Craftsman Bungalow and English Cottage styles were popular choices for the new brick houses in the 1920s and 1930s. Both the Old Southwest and Old Northwest neighborhoods are excellent loca-

tions to appreciate the many different ways a square piece of baked clay can be used to build and decorate a home.

Walking and Driving Guides

The walking and driving guides are arranged by chapter, as follows:

1. Downtown Reno
2. West Court Street
3. Liberty Street
4. California Avenue
5. Old Southwest
6. Old Northwest
7. University of Nevada, Reno
8. Ranches

Each chapter includes a brief history of the neighborhood and a map marking the location of each house. Each page contains a photograph of the selected house or building, followed by the history of the structure and a description of its architecture.

In addition, those who want to learn more about architectural terms used in this book will find them in the Glossary, located in the Appendix. A description of the major architectural styles found in the Reno area follows the Glossary, with specific examples listed.

The Appendix also includes a listing of Reno's most prominent architects, a brief description of their preferred styles, and a list of some of the houses and buildings they designed.

⇒ OVERVIEW MAP ⇐
Areas Covered in Chapters 1-8

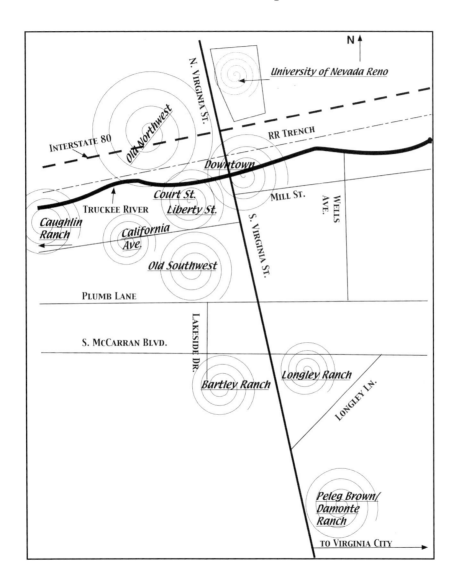

N ↑

University of Nevada Reno

N. VIRGINIA ST.

INTERSTATE 80

Old Northwest

RR TRENCH

Downtown

Court St.

TRUCKEE RIVER

Liberty St.

MILL ST.

WELLS AVE.

Caughlin Ranch

California Ave.

S. VIRGINIA ST.

Old Southwest

PLUMB LANE

LAKESIDE DR.

S. McCARRAN BLVD.

Bartley Ranch

Longley Ranch

LONGLEY LN.

Peleg Brown/ Damonte Ranch

TO VIRGINIA CITY →

ᴥ Chapter One ᴥ
DOWNTOWN RENO

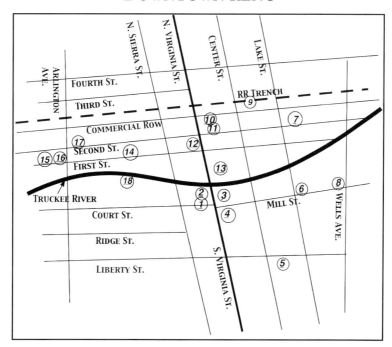

1. Washoe County Courthouse (1911)
2. Riverside Hotel (1927)
3. Reno Downtown Post Office (1934)
4. Pioneer Theater-Auditorium (1967)
5. Southside School Annex (1936)
6. National Automobile Museum (1989)
7. Pincolini/Mizpah Hotel (1922)
8. Artists' Co-op/French Laundry (c. 1909)
9. Amtrak Depot (1925)
10. Harolds Club Site (1935)
11. Reno National Bank (1915)
12. Reno Savings Bank/Oddfellows' Hall (1877)
13. Mapes Hotel Site (1947)
14. First United Methodist Church (1926)
15. Twentieth Century Club (1925)
16. St. Thomas Aquinas Cathedral Complex (1908, 1910)
17. El Cortez Hotel (1931)
18. Trinity Episcopal Church (1929)

⤳ DOWNTOWN RENO ⤳

Lake's Crossing

Reno got its start in 1859 as a toll bridge across the Truckee River, named Fuller's Crossing. In 1861, Myron Lake bought the bridge, renamed it Lake's Crossing, and built an inn (the Lake House) adjacent to it. In 1902-1907, the Lake House was replaced by the Riverside Hotel[1], a three-story, 110-room brick structure with ornate towers. It burned down in 1922, and was replaced by the present Riverside Hotel in 1927.

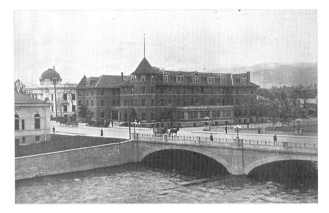

Virginia Street bridge and the Riverside Hotel.

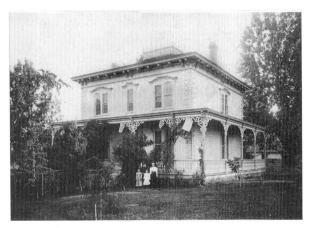

Myron Lake House.

An Important Railroad Junction

When the iron horse pushed across Donner Pass from Sacramento in 1868, Lake's Crossing lost its name but gained importance. Named after General Jesse Lee Reno, a Civil War hero, the new town rapidly became a very important junction on the two new railway systems that merged their tracks at the new depot downtown: the transcontinental Central Pacific Railroad and the Virginia and Truckee (V & T) Railway. The Central Pacific, which later became the Southern Pacific and now the Union Pacific, carried passengers and freight between the Pacific and Atlantic coasts, while the V & T connected Reno with the state's capital, Carson City, and Virginia City.

The Central Pacific Railroad drew up plat maps of the land surrounding the new train terminus north of the Truckee River and sold lots that soon filled with houses and businesses. The city of Reno was born, and became officially incorporated in 1903.

Today's recently remodeled Amtrak depot, built in 1925, occupies the site of the original 1868 railroad depot that served Reno's first train passengers.

Another major railroad was constructed in the 1880s, providing a way to ship timber out of the Sierra foothills north of town to the Central Pacific junction in Reno. The narrow-gauge Nevada-California-Oregon railroad also carried passengers, as well as cattle and sheep. The

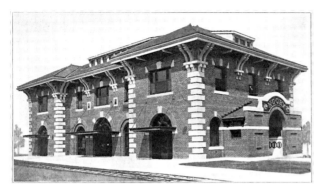

Nevada-California-Oregon Railway passenger depot.

north-south tracks were laid to the east of the University of Nevada and terminated at the elegant Italianate depot at 325 East Fourth Street, designed by Frederic DeLongchamps in 1910. Western Pacific Railway purchased the depot and the rail route in 1917, standardized the gauge and still uses the tracks.

Reno's Commercial District in the 1920s

A thriving new commercial center of activity sprang up around the depot on Commercial Row. Incoming railway passengers were welcomed by hotels, restaurants, saloons, and brothels. Other businesses facing the tracks included mercantile stores (clothing, hardware, and food), banks, and liquor stores.

Only one building remains from Reno's important railroad past, just south of the railway tracks, at the corner of Sierra Street and Commercial Row. Built in 1873, its ground floor was occupied by Reno Mercantile between 1895 and 1970, while the upper floor was used by the Masons as a meeting hall. Today it is used as a storage facility for Fitzgerald's Casino.

Levi's Blue Jeans in Reno

In 1871, a Reno tailor put together some heavy cotton duck canvas pants for a portly man, reinforcing crucial seams with copper rivets.[2] The pants became instantly popular, and the same method is used today for durable pants and jackets. The tailor, Jacob Davis, was a Latvian immigrant who had moved to Reno from Virginia City in 1868 and bought a building at what is now 211 North Virginia Street (a commemorative plaque was placed there in May 2006).

Davis had bought the white duck canvas-type cloth from Levi Strauss Co., a San Francisco merchant. Davis, with the help of Strauss, patented the popular design, and Davis soon moved to San Francisco, where he headed up

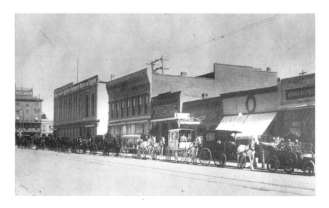

Reno commercial district, circa 1890s.

the production of Levi's blue jeans. Blue material was used later, imported from Nîmes, France, giving rise to the phrase "de Nîmes" or "denim." The word "jeans" comes from the French word for Genoa, Italy, where many of the first pairs were sold.

Impact of Legalized Gambling on Downtown Buildings

After the Nevada Legislature legalized casino gambling in March 1931, the face of downtown Reno began to change. By the late 1940s, small gambling clubs, followed by large ground-floor casinos, soon took over, displacing most of the retail shops, banks, and office buildings on the three busiest streets, Virginia, Center, and Lake. Older buildings were either demolished or radically transformed. Consequently, very little is left of "old Reno" today on those streets.

Two pre-1931 buildings on Virginia Street survived the downtown casino boom of the late 1940s: (1) the

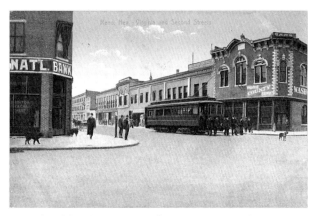

Second and Virginia Street, early 1900s.

three-story Neo-Classical Reno National Bank building (now Harrah's Club and a Japanese restaurant) built in 1915 on the northeast corner of Virginia and Second streets, and (2) the two-story, Italianate building that once housed the International Order of Odd Fellows (IOOF) and the Reno Savings Bank, built at the southwest corner

of Virginia and Second streets in 1873, currently a souvenir shop.

Lake Street, one block east of Center Street, was the site of many businesses catering to the growing ethnic communities, which included Chinese and African-Americans. Reno's numerous Italian families in the 1920s supported hotels, restaurants, and delicatessens on Lake Street. The Pincolini/Mizpah Hotel was the only remnant of that bygone era until an arson fire destroyed it in October 2006.

The Reno Arch

Reno's first arch was dedicated on October 23, 1926, to highlight Nevada's Transcontinental Highway Exposition in 1927. It was erected downtown, where Virginia Street met the railroad tracks. In 1929, the wording was changed, proclaiming Reno as the "Biggest Little City in the World." The arch can be seen over Lake Street, between the National Automobile Museum and the Siena Hotel-Casino. (Be sure to read the commemorative plaque adjacent to the sidewalk.)

By the 1950s, the location of the Reno Arch pinpointed North Virginia Street as the most profitable location, with Harolds Club, the Nevada Club, and Harrah's Club as the major attractions just steps away. Throngs of people still mill around under the arch, every parade begins under it, and no photograph of Reno is complete without it.

The present-day arch was erected in 1987, replacing the 1963 version (which is now over the main street of Willits, California).

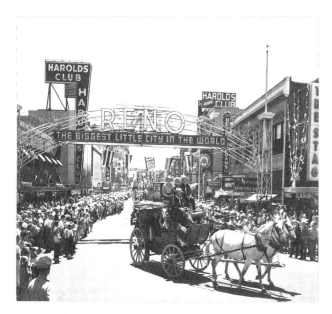

Reno Rodeo Parade, ca. 1955.

America's Most Exciting City

By the 1930s, Reno looked—and sounded—like no other American city. Visitors walking down the wide sidewalks on Virginia Street could peer into the expansive entrances of casinos through their seemingly magic "curtain of air" and see a myriad of games of chance, from slot machines to roulette wheels and craps tables. The noise from loudly clanging slots competed with the shouts of the barkers on the sidewalks trying to lure potential gamblers through the air curtain, with promises of instant riches and free drinks.

Worried about the effects of wide-open gambling on the quiet streets of Reno, in the late 1940s, the City Council drew a "red line" around a four-square-block downtown area, blocking further expansion of gaming. Thus,

except for the Riverside Hotel and the El Cortez Hotel (grandfathered in because of their previous gambling licenses), until 1970 no casinos and clubs could receive a gaming license outside the red line. Even then a 100-room hotel was required as part of the package.

A Trio of Important Historical Buildings

Three of Reno's most notable downtown buildings are architecturally and historically significant enough to be listed in the National Register of Historic Places. Not only were all three designed by the same architect, Frederic DeLongchamps, but they are clustered together on Virginia Street, just south of the historic bridge over the Truckee River. DeLongchamps was Reno's most prolific and prominent designer of public buildings and private residences (see Appendix for further information). These buildings demonstrate three highpoints in his career as well as in American architectural styles:

- 1911 (Beaux Arts): Washoe County Court House, 117 South Virginia Street
- 1927 (Period Revival): Riverside Hotel, 17 South Virginia Street
- 1934 (Art Deco): Reno Main Post Office, 50 South Virginia Street

The New Face of Downtown Reno

Downtown's allure has always been centered on the Truckee River, which can be a serene stream or a raging torrent, depending on the weather and the amount of snow in the Sierra Nevada range west of Reno. Frequent floods were the reason many of Reno's early buildings turned their often ugly, monolithic backs on the river. Now

new buildings have replaced most of those old buildings, gladly facing the river to take advantage of its beauty and the constant activity along its banks.

As is evident from the on-going construction activity in and around the downtown area, Reno is once again reinventing itself. Starting in the 1990s, and gaining renewed strength after the unfortunate demolition of the Mapes Hotel in January 2000, preservationists and city planners set about to create a more livable atmosphere around the historic downtown core. Prominent members of the arts community, such as Sierra Arts and VSA Arts of Nevada, joined forces with local artists and artisans to pressure the City of Reno to improve the area.

The results of these efforts are clearly seen now, as several long-vacant hotels undergo transformation into luxury condominiums. The first such conversion took place when the former Comstock Hotel on West Street became the Residences at Riverwalk in 2005. Hotel conversions and new residential construction are attracting visitors and residents alike to the banks of the Truckee River. Just as Reno's first residents were once attracted to the Truckee's beautiful setting, so too are today's new downtown dwellers and visitors.

The new residents also take advantage of the redesigned Truckee River pedestrian corridor, which offers inviting places to relax on the lawn under the trees, go for a swim, try out a kayak, play tennis, or fish for trout. The installation of flood-proof walls, pedestrian bridges, promenades, and stairways leading to the water's edge now make access easier and safer.

In one of historic preservation's most celebrated victories, the City of Reno worked with developers and the Sierra Arts Foundation in purchasing the long-closed historic Riverside Hotel and converting it to artists' lofts, available only to those with much talent but very little money. The innovative utilization of the Riverside Lofts as a center for "starving artists" has made Reno famous in artistic and preservation circles around the nation.

The revamped Riverside Hotel was a catalyst for spurring renewed interest in the arts. Many artistic and musical events have been combined into a month-long celebration called Artown, which takes place in July. During Artown, visitors enjoy exhibitions by local and visiting artists, street dances, ethnic food festivals, free movies, and live theater, all taking place along the river and on the streets where Reno's most historic buildings still stand.

Beginning the Walking Tour: Where to Start

While there are several excellent entry points along the Downtown Walking Tour, good starting points include the Arlington Street bridge over the kayak race course, as well as in front of the Riverside Hotel or the Washoe County Courthouse. On the north side of the historic downtown area, you might start at the Reno Arch and walk south along Virginia Street or east over to Lake Street. But no matter where you start, and no matter how many times you follow the walking tour, you will learn something new about Reno's past and pick up a little bit of architectural knowledge at the same time. Enjoy!

☙❧

WASHOE COUNTY COURTHOUSE
(1911; 1946; 1949; 1965)
117 South Virginia Street

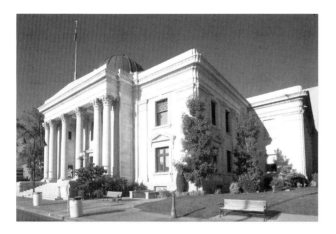

Picture Marilyn Monroe walking up these steps in the 1960 movie, *The Misfits*, playing the part of a young divorcee on her way to court (ironically, Monroe divorced her playwright husband Arthur Miller shortly after finishing this film, although not in Reno). The elegant Washoe County Courthouse was an ideal, real-life set for Marilyn's scene in Reno, the divorce capital of the world. Rich or poor, famous or unknown, everyone ascended these granite steps and passed through the Corinthian portico of the elegant Beaux Arts courthouse, on their way to "Renovate" their life.[1] Striding through the main corridor, divorcees and their attorneys then climbed the grand staircase to the second floor courtroom, perhaps oblivious to the magnificent stained glass dome overhead. Through the double doors of the courtroom, the judge awaited them on the bench, which was elaborately deco-

rated with a segmental, keystoned arch and surrounding pilasters embellished with garlands.

After the divorce was granted, most divorcees departed Reno within hours, but many remarried quickly (often to another recently divorced person), returning to this courthouse again for a marriage license and tying the knot in the conveniently placed wedding chapels adjacent to the courthouse.

The Washoe County Courthouse was designed by Frederic DeLongchamps early in his career; he later became known as Reno's most prominent and prolific architect (note the spelling of his name on the cornerstone, reflecting how his family spelled it prior to discovering its proper form). The original courthouse dating to 1873 was incorporated into the present building, with traces still visible, such as the wooden staircase in the central hall. Built in 1910-11, the building has been remodeled twice: the north and south wings were added in 1946 and 1949, respectively, and the modern addition on the west side was built in 1965. An extensive restoration project in 2001 cleaned and rebuilt the stained glass dome, which had begun to sag and crack. The dome was dismantled and transported to Emeryville, California, where artisans restored color to the glass panels and built a new, safer framework.[2] The courthouse is open to the public, through the south-facing door on Court Street.

RIVERSIDE HOTEL (1927)
17 South Virginia Street

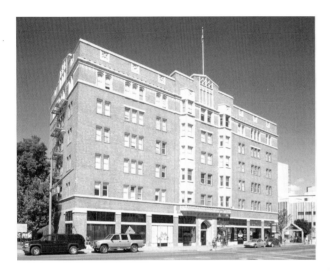

One of the most visible, historic structures to be found in Reno today, the Riverside Hotel occupies the site of the city's first structure, a hotel built in 1868 to accommodate Reno's first visitors.[1] In 1902, work began on a three-story, 110-room hotel, completed in 1907. That hotel burned to the ground, leaving a vacant lot in the center of downtown. Meanwhile, Nevada's most prominent citizen, George Wingfield, had been promoting an idea to bring more potential divorcees to Reno: lower the residency requirements from six months to three months. The Nevada Legislature liked the idea, so Wingfield bought the vacant lot and built this hotel just in time for the new law to take effect. (In 1931, the requirement was slashed to just six weeks, an even more enticing incentive.) Wingfield had already made a fortune in the gold mines of Central Nevada, which led to his control over a statewide system of banks, cattle ranches, real estate, and hotels. His uncanny business sense correctly predicted the Reno divorce boom. The Riverside Hotel, which cost $750,000 to build, offered luxurious accommodations: forty corner suites with combination living room/bedroom, kitchen, and dining room; individual temperature regulators; specially-designed refrigerators; and electric ranges, all rare for the 1920s. Hotel guests' names were kept secret, but research shows that notables such as Clare Boothe Luce and Gloria Vanderbilt were residents. [2]

In 1949, Wingfield expanded the hotel by adding new lanai apartments, an enclosed swimming pool, an enlarged kitchen and dining room, and a casino. Jimmy Durante was the first top performer to appear, in 1950. But after a series of owners and financial problems, the hotel closed in December 1986, and its fate seemed to be demolition after sitting vacant for many years. In 1998, the City of Reno, working with Sierra Arts and Art Space, rehabilitated the hotel, creating artists' lofts, office space, and restaurants. Today, Reno is nationally famous for its preservation of this landmark hotel, by utilizing the policy of adaptive re-use.

Designed by prominent Reno architect Frederic De-Longchamps, the Riverside's Period Revival style with Gothic elements utilizes terra cotta decoration of its slanted bay windows, with brick spandrels of inlaid zig-zag patterns separating the windows. The top floor has terra cotta surrounds of Gothic arched heads with quoins.

RENO POST OFFICE (1934)
50 South Virginia Street

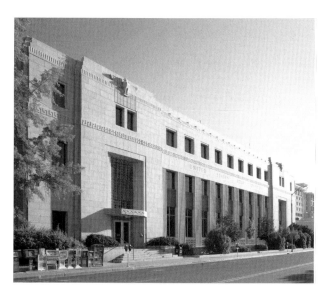

This fine example of the Art Deco style was a product of the 1926 Public Buildings Program established by Congress to employ private architects in the construction of public structures.[1] The original design on the blueprints from the Supervising Architect's office in Washington, D.C., required a plain, utilitarian, federal-style building. Fortunately, the final product in 1934 was a great departure from those plans, because of the involvement of Reno's most prominent architect, Frederic DeLongchamps. The post office's ultra-modern design, with its shiny, geometric aluminum trim and weatherproof terra cotta walls brought beauty and modernity to the site overlooking the Truckee River. Further, its construction was a national recognition of Reno as a rapidly growing town despite the ravages of the Great Depression in other states.

The Zig-Zag Moderne style, part of the Art Deco and Art Moderne movements of the 1930s, can be seen in the stylized aluminum chevrons around the windows and the terra cotta American Eagles along the roof line. The light green terra cotta walls still retain their original patina, as does the original aluminum framing of the windows, vestibules, and doors.

As you enter the building, notice the intricate brushed-aluminum molding surrounding each pane of glass on the inner doors of the vestibules. The motifs indicate a salute to modern transportation, from the winged-god Mercury to the airplane. The service counter is also decorated in a similar manner. The inside doors, frames, and window sashes are made of maple. The dimly-lit main lobby, with its original terrazzo and marble floors, aluminum lock boxes, and marble writing tables, retains its mid-1930s aura of sleek, industrial-style modernism with touches of abstract geometrical symbols and governmental motifs. The sky-lighted central atrium was later converted to accommodate the installation of HVAC ductwork. Don't miss the elevator doors: they are a fine example of Art Deco design.

The post office served as a "police station" set during the filming of the movie *Sister Act*, starring Whoopie Goldberg.

PIONEER THEATER-AUDITORIUM (1967)
100 S. Virginia Street

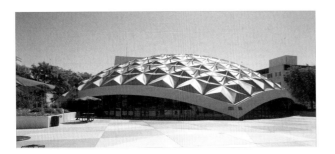

Some might think that this building resembles a bird that has swooped down to the ground with its wings spread.[1] Or, it could be called the "golden turtle," as local wags described it during construction. No matter what one thinks of it, all agree that the Pioneer Theater is certainly unique, and was a great leap in design from Reno's traditional public buildings. The only gold-anodized geodesic dome to be found in Nevada, it represents a popular style that was patented in 1954 by Buckminster Fuller, who observed that the triangle is the strongest shape in nature. Many Cinerama theaters in America were built in the 1960s using the geodesic dome design. Kaiser Aluminum has built more than 5,000 dome structures since they were first patented. This dome was constructed by Temcor, a Torrance, California, company involved with Kaiser.

Constructed in 1967, when Reno's population was booming and the need for a home for performing arts was critical, the Pioneer Theater-Auditorium serves as a monument to the coalition of local arts and community groups that convinced the city council to build it. Among the many groups who perform here are the Reno Philharmonic Orchestra, the Nevada Opera, the Masterworks Chorale, and the Broadway Comes to Reno Series. The name Pioneer derives from the 1939 bronze statute of a pioneer family that stands in front of the theater.

The roof of the theater is actually a dome within a dome—an exterior aluminum dome and an interior steel frame dome. The steel frame dome supports the interior catwalks, sprinkler system, and the lobby ceiling. The exterior walls are reinforced concrete, and the stage loft has a structural steel framework. Five post-tensioned concrete arches support the gold-anodized aluminum geodesic dome roof, 140 feet in diameter. The roof has 500 faceted panels. Vertical window panes fill the space under the two front arches. Inside, gold aluminum panels, molded into large stars, cover the ceiling. The main seating area contains 987 seats, while the balcony contains 513 seats, with no obstructions. Concerts in the Pioneer Theater are a special treat because the acoustics are excellent due to walnut wood veneer on the walls and the proximity of the seating to the stage and performers.

SOUTHSIDE SCHOOL ANNEX (1936)
190 East Liberty Street

An understated example of the Art Deco style in Reno, the Annex was originally built to provide additional classrooms for Southside School in the same block, which was demolished in 1960.[1] The Annex was built with Work Progress Administration (WPA) funds and labor in 1936,

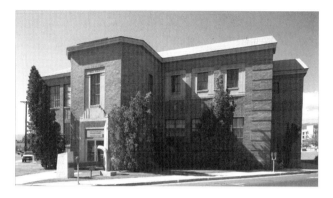

and housed kindergarten and fifth and sixth grades. Several Reno educators who taught at this school have been memorialized in the names of some local elementary schools: Jessie Beck, Echo Loder, Alice Maxwell, and Marvin Moss.

The Annex is a tall, two-story, red brick building with a decorative Art Deco entrance frontispiece. The main rectangular, gabled roof is bisected bilaterally by a hipped roof. A rectangular wing, two stories high, with one bay has been attached to the north wall, and a one-story wing is attached to the south side. Brick quoins decorate the corners, while recessed spandrels between the first and second story windows are decorated with a crest with the letter "S" and bricks laid in decorative patterns.

Large expanses of glass form the windows: Single, three-over-three, double hung, single or paired nine-light awning windows. An owl (for wisdom) and floral motif frames three of the second story front and rear windows. A stepped, recessed concrete frontispiece surrounds the central, first story double doors and the second story nine-light window.

A recessed rectangular panel containing the school name is mounted above the door. Inside, a main hallway bisects the first floor, and the four former classrooms have been converted to offices. A stage is located in the eastern corner of the large room upstairs, echoing earlier days of assemblies and school gatherings.

The Southside Annex now serves as facilities space for the City of Reno.

NATIONAL AUTOMOBILE MUSEUM (1989)
10 South Lake Street

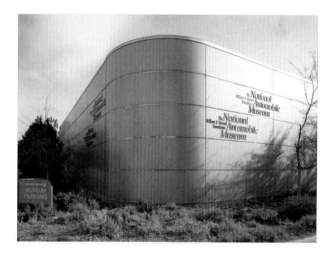

This ultra-modern building houses one of Reno's—and the nation's—treasures: the Harrah's Automobile Collection, which first opened in 1962 in an old ice storage warehouse in east Reno, off Glendale Avenue. This museum preserves more than 200 prime specimens from gaming pioneer Bill Harrah's once-vast collection of horseless carriages, old cars, and trucks. In the museum, you

can stroll through real-life street scenes of early America, with store façades, autos, and artifacts reflecting the four 25-year periods of the 20th century.[1] The cars date from 1892 to the present, including one of the largest and finest horseless carriage collections in the world. Even the exterior color of the building is historic: It was adapted from an actual automobile paint color known as "Heather Mist."

The research library is world-renowned for its extensive collection of automotive history, including technical books and restoration manuals, shop and owner's manuals, wiring diagrams, upholstery samples, paint color chips and formulas, photographs, and books. The museum store offers gifts and merchandise for sale.

Bill Harrah was one of the most important figures in the history of Nevada gambling. He opened a small bingo parlor in 1937 and then went on to buy out competitors along Virginia and Center streets, eventually erecting a large casino with hundreds of badly-needed hotel rooms downtown. When Bill Harrah passed away in 1978, the Holiday Inn corporation purchased his multi-national business, along with the auto collection, which they soon put up for sale. A public outcry ensued, and a non-profit organization was set up to save at least part of the 1400-car collection. As a result, 200 cars and the research library were donated to the future museum, and fundraising efforts succeeded in buying this site and erecting this building.

History buffs as well as car lovers should not miss visiting this collection. Among the cars inside are Elvis Presley's 1973 Cadillac Eldorado; James Dean's 1949 Mercury from the 1955 movie, *Rebel Without a Cause*; Frank Sinatra's 1961 Ghia; John F. Kennedy's 1962 Lincoln Continental Convertible; Jack Benny's 1923 Maxwell; and the 1912 Rambler that appeared in the 1997 movie *Titanic*.

PINCOLINI/MIZPAH HOTEL SITE
(1922; burned 2006)
214 Lake Street

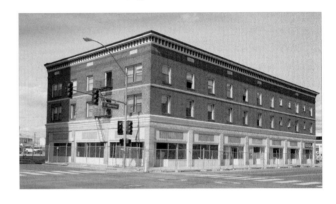

Constructed in 1922 by four Italian brothers (Joseph, Evaristo, Adelvaldo, and Dante Pincolini), the Mizpah Hotel was the only structure from Reno's "Little Italy" days to have survived the ubiquitous wrecking ball on Lake Street, until its tragic end in 2006.[1] An arson fire in October 2006 gutted the hotel and resulted in 12 deaths. Lake Street, between Second and Center Streets, at one time was home to grocery stores, Italian delicatessens, liquor stores, insurance agencies, a travel agency, and hotels aimed at the Italian-American market, which was very large in northern Nevada in the 1920s and 1930s.

Originally involved in cattle ranching and potato farming, the Pincolinis purchased the San Rafael Ranch north of Reno (now a regional park) in 1896 and expanded their holdings across Northern Nevada. Their use of the new potato planting machines boosted their profits, inspiring the family to build "the most unique modern hotel in the state of Nevada." The hotel boasted that every room had "cold, pure spring water" and steam heat; some had hot water and private bathrooms. Major additions in 1925 and 1930 increased the height and width of the building. Built before gambling was legalized in 1931, the lower floor served as retail space. The hotel lobby was a time capsule of by-gone years, with original pine paneling painted to simulate oak, plus original light fixtures and registration desk. The lobby still had the old Reno Electrical Works "ringing board" from the area's first telephone system, as well as a vintage telephone.

The hotel was a U-shaped brick structure supported by a rubble masonry foundation. The flat roof had four skylights. The ground floor was separated from the upper stories by a patterned brick frieze and projecting sheet metal cornice. A narrow belt course banded the building between the second and third stories. The original 1922 roofline included a slightly projecting parapet that spanned the central three bays. The outside walls were decorated by plain brick pilasters which marked the front door and corners of the building. The venerable old hotel will be sorely missed.

ARTISTS' CO-OPERATIVE/FRENCH LAUNDRY (c. 1909)
627 Mill Street

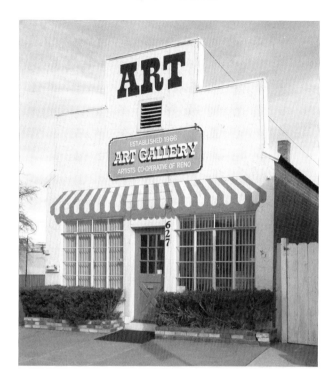

In the late 1800s, there were Chinese laundries, for ordinary sheets, towels, workmen's clothes and the like, and then there were French laundries for frilly lace blouses, long silk dresses, men's silk suits, and linen shirts (fitted out with French cuffs, of course). A French laundry provided the highest quality service available at the time for the care of fine clothes, curtains, and draperies. The Cyril Escallier family, who operated a French laundry in this

structure in the early 1900s, used long-gone tools such as bonnet puffers, fluters, and 8-12 pound irons, to serve wealthy clientele until the mid-1960s.[1] The laundry also owned the first Model A delivery truck in Reno, as part of their deluxe service.

In 1966, the building was reborn as an artists' co-operative, led by local artists Lyle and Ester Ball. The shabby old building was retrofitted with narrow, horizontal slats affixed to the walls, from which four paintings by each artist were hung by hangers fashioned from bent shirt hangers. Heavy laundry equipment was removed—such as the old mangles that ironed sheets—and many repairs were made to the badly-deteriorated structure. Much of the furniture and fixtures came from donations and recycling. Even the toilet is an artifact: it was obtained from Orvis Ring Elementary School (ca.1910) when it was demolished to make way for the I-80 freeway. The wood paneling in the back room is older still: it came from the Kleppe Ranch barn, built in 1873.

Today only one of the founders is still alive, Mahree Roberts, who states that in the 1960s Reno was a "cultural desert," and this gallery was considered a good way to bring the arts to the town.[2] The dominating theme of the art work is mainly Western, specifically "old Nevada," according to current board member Jack Hursh, Jr. The prices of the paintings, photographs, baskets, pottery pieces, and jewelry are low enough for most budgets. The gallery recently held its 40th anniversary show, and is open to the public.

AMTRAK DEPOT
(Southern Pacific Railroad Depot) (1925)
135 East Commercial Row

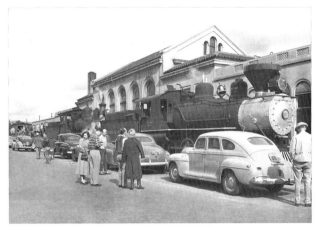

Southern Pacific Railroad Depot, 1940s.

The dream of linking California with the Midwest and East Coast began in 1854, when Congress first debated funding a transcontinental railroad. Proposals for its route ranged from a southern line going through Santa Fe to San Diego, to a northern line along the Lewis and Clark trail of 1804.[1] By 1862, the "central overland route" over Donner Pass in the Sierras became the preferred route, and President Lincoln signed the bill that granted to the Central Pacific Railroad not only huge sums of money for its construction, but the railroad company received one-mile-square sections of land for hundreds of miles along the route between San Francisco and the Mississippi River. Those blocks of private land, which alternated alongside the tracks in a "checkerboard" pattern, later allowed the sale of railroad lands for the development of towns

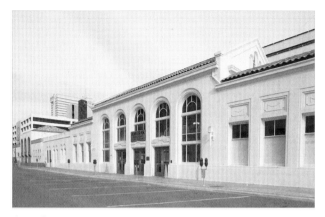

Amtrak Depot, 2007.

and cities, as well as private forestland for the timber industry and ranchland for cattle grazing.

Three years ahead of schedule, the iron horse rolled into the newly-named little town of Reno on May 5, 1868, and four days later town lots were auctioned off by the Central Pacific Railroad.[2] Within a year, the Virginia and Truckee Railway (V & T) spur line was begun, carrying passengers and silver ore down from Virginia City mines. Reno's first depot, built in 1868, burned in the great fire of 1879. Another depot was built on this site in 1889, but it too burned down. When Southern Pacific took over Central Pacific a few years later, this depot was built.[3]

Crafted in the elegant Mission Revival style popular in the 1920s, the depot has been extensively restored and modified to accommodate the recent lowering of the railroad tracks into the "trench" below street level. Open to the public, the historic building is a beautiful time capsule of train travel in years past, with its old doors, high coffered ceilings, and decorative motifs. Not to be missed is the fountain on the new platform downstairs, which once graced a Reno street corner courtesy of the Women's Christian Temperance Union, and provided a cool drink to people as well as dogs and horses (from the lower basin). Note the mural on the wall behind the fountain.

HAROLDS CLUB SITE
(1935; demolished in 1999)

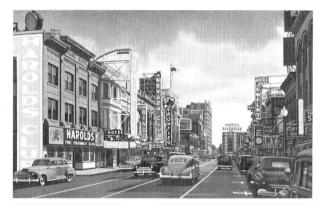

On this site was the casino that put Reno on the world map in the 1930s. Gaming pioneering brothers Harold and Raymond Smith started it all in 1935, when they borrowed $500 from their father, Raymond I. "Pappy" Smith, and opened a single penny roulette game and two slot machines in a small, narrow room on North Virginia Street.[1] Harolds Club (always without the apostrophe) was the first casino to launch a worldwide casino advertising campaign. Seen by motorists in 45 states by 1950, "Harolds Club or Bust" billboards and signs were eventually found all over the world after Nevada military per-

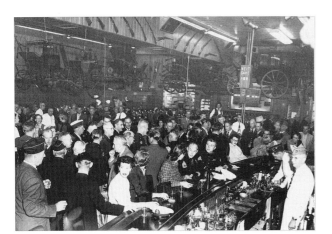

Roaring Camp Bar, Harolds Club, 1950s.

sonnel requested signs for their foreign posts.

As the casino's popularity grew, the Smiths added various games of chance, from fan-tan and craps to mouse roulette (a real mouse jumped around the numbers!) and racehorse keno. In 1947, Harolds Club expanded, bringing in Nevada's first escalator to carry western art aficionados (including children) to the second-floor, where they flocked to the Covered Wagon Room to gaze at the animated, lighted wall maps showing pioneer wagon routes, mountain scenes with waterfalls, antique western gun collections, and western paintings and memorabilia. The Roaring Camp Bar (above) was a gathering point for Renoites for many years.

Always innovative, the Smiths hired Nevada's first female dealers, a shrewd move that welcomed once-wary women to these newly sanitized dens of iniquity. The Smiths were also colorful characters, beloved by locals for their stunts such as riding a horse onto the casino floor, and for their generosity, such as handing out free quarters on the sidewalk and granting hundreds of University of Nevada scholarships to local high school graduates.

By 1967, Harolds Club was the largest casino in Nevada. It was sold to Howard Hughes in 1970, and then eventually to Harrah's Club. It was demolished in 1999.

Nothing remains of Harolds Club except memories and one huge masterpiece: a porcelain enamel mural, 35 feet high and 75 feet long, that once hung on the entire length of the Virginia Street side of the building. Erected in 1949, declaring that it was "Dedicated in all humility to those who blazed the trail," the brightly colored mural depicted Nevada pioneers and Native Americans camped at the base of the Sierras on the Emigrant Trail. Part of the surrounding scenery includes illuminated, flickering campfires and cascading waterfalls. The mural was spared from demolition in 1999, carefully dismantled and then reassembled on the south wall of the Reno Livestock Events Center on North Wells Avenue in northeast Reno. The preservation of the mural is a tribute to Reno's first gaming family and their many contributions to the community.

RENO NATIONAL BANK
WASHOE COUNTY BANK (1915)
204 North Virginia Street

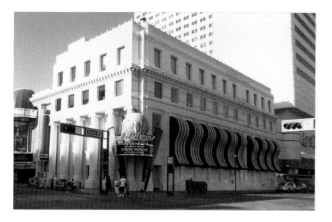

This Classical Revival bank building was designed by prominent Reno architect Frederic DeLongchamps in 1915.[1] It became the power center of the state of Nevada during the 1920s, when it housed the office of the most powerful man in Nevada, George Wingfield, known variously as the "owner" and "operator" of Nevada, the "Sagebrush Caesar," and "Nevada's Napoleon."[1] Incredibly successful in the gold and silver mines of Tonopah and Goldfield, he and his partner, future U. S. Senator George Nixon, built a statewide financial empire that included twelve banks, numerous mines and cattle ranches, and the Riverside and Golden hotels. Wingfield actively promoted quickie divorces and legalized gambling in Nevada, accurately predicting Reno's profitable future as the nation's first "sin city." He donated the land where Wingfield Park now stands, at Arlington and Island av-

enues, and his weekend home was his ranch in the Spanish Springs valley, a housing development now known as Wingfield Springs. His former residence, at 220 Court Street, tragically burned to the ground, in 2002.

Remarkably spared from the wrecking ball during the casino building boom of the 1930s and 1940s, this building still looks like a bank, despite its current use as one of the entrances for Harrah's Club. For several years, restaurants have occupied the building's corner on Second and Virginia streets. Fortunately, the casino-style exterior additions do not obscure the building's Classical Revival lines, and can supposedly be removed without permanent damage.

The most striking feature of the terra cotta-faced building is the portico, a row of massive Ionic columns on the west and south façades, rising two stories high. The central entrance on the corner has a highly ornamented foliated door surround, with a heavy cornice decorated with a crowning oval medallion. Several friezes and belt courses separate the stories, some with motifs depicting lion heads, dentils, palmettes, and Greek Keys. Note the large eagle at the top of the building.

RENO SAVINGS BANK/
ODDFELLOWS' HALL (1877)
Second and Virginia Streets

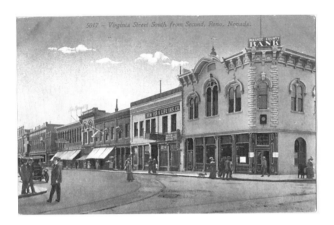

The Reno Savings Bank was founded by Myron Lake and other civic leaders in 1877.[1] The Odd Fellows and Knights of Pythias held meetings upstairs. Despite its location in the town's newest and finest business block, the bank closed only three years later because of blatant embezzlement by its directors plus losses on real estate values in the 1879 fire, which devastated 50 acres of downtown buildings. An angry mob of depositors brandished hanging ropes in front of directors' houses, but eventually all the directors were exonerated by the equally corrupt state investigators. In 1880, the new First National Bank of Reno utilized the building as its headquarters and expanded its size in 1887-89. In 1896, the bank reincorporated as the Washoe County Bank, and the western end of the building was dug out for a basement vault to hold trunks of family valuables. During the Depression, To-nopah mining baron George Wingfield absorbed the bank into his statewide banking system. In 1939, it became the Security National Bank, but later was remodeled to hold Edises' Jewelry. Reflecting increased competition and suburban shopping malls, Edises' closed in 1982. Recent tenants include souvenir and gift shops.

The intricate High Victorian Italianate exterior has been radically changed since 1877. It once boasted a deeply projecting roof cornice, large curved roof brackets, round arch window hood molds, corner quoins, and cast-iron pilasters around the front door. The corner cupola was removed in 1908, when a more restrained Renaissance Revival style was desired. A simple flag pole replaced the tower, the hood molds and heavy brackets were removed, and an entablature with a projecting cornice, dentils, and a wide frieze were added. In the 1980s, the store-front window and door frames were replaced with modern aluminum frames. A clock tower was built at the upper corner, reflecting French Second Empire style with its S-curved mansard roof.[2]

The interior is very well maintained: the pressed tin ceiling, the elegant cut glass chandeliers, and the curved staircase remind us of Reno in the 1930s.

MAPES HOTEL SITE
(1947; demolished 2000)
North Virginia and First Streets

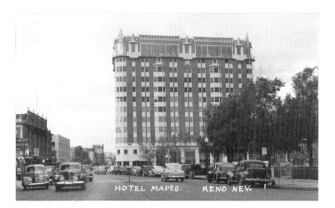

The Mapes Hotel was located on this site, built in 1947 at a cost of nearly $3,000,000. It was the first high-rise hotel completed in the world after World War II.[1] When it opened in 1947, the 12-story Art Deco hotel was Nevada's tallest building until the 15-story Fremont Hotel and Casino opened in Las Vegas in 1956. The Mapes was also the first building on the National Trust for Historic Preservation's list of eleven sites most in danger of being demolished, but that didn't protect it from being leveled in January 2000.

The hotel had been a long-time dream of Charles Mapes, Jr., son of a Reno cattle baron, who saw the opportunity for a large, first class hotel and casino downtown. Modeled on luxury hotels of New York, the thoroughly modern high-rise, topped by a glass-enclosed Sky Room, attracted thousands of locals and tourists during its 35-year history. The Sky Room, surrounded by high windows, soon became the favorite venue for high school proms, large parties, and live entertainment featuring top performers from Hollywood and Broadway. In 1960, the hotel was the center of activity throughout the Winter Olympics in nearby Squaw Valley. During the filming of *The Misfits* later that year, Marilyn Monroe stayed at the hotel, whose ground-floor casino hosted many film company parties and all-night gambling sprees.

The demise of the hotel came after the Mapes family expanded its other casino, the Money Tree, three blocks north on Virginia Street, in 1978. That was a bad year to invest in gambling, it turned out, because several large casino-hotels were built, eventually overextending Reno's gaming economy. Not long after the MGM Grand (later the Reno Hilton and now the Grand Sierra Resort), the Circus-Circus, the Sahara Reno, and the Comstock Hotel opened in 1982, both the Money Tree and the Mapes

The Mapes site today.

Hotel were bankrupt. After 18 years of neglect and many well-intentioned, but futile attempts to save the long-vacant hotel, the City of Reno demolished the building in January 2000. The site is now a city plaza that hosts ice skating in the winter and open-air community events in the summer.

FIRST UNITED METHODIST CHURCH
(1926)
201 West First Street

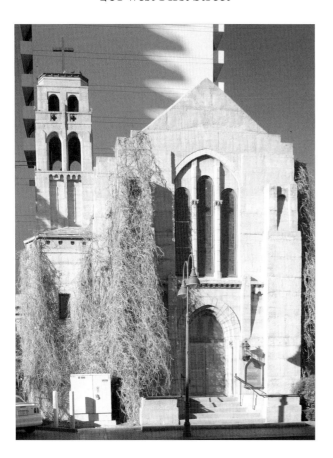

The "gray lady of West First Street" was one of the first poured concrete buildings in Reno.[1] A close look at the concrete walls of this Gothic Revival church reveals the wood grain marks of the forms into which the concrete was poured. Its melodious bell, consisting of a veritable ton of cast iron, was forged in San Francisco for the church. An Oakland architecture firm designed the present church, but the parish house and connecting wing were designed by prominent Reno architect Edward Parsons in 1940. In 1942, the sanctuary was remodeled, and the first stained glass windows were added, through generous gifts from church families. The Holy Family Window was installed in 1942, and has been appraised at over $8,000. The faces in the Hosanna Arch of the window are depictions of the 50 children who attended the church school in 1943. More recently, in 2000, additional windows were created by the local firm Tapestry Glass. Situated precariously close to the river, the church has suffered from Reno's periodic floods. In 1950, water, mud and dead fish filled the basement, but sandbagging and a brick retaining wall have mitigated damage since then.[2]

The cathedral's towers are over four stories high, and the main building utilizes large gabled rectangles with an intersecting cross gable across the nave.[2] Heavy vertical piers buttress the corners of the nave in typical Gothic style. The main façade, facing First Street, contains an arched entry outlined with a band of scored molding, beneath three large stained glass windows. The panels are arched and recessed into a large Gothic arch. The two-story wing connecting the church with the parish house was constructed in 1940. It contains paired arched windows set into larger Gothic arch frames, as well as a large door in a Gothic arch frame. This insetting of windows makes the building appear even larger and more impressive. The parish house contains tall arched windows, a tiered brick chimney stack, and an upper parapet wall with a cut-out quatrefoil design. The basement rooms were finished in 1948, based on a design by another

prominent Reno architect, Russell Mills. In 1965, an extension unit was added to the north of the building because of the construction of the adjacent parking garage. In 1976, the balcony and second floor of the passage wing were constructed, and fire access was added.

The church is especially beautiful at night, its towers aglow, as it presides over the eclectic business district emerging along First Street and around the Truckee River plaza just across the street. A survivor of floods and continual urban renewal downtown, "the quiet gray lady still stands proudly on her corner of the city, reminding all who pass of her illustrious past and contributing her grace and history to the present and future of Reno."[3]

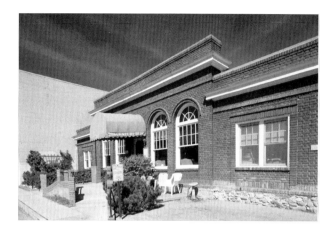

TWENTIETH CENTURY CLUB (1925)
335 West First Street

Organized by eighty-four of Northern Nevada's most prominent women in 1894, the Twentieth Century Club challenged the "dangerous new idea" that women's organizations would "end feminine charm and break up homes."[1] Among their first projects were the establishment of a free kindergarten for needy children, a cooking school for young girls, lectures by nationally-known speakers such as suffragette Susan B. Anthony, a free public library, and a state law banning spitting on sidewalks. During the aftermath of the 1906 San Francisco earthquake, food and supplies were collected and sent by train to the homeless. Throughout World War II, the club hosted an active branch of the U.S.O., helping the war effort by knitting sweaters, making bandages, and selling government bonds. The club organized Reno's first Parent-Teachers Associations (PTAs) in the public schools through the efforts of its prominent members, educators Hannah Clapp, Mary S. Doten, Libby Booth, and Echo Loder. To beautify Reno, members planted trees along Riverside Drive, some of which still stand.

After years of meeting in other facilities, such as the downtown YMCA and the Oddfellows' Hall, members raised enough money to purchase a lot and begin construction on their clubhouse. Designed by Reno architect Fred M. Schadler, the clubhouse was finished in 1925. The strong horizontal thrust of the structure, echoing the Prairie School style, is "greatly enlivened" by the use of the large, prominent arched windows, a Classical touch that results in a decidedly eclectic appearance.[2] The parapet around the roofline hides the hip and shed roof forms, while a projecting cornice wraps around the lower part of the parapet. The front entrance was originally on the right of the building, but was later moved to the central arch-

way, framed by two pairs of multi-paned windows with eye-catching fan lights.[3] The interior resembles an old San Francisco lobby, with overstuffed furniture, wrought iron torchieres, and ornate chandeliers. The main hall hosted Junior Assembly dances during the 1950s and 1960s. The building is currently used as law offices.

ST. THOMAS AQUINAS CATHEDRAL COMPLEX (1908; 1930)
Arlington Avenue and West Second Street

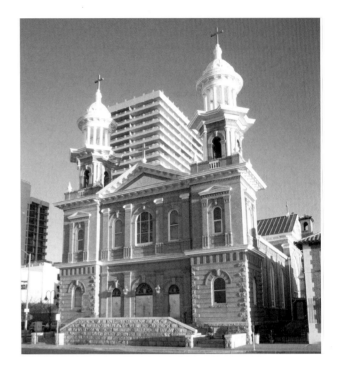

The St. Thomas Aquinas cathedral, rectory, and school building are the center of Reno's Catholic Diocese, which at one time spanned not only the entire state of Nevada but also part of Northern California.[1] The cathedral's Baroque/Classical towers dominate the skyline on downtown's western edge. A Catholic church and school had existed in Reno from its earliest beginnings. A Gothic-style church with stained glass windows was at Lake and 6th streets, but it was destroyed by fire in 1905.[2] The parish then purchased this site at Second and Chestnut (now Arlington) and constructed a new church. Less than a year later, in 1909, fire struck again, but the partially destroyed church was patiently reconstructed by its dedicated parishioners. In 1931, the church became a cathedral with the installation of its first bishop, Thomas Gorman (namesake for Gorman High School in Las Vegas).

Architecturally a mixture of Renaissance, Classical, and Baroque styles and motifs, the brick structure's main façade has corner quoins and keystoned brick arches, while the windows and roof gable are pediment-shaped. Minerals from Nevada were used in the church's reconstruction. The main doors, facing on Second Street, are made of sheet copper from the mines in Ely, while the altar and rails inside are of aragonite from Tonopah. Local artists contributed their talent to the cathedral: Gordon Newby embossed the copper doors with intricate Bible scenes; Bill Lutz designed the paintings; and the stained glass windows were crafted in the 1960s by the internationally acclaimed Hungarian artist, Isabel Piczek.

The rectory and the school building were designed in the 1930s by prominent Reno architect Frederic DeLongchamps. Striving not to compete with the Baroque

exuberance of the cathedral, both structures are understated and subtle in style, except for the rather flamboyant Baroque entrance on the east side of the school.

EL CORTEZ HOTEL (1931, 1932)
239 West Second Street

Now one of only a few remaining large Art Deco buildings

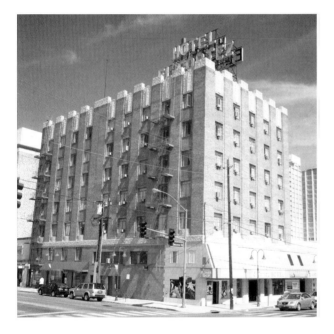

in downtown Reno (the Reno Downtown Post Office is another example), the El Cortez Hotel was a first-class destination for divorcées heading to Reno to take advantage of the newly legalized "quickie divorces" in 1931.[1] Designed by the architectural firm of George A. Ferris & Son for real estate broker Abe Zetooney, a native of Syria, the seven-story El Cortez was a bustling place from the beginning.[2] The Trocadero Room, known as "the Troc," featured top performers from Hollywood and Broadway, such as the Andrews Sisters and Sophie Tucker. The large dance hall with its live bands and popular restaurant (filet mignon for only 95 cents!) were packed during the war years. A collection of menus and other memorabilia from that era is located on the second floor. Between 1972 and 1982, Bill Fong, formerly of the New China Club on Lake Street, operated a bar and Chinese restaurant on the first floor. The hotel continues to operate and its rooms are furnished with antiques.

In the early 1960s, Reno began to grow rapidly, and the El Cortez became the regular meeting place for several community groups. Among those was the Committee of Fifty, a citizen's group dedicated to overhauling Reno's cumbersome, outdated city government.[3] Headed by long-time Reno educator Earl Wooster, the 50 members met here for over two years. Eventually, they drew up a charter proposal that abolished the old ward system, substituting a strong city council that selected the city manager.

The El Cortez Hotel has undergone several major remodels and additions. A year after its construction, the booming divorce trade brought in enough customers for more rooms, and an addition was made to the hotel. The storefront level was altered in 1949, when the large plate glass windows with multi-light transoms were replaced with smaller windows surrounded by smooth terra cotta tile siding. Some Art Moderne elements were also added, such as rounded corners and windows and signage typical of the era (now gone). The main entrance, with its stepped frontispiece with framing volutes enhanced by a low relief, terra

cotta foliated motif, was unchanged during the remodels. On the exterior walls, original rectangular terra cotta panels top the vertical brick pilasters, ornamenting the roofline.

TRINITY EPISCOPAL CHURCH
(1929; 1948)
200 Island Avenue

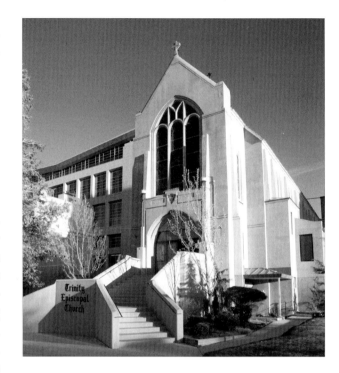

Under these soaring, Gothic-style walls there exists a crypt, which was the first structure on this site.[1] Affectionately called "the potato cellar" because of its flat roof covered with tar paper, the 1929 structure, now the church basement, served members until 1948. The Episcopal congregation had been active since 1870, holding its first meetings in the public schoolhouse near Second and Sierra streets. Long a majestic landmark on the south bank of the Truckee River, the church's basement has been flooded numerous times in its history, despite modern upstream flood-control dams.

Over the altar is an older stained glass window depicting the Trinity (Father, Son, and Holy Spirit). The kneeling cushions depict many northern Nevada scenes. At the opposite end of the building is a newer stained glass window above the balcony, which contains many religious symbols and figures. The high, clerestory windows carry biblical themes and historical figures, but one has a distinctly Nevada detail: a pair of dice, alluding to Nevada's primary industry. The lower windows, done in light colors, depict famous contemporary religious figures such as Mother Teresa and Desmond Tutu. The main doors leading to the river on Island Avenue carry mosaic seals, representing the Trinity, the State of Nevada, the Episcopal Diocese of Nevada, and the United States of America. The 115-foot bell tower houses a carillon of 35 Flemish bells, with the largest one weighing 1,000 pounds. Downtown workers and residents relish the chimes' varied repertoire.

The church's prize possession is the Casavant Frères Pipe Organ, Opus 3778, which is the largest in Nevada. First played in May 1999, the $400,000 organ was constructed in Quebec, Canada, and carries the names of donating members engraved on one of the pipes. Public organ concerts are held often, in addition to silent movie accompaniment and recitals.[2]

☙ Chapter Two ☙

WEST COURT STREET/ARLINGTON AVENUE

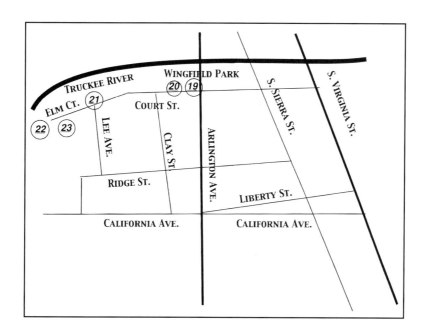

19. Gibbons/McCarran Mansion (1913)
20. Gray Mansion (1911)
21. Hawkins House (1911)
22. Newlands Mansion (1890)
23. Frederic DeLongchamps'
 Honeymoon Cottage (ca. 1926)

❧ WEST COURT STREET/ ❧ ARLINGTON AVENUE

The First Fashionable Addresses

Many of early Reno's wealthiest families built large, fashionable homes on this once-treeless bluff overlooking the Truckee River. The first houses were built on West Court Street, which follows the edge of the bluff above Wingfield Park. Dominating the skyline was the large Shingle-style house built by U. S. Senator Francis G. Newlands in 1890, at the west end of Court Street, behind the iron gate. The Newlands Mansion was the first Nevada home to be designated as a National Historic Landmark, in 1965. Senator Newlands correctly predicted the popularity of the bluff for development. His real estate company bought enough land to accommodate a robust building boom of upscale homes on estate-sized lots in the Newlands Heights (originally Rio Vista Heights) subdivision along Court Street and California Avenue. Chapter 4 discusses the many important homes found on both sides of California Avenue, often called the "mansions on the bluff."

Trembling Leaves over Newlands Heights

Newlands Heights is one of Reno's best-kept secrets—a place that captivates everyone who stumbles upon it for the first time. Walking up Court Street past the elegant white McCarran Mansion on the corner, you pass under a massive canopy of tall trees—maples, elms, and cottonwoods—which completely protect everything below from the brutal summer sun. This cool, green oasis seems almost surreal in the high desert of northern Nevada.

Indeed, the leafy blanket over the quiet streets and the huge, somnolent mansions so impressed a young Nevada writer that he chose this neighborhood for the location of his second novel. Walter Van Tilburg Clark, famous for *The Oxbow Incident* in 1940, forever memorialized the houses along Court Street in his 1945 novel about Reno, *The City of Trembling Leaves*. Clark chronicles the life of a young man who falls in love with a millionaire's daughter who grew up in one of these mansions in the 1940s.

A significant feature of the novel is the almost human-like presence of the massive trees and the secretive abodes of the super-rich, portrayed as foreboding, "moribund" symbols of wealth and status so unattainable by the young hero that he is adversely affected by them for the rest of his life.

Who Built These Homes on Court Street?

Most of Reno's first millionaires built showcase mansions on this street, all of which can be seen marching up the edge of the bluff, above the tennis courts of Wingfield Park. The list of families who chose a fashionable Court Street address includes the Hawkins family (heir to the Mackay fortune), the Newlands family (prominent U. S. Senator), Joseph Gray II (founder of Gray, Reid, Wright department store), Lewis Gibbons, and Patrick McCarran (prominent Reno attorneys and civic leaders), all of whose houses are highlighted in this chapter.

As you walk up Court Street, you will observe that all of the houses on the north side of the street were built especially to take advantage of the panoramic views over the Truckee River, and Peavine Mountain to the north and the Sierras to the west: each house is generously endowed with massive windows. In addition, terraces, solariums, and ga-

zebos extend the enjoyment of the views to the outdoors in the summer. An excellent view of those "backyards" is from Riverside Drive, on the north side of the Truckee River.

These early Reno families on Court Street truly enjoyed their houses and their proximity to the Truckee River. Most built steps down to the river's edge, where in the winter they ice-skated on the shallow pond formed by an artificial dam across the channel, or fished and swam when the water was lower and warmer. An added benefit to living high on the bluff was complete protection from the frequent floods caused by heavy spring run-off from deep snows in the nearby Sierras.

Many other interesting houses in the Court Street neighborhood are architectural gems in their own right, but space limits a discussion of them. If you have the time, spend an hour or so walking around the several blocks west of Arlington Avenue and north of California Avenue, enjoying the foliage and varied architecture of Reno's oldest and finest neighborhood.

GIBBONS/McCARRAN MANSION (1913)
401 Court Street

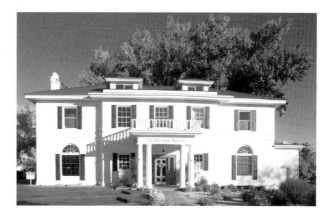

Designed by renowned Reno architect Frederic DeLongchamps in 1913, this Neo-Classical/Greek Revival home was built for Lewis A. Gibbons from Tonopah, who became one of Reno's most successful attorneys.[1] In 1921, Patrick A. McCarran, a divorce lawyer who became famous after helping popular Broadway silent film actress Mary Pickford with her divorce in 1920, purchased the house. (Contrary to a persistent local legend, Mary Pickford never owned or lived in this house, and probably was never even inside.)

Having made his mark (and fortune) in the growing divorce trade in Reno, McCarran was elected to the United States Senate in 1933, and was one of the nation's most powerful Senators until his death in 1954.[2] McCarran Boulevard in Washoe County and McCarran International Airport in Las Vegas are named for this famous Reno native.

In 1973, Richard and Antonia Lowden purchased the

house, and began to restore it to its original state. Dick Lowden's insurance company and Antonia's art studio occupied the building for many years.

In 2004, the house was purchased by Tom and Tonya Powell of IntoHomes Mortgage Services. A major restoration project was launched in April 2005. The careful renovation is an excellent example of adaptive re-use.

The house's symmetrical classical exterior is adorned with Tuscan Doric columns and a balustrade on the balcony over the portico. Note the arched fanlight windows, with their original glass panes. The foundation consists of river rock. Inside, the two fireplaces in the house are faced with marble brought from a Tonopah quarry. Historic paint colors dating to the early 1900s adorn the walls, and antique-type lavatory fixtures and lights are used throughout.

The McCarran Mansion is often open for tours, especially during Artown, or by appointment.

JOSEPH H. GRAY MANSION (1911)
457 Court Street

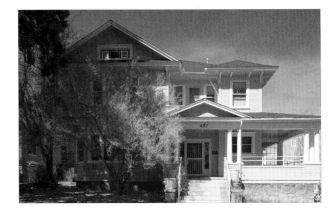

Long-time Reno residents may remember the Gray, Reid, Wright department store, which once occupied the site of today's Circus Circus Casino between Virginia and Sierra streets. In the early 1900s, Joseph H. Gray II was one of the founders of the store, which remained in business until the 1980s (its last site was in the Old Town Mall on South Virginia Street).[1] Gray was not only a prominent Reno merchant when he built this house, but he happened to be the first white child born in the new town of Truckee, California in 1868. In fact, Truckee's first name was Gray's Station, named after Joseph H. Gray, Sr., who constructed the first cabin there in the 1850s. The site of the Gray's cabin in Truckee is where the stone building housing Sierra Mountaineer now stands, at the corner of Jibboom and Bridge streets.[2]

Gray moved to Reno around 1900 and soon became a successful merchant. With his two partners, he helped turn their new department store into one of Reno's most

successful businesses. In 1928, Gray sold his interest in the store, but continued as an active participant until the early 1950s. The store was well known for its high quality clothing and household items.

Gray chose the fashionable Newlands Heights area on Court Street for his large Colonial Revival/Queen Anne residence. A raised, random rubble foundation supports the house, and the exterior walls are sheathed in weatherboarding, while building corners are defined by a narrow corner-board. The entrance porch is pedimented, supported by paired Tuscan columns, which rise from a shallow balustrade sheathed in weatherboarding.

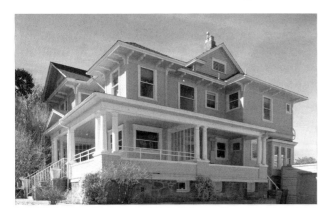

HAWKINS HOUSE (1911)
549 West Court Street

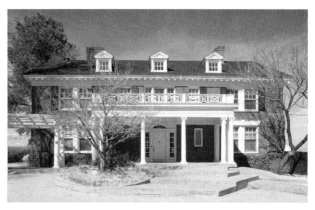

Imagine Eleanor Roosevelt sitting here on the front porch, sharing a beautiful summer evening in Reno with her friends Prince and Myrtle Hawkins, the proud owners of this Georgian mansion. Such were the circles that the Hawkins family traveled in during their 60 years in the house. Prince Hawkins originally left Denver to open a law firm in San Francisco, but the 1906 earthquake persuaded him to choose Reno instead.[1] One Hawkins son, Robert Ziemer Hawkins, married Katherine Mackay, great-granddaughter of Virginia City silver baron John Mackay (whose family has donated millions of dollars to the University of Nevada). The Robert Z. Hawkins Foundation has continued the Mackay tradition of donating to good causes, contributing very generously to social services, animal assistance, education, law, medicine, religion, and youth programs in northern Nevada. The Foundation donated this house to the Sierra Nevada Museum in 1979, for use as Reno's only public art gallery un-

til 1989, when the new Nevada Museum of Art was built on Liberty Street. The house is now owned by the same family that purchased the nearby Newlands Mansion.

Built in 1912 on the high bluff overlooking the Truckee River, the Hawkins House was designed by famous Los Angeles architect Elmer Grey, who built the Beverly Hills Hotel and the Huntington Library in San Marino.[2] Suited well for lavish parties, the 2-1/2 story house includes a vast kitchen complex, servants' quarters, full basement with windows, and a magnificent view of the Truckee River and downtown Reno from its large windows on the north and east sides. The brick walls are of Flemish bond pattern, and semi-circular fan windows decorate the first story.

The house is in excellent condition, having been well-cared for over the past century by its previous owners.

NEWLANDS MANSION (1890)
7 Elm Court

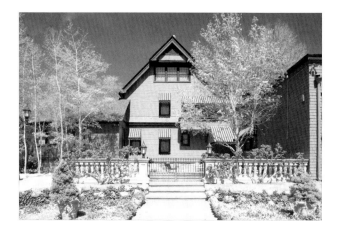

Try to picture the distinguished-looking U. S. Senator Francis Newlands (1849-1917) clambering down the steep slope behind the house with his young family, to ice skate on the frozen Truckee River in the winter and to swim and fish in the summer. An ardent lover of western rivers and lakes, Newlands came to Reno in 1889 from San Francisco, and immediately launched his political career as an advocate for water conservation in the arid West.[1] Convinced that dams and reservoirs were the key to economic prosperity, Newlands championed the Newlands Reclamation Act in 1902, which allocated federal funds for dams and crop irrigation projects. Acutely aware of Reno's precarious water situation in times of drought, Newlands used his personal funds to purchase all the water rights in Donner Lake, one of the Truckee River's main sources of water, which he then donated to the city as a reservoir to be used in case of drought.[2] Independently

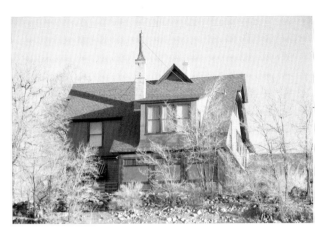

Because access is limited by the iron gate on Elm Court, the best view is from Riverside Drive on the north side of the river, where its silhouette rises from the high bluff known as Newlands Heights.

FREDERIC DELONGCHAMPS' "HONEYMOON" COTTAGE (1926)
4 Elm Court (west end of Court Street)

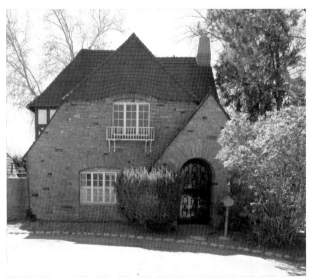

wealthy because of his marriage to the daughter of William Sharon, one of Virginia City's richest entrepreneurs, Newlands shrewdly bought up the land on this high bluff over the river and sold off estate-sized lots to prominent Reno families. Newlands Heights became the most fashionable neighborhood in town.

This Queen Anne/Shingle-style house, with its distinctive, steeply gabled roof, has 6,700 square feet, consisting of 22 rooms, including a kitchen and butler's pantry, maid's quarters, and utility room. To take advantage of the views over Newlands's beloved Truckee River, the house has 87 large windows. Although the house fell into disrepair after the deaths of its second owners, attorney George Thatcher and his wife, in the 1960s, it was saved from demolition by the National Trust for Historic Preservation in 1979, and ultimately sold to the current owners in 1984. The house was also placed on the list of National Historic Landmark, one of only six in the state of Nevada. After years of careful, historically accurate restoration, the home is once again a showplace.[3]

Frederic DeLongchamps, Reno's most prominent architect, built this English cottage in celebration of his honeymoon with his second wife, Rosemary, whom he married in 1926.[1] The adjacent small garage has a two-room upper apartment, where the DeLongchamps's daughter

lived, since the main house had only one bedroom (which covers the entire second floor). Of all the architectural styles in his ample portfolio of over 500 buildings, he particularly loved the nostalgic "country cottage" style imported from England, with its native stone, curved, shingled roofs, heavy timbers supporting the ceilings, and miniature-size doorways and window.

The second owner of the cottage (c. 1942) was Emily Hilliard, widow of attorney Albert Hilliard. Emily generously supported the humanities at the University of Nevada in her late husband's name. In 1962, CPA John "Jake" Gidney bought the house for $30,000, and discovered a beautiful oak floor with mahogany pegs under layers of black paint, which he restored. After nine years, the Gidneys sold the cottage to Joan Garfinkle, future wife of Ferdinand "Buzz" High. The Highs had met during the rehearsal for the local production of "South Pacific" and were married at this cottage, making it the second time newlyweds crossed its threshold and began a life together. Members of the Garfinkle family are well known as dedicated local school district educators.[2]

A tiny house once covered with somewhat destructive English ivy, its intricate stonework can now be fully appreciated. The building stone came from central Nevada. Note the Roman arch doorway with arched door to match. The window panes and frames are all original, as are the iron balcony and screen door.

⪼ Chapter Three ⪻
LIBERTY STREET

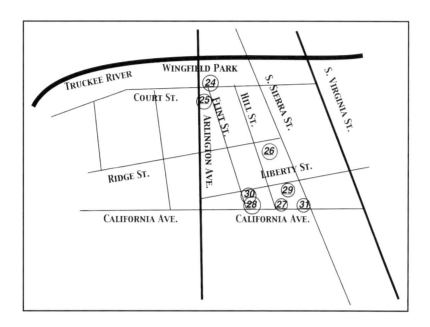

24. Frisch House (1920)
25. Lake Mansion (1877)
26. Nortonia Boarding House (1900)
27. Howell House (1915)
28. Giraud/Hardy House (1919)
29. Nevada Museum of Art (2003)
30. Tyson House (1904)
31. Levy House (1906)

⤐ LIBERTY STREET ⤏

This neighborhood, behind the Riverside Hotel and the courthouse, was notable for its apartment buildings and boarding houses (e.g., the Nortonia on Ridge Street, featured in this chapter, and the Humboldt House at California Avenue and Humboldt Street), all built to accommodate the numerous divorce petitioners who wanted to live downtown during their six weeks' required residency. Small grocery stores and retail shops along Liberty Street and California Avenue made shopping easy and convenient.

But, most importantly, here were the lawyers' offices (and wedding chapels for those who tied the knot again shortly after untying the first knot!), all conveniently located near the courthouse, the major center of activity of the divorce trade.

Some fine Victorian homes were also built here, which are featured in this chapter: the Tyson House on Liberty Street, a Queen Anne structure once owned by the Newlands family; and the Lake Mansion, carefully preserved and relocated just a few blocks away from its original site in the 1870s, owned by Reno's founder, Myron Lake.

Other important buildings in this chapter are the Neo-Classical-style Levy House with its tall white columns on California Avenue and the decidedly 21st century Nevada Museum of Art on Liberty Street, designed by a well-known architect who favors tilted walls and hanging staircases.

Where to begin the walking/driving guide

The best place to start the tour is at the corner of Arlington Avenue and East Court Street, in front of Reno's most historically significant landmark, the Lake Mansion.

As you stroll the Liberty Street/East California Avenue neighborhood, be sure to drop into the unique retail shops or sample the wares in a variety of small cafes and tea shops. Ongoing attractions in this neighborhood include new luxury condominiums, theaters, the Nevada Museum of Art, organized events hosted by retail merchants along California Avenue, and exhibits by the "starving artists" who live in the Riverside Hotel artists' lofts.

FRISCH HOUSE (1908)
247 East Court Street

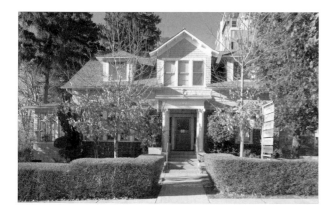

This house is famous for the unsolved, presumed murder of its owner, Roy Frisch, in 1934. Frisch was preparing to testify for the FBI against two of Reno's most notorious operators of illegal gambling dens and speak-easies selling bootleg liquor: William Graham and James McKay. The duo worked closely with mobsters from Chicago and New York to defraud wealthy visitors, relieving them of the cash in their bank accounts in exchange for worthless securities from the Riverside Bank in Reno. As a cashier at the bank, Frisch had witnessed the fraudulent process, and was ready to testify against Graham and McKay at their New York trial.[1]

But one night prior to the trial, Frisch walked out of this house, strolled to a nearby theater and watched a movie, after which he left the theater and chatted with friends outside. Then he completely disappeared. His body was never found and the crime was never solved. His mother kept the porch light burning after his disap-pearance, hoping for his return. It was rumored that Pretty Boy Floyd and Baby Face Nelson were hanging around Reno at that time, and these gangsters may have helped their friends Graham and McKay "rub out" a potentially damaging witness.[2] Some speculated his body had been thrown down a mine shaft or encased in cement and dropped into Lake Tahoe. The notoriety stemming from the sordid crime in Reno filled the nation's newspapers for a long time, tarnishing the city's reputation for fun and good times, while at the same time luring visitors to the seemingly wide open, lawless society where all kinds of sins and vices were tolerated, even touted.

The Frisch house is a two-story Queen Anne-style house originally built in 1908 with seven bedrooms and three full bathrooms. Overlooking Wingfield Park from the high bluff along Court Street, the house was built by Lewis Hinckley.[3] The Frisch family bought it in 1918 and remodeled it in 1920. Still owned by the Frisch family, it is used for commercial purposes now. The porch light still burns every night.

LAKE MANSION (1877)
250 Court Avenue

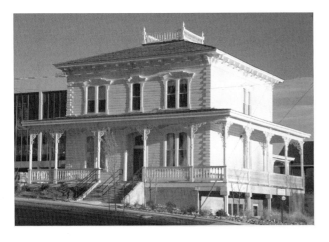

Try to picture this Italianate-style house being towed, very slowly, by a massive moving truck over three miles through Reno's busiest streets—not once, but twice! The first relocation of the Lake Mansion, in 1971, saved it from demolition as downtown Reno office buildings pushed southward along Virginia Street. The house was towed from its original location at the northwest corner of California Avenue and South Virginia Street to the Centennial Coliseum (now Reno Convention Center), near today's Atlantis Hotel-Casino, far to the south of downtown Reno. The 1971 move was organized by several Lake family descendants as well as the Washoe Landmark Preservation Society. However, expansion of the convention parking lot in 2004 threatened access to the mansion with a now-familiar dilemma: demolition or removal. The million-dollar move to this site and subsequent restoration, coordinated by Very Special Arts of Nevada (VSA),[1] was funded by many private and public entities. The mansion's successful relocation to this his-

torical neighborhood has greatly inspired Reno's preservationists to continue fund-raising efforts to save—and move, if necessary—Reno's historic homes from demolition.[2]

The original house was built by Washington J. Marsh (one of Reno's earliest developers) for his large family in 1877. Six bedrooms, double parlors, a large dining room, a kitchen with running water from a well under the back porch, and an expansive wrap-around veranda (necessary for shade in this once-treeless city) marked the home as one of Reno's finest. Stylistic touches typical of that era include the widow's walk on the roof, the use of crushed oyster shells in the ornamental plaster on the interior ceilings, the hand-carved porch balustrade, and the simulated corner quoins on outside corners.

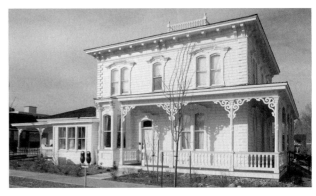

Myron Lake, "the father of Reno," purchased the home from the Marshes because it was part of a large block of land that he was developing for residences and commercial buildings in the booming new town.[3] Since 1971, the Lake Mansion has served as a museum, the Reno-Sparks Convention Authority, March of Dimes, and for Hot August Nights. It is now the VSA headquarters, used for art workshops, children's camps, and special events.

NORTONIA BOARDING HOUSE
(1900-04)
150 Ridge Street

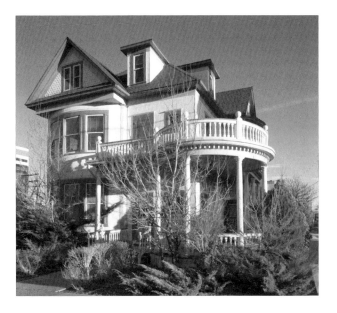

In the early1900s, Reno was fast developing an international reputation as the divorce capital of the world, where people came to get their quickie divorce. Many supposedly threw their wedding rings from the Virginia Street bridge into the Truckee River before they quickly left town.[1] In 1900 the waiting time was six months, but by 1927, it had been slashed to three months. In 1931, that was reduced to a mere six weeks' wait. Short-term housing for all those potential divorcées flocking to Reno became scarce at the height of the divorce boom in the 1930s and 1940s. Many out-of-towners rented private homes, while others camped out along the Truckee River.

"Divorce dude ranches," a new way for cattle ranchers to make extra cash, offered lodging plus horseback rides and singing cowboys for lonely divorcees. Reno's few first-class hotels, such as the Riverside (1927) and the El Cortez (1931), charged up to $10 a day, excluding food, making boarding houses and apartment buildings (at $15-20/month) better choices for the less wealthy clients.

This Queen Anne structure is one of the best remaining large boarding houses in a neighborhood that was once heavily populated with multiple dwelling residences aimed at the divorce market. When it was sold in 1906 by its owner, Mrs. Annie Rogers, to a Mr. Norton, it was converted to a boarding house.[2] Presumably named after its new owner, the Nortonia remained a boarding house for several decades, a popular option during the Great Depression and war years, with so many people unwilling or unable to buy or rent their own home.

The circular balustrade on the porch is identical to those found on other Reno houses of the same era, indicating the trademark of an unknown local builder. The structure has been modernized on its exterior, with composition roof shingles and siding, small additions and dormers, and a fire escape. Its rounded bays, multi-formed roof and circular porch are very typical of the Queen Anne style, but the balustrade and simple columns lend a Colonial Revival touch. The structure has been very well preserved.

HOWELL HOUSE (1915-16)
448 Hill Street

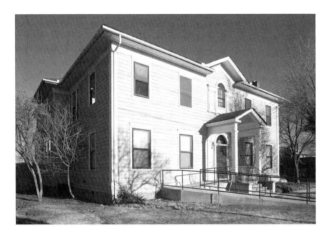

This fine residence figured prominently in the early history of Nevada as well as Reno. It remained in the Howell family for over 60 years, being home to five generations of children.[1] Eugene William Howell was Nevada Secretary of State and later a Tonopah banker. Howell's wife, Maud Wallace Haines, was the daughter of Nevada State Senator James Wallace Haines, one of the signers of Nevada's Constitution in 1864. Howell was looking forward to moving to Reno in 1914, but shortly after Maud Howell, their Chinese cook Charlie Hay, and four children arrived in town, Howell suddenly passed away in Tonopah. Maud bravely continued with plans for the new house, successfully raised her large family, lived a long life, and passed away in 1933. Son Eugene Howell, Jr., and his wife, Neal, then moved in with their family of four children. Afterwards, Neal and daughter Carole lived in the house for many years until Eugene's death in 1960. Family luncheons, suppers, wedding receptions, and Christmas celebrations were held here, before it was sold by the Howells and converted to law offices in 1977.

The Howell House is an excellent example of a combination of Neo-Classical and Neo-Colonial details. Note the pediment roof of the portico, flanked by square, fluted columns with dentil decorations below the portico roofline. The second-story Palladio-inspired window over the portico is framed by pairs of pilasters that echo the detailing of the portico. The second-story roof gable echoes the pediment lines of the portico roof. The fan window over the door is enhanced by additional fluted columns, completing the symmetrical, classical look of the main entrance. Additionally, pilasters with the fluted, square design adorn the outside corners of the house.[2]

The house is currently utilized as a law firm, remaining very well maintained and preserved.

GIRAUD/HARDY HOUSE (1919)
442 Flint Street

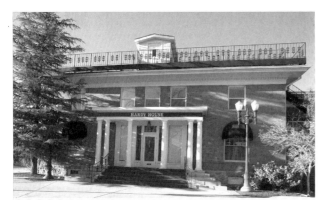

Many Renoites have fond memories of dining at the Hardy House restaurant; male customers may have even fonder memories of the large tiled mural of a nude in the upstairs men's restroom.[1] Designed by prominent Reno architect Frederic DeLongchamps for French Basque sheepherder Joseph Giraud, the elegant Colonial/Georgian Revival home was a residence until 1976, when a series of restaurants began to occupy the site.[2] In 1934, the home was purchased by mining magnate Roy Hardy, one of Nevada's outstanding figures in mine and milling operations.[3] A graduate of the Mackay School of Mines at the University of Nevada, Hardy was active in Tonopah and Virginia City (he built the American Flats plant to revive the Comstock), but his 40-year partnership with George Wingfield in the rich Noble Getchell Mine in Humboldt County was the most lucrative project. As a University of Nevada Regent in the 1950s, he organized the funding of the Jot Travis Student Union, in memory of his long-time friend Wesley E. Travis. He also played a major role in the

firing of UNR President Minard Stout.[4]

The building's foundation is of hand-cut stone found on site; its walls are of 14-inch-thick brick laid in a Flemish bond pattern. The shallow-pitch hipped roof is ornamented with a pronounced molded boxed cornice, dentil course, and a wide frieze, typical of the Colonial/Georgian Revival. Porches project from three sides of the house, their pairs of Tuscan columns serving as the main decorative features. A porte cochère originally protected the entry on the north side. The two-story kitchen wing was added to the east wall, blending well with the exterior. Prior to its use as a restaurant, the second floor had three bedrooms, a sleeping porch, and a sewing room. Maintained in excellent condition by its previous owners, the Hardy House remains a fine example of the fashionable homes that once lined the streets in this neighborhood.

THE NEVADA MUSEUM OF ART (2003)
160 West Liberty Street

When Arizona architect Will Bruder visited Reno to begin drawing up plans for this building, he learned that long-time residents really missed the view from the Sky Room

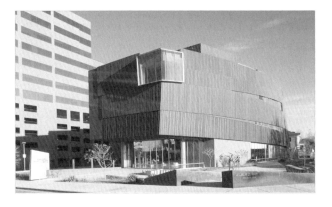

at the top of the old Mapes Hotel (built in 1947, demolished in 2000).[1] Consequently, Bruder decided to incorporate that same sweeping panorama of the Sierras into his design. Bruder said this building should be "interesting architecturally… a place to allow citizens and visitors to see the world from a different view: a mysterious dark vessel."[2] The result? An initially controversial 60,000 square foot black steel building with a rooftop sculpture garden that "resembles a camera lens: There is the edge of Reno and the skyline and there is the world beyond."

Hanging above the lobby is a black staircase, suspended in a towering atrium by a center pole stretching 68 feet up toward the ceiling.[3] Glass portals and windows peering through walls on each floor beckon visitors to the ever-changing exhibits of paintings, photographs, and sculptures. In the lobby, one wall contains a large donor list, which highlights the many generous gifts to the museum and the high level of support for the arts in Reno today.[4] A lobby café offers light, Napa Valley-style cuisine.

The first Nevada art museum was founded in 1931 by Professor James Church (University of Nevada classics professor and snow surveying pioneer) and Charles Cutts, whose house on Ralston Street became the museum's first home in 1949.[5] In 1978, the Hawkins House[6] on West Court Street became the museum's next home, followed in 1983 by a smaller museum on this spot, which was demolished to make room for this new structure in 2003.

The first exhibit, at its grand opening in May 2003, featured a large collection of paintings by Mexican artists Diego Rivera and Frida Kahló, attracting nearly 10,000 people on opening day.

TYSON HOUSE (1904-06)
242 West Liberty Street

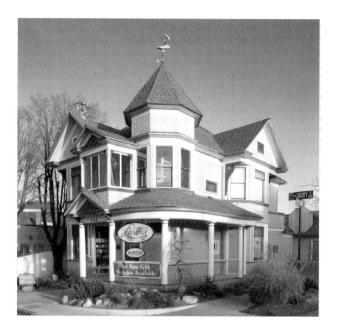

This fine Queen Anne house, standing prominently on the corner of Liberty and Flint streets, is one of the best remaining representatives of that once-popular style.[1] Although it is not known who constructed the house, it has been associated with prominent Reno families since it was built in 1906. The Francis Newlands family once owned it, and others, such as professional gambler Mark Frankovich and mine owner James Burris, may have been associated with it. As happened to many large houses in this neighborhood after six-week divorces were legalized in 1931, this house was cut up into small rooms for use as a boarding house in the 1940s. The carriage house, at 418 Flint Street, was also remodeled.

For its time, it was a very well constructed house, based on a concrete-block foundation. Its solid wood frame is surfaced with narrow clapboard and shingles. An octagonal tower with a peaked roof projects from one corner. The roof forms are varied, with three gables intersecting a pyramidal roof and a hipped extension. Two gabled, tall slanted bays and a smaller square one decorate the front façade. Decorative console brackets support the gable ends of the larger bays, while the smaller bay is supported by columns. Encircling the entire structure at the second story roof line is the base line of the gable pediments.

The rounded veranda is supported by simple Doric columns connected by a balustrade. Some Colonial Revival elements are found in the decoration of this porch. On the rear extension, patterned shingles match the first and second floor bases of the large bays. This varied use of surface materials has resulted in a visually interesting composition, very reflective of the Victorian era's Queen Anne style.

LEVY HOUSE (1906)
111-121 California Avenue

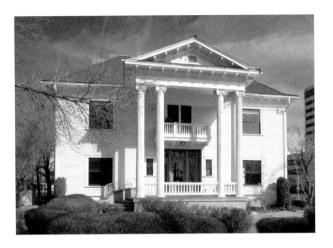

Dramatic and tall, with its slender Ionic columns supporting a Greek-inspired gabled pediment, the Levy House could be right at home on a hill overlooking a Southern plantation or on a shady street of fine old homes near the Capitol in Washington, D.C. This elegant Neo-Classical building is one of the best examples of that style in Reno, and its past owners have diligently maintained its integrity and condition during the last 100 years, even after the house was raised up from its foundation, rotated 90 degrees, and placed on a new foundation in 1940.[1]

Originally facing Granite Street (now Sierra Street), the house was built in 1906 by a German immigrant, William Levy, owner of the Palace Dry Goods store on North Virginia Street.[2] Levy married Tillie Goldsmith, and one of their two daughters, Mildred Levy, lived in the house until her death in 1976. The house was moved because the two daughters split the property when Tillie died in 1938, and a Signal Oil gas station occupied the other half of the lot for many years, facing Sierra Street.

The structure has shallow, angled bays projecting from the first floor, while the two-story entrance porch is supported by groups of three columns. A balcony was added to the second floor after the 1940 move. Exterior decorations include dentil courses, a porch pediment, and a louvred oval vent. Visual interest is created by the brackets under the eaves, and a plain frieze separates the clapboard siding from the eaves.

Inside, a large icebox near the kitchen was stocked with ice from an exterior opening, and is now used for storage. Two grand stairways ascend to the second floor, which is now occupied by offices. The third floor is rumored to house a ghost, making long-term rentals somewhat difficult, but the venue is well-suited for annual Halloween parties.

☙ Chapter Four ❧
CALIFORNIA AVENUE

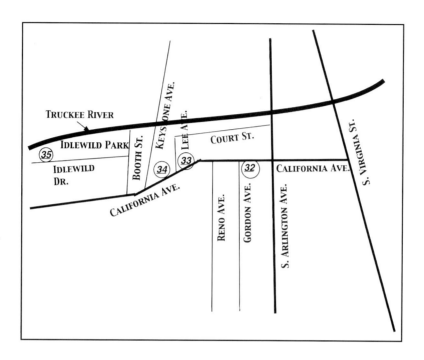

32. William J. Graham House (1928)
33. Luella Garvey House (1934)
34. Nixon Mansion (1906)
35. California Building (1927)

✒ CALIFORNIA AVENUE ✒

Reno's Most Fashionable Address

It is a shame that most visitors never happen upon this street, because California Avenue has been, and still is in many ways, the most fashionable and important address in Reno. On this street, wealthy businessmen and politicians chose to make a very visible statement about their status. As a result, California Avenue is a string of precious architectural gems, a place where residents take visitors to show off the "other side" of their town. This neighborhood is surprisingly similar to elegant neighborhoods in other American cities, but only in Reno would such a district be so very close to the gaudy casinos which have been downtown Reno's trademark for many decades.

California Avenue's Place in Reno history

As you stroll the streets in this neighborhood (and you really should walk rather than drive, to achieve the full effect of the vegetation and architecture), try to absorb the ambiance of the area and ponder what life was like here in the first decades of the 20th century. Consider how different each house is from its neighbor, running the gamut from Victorian shingle-style to Georgian, always following the architectural fashions of the day and the individual whims of architects and owners.

On the north side of the avenue, notice the grand gardens and courtyards surrounding the houses, and try to peer between the houses to catch a glimpse of the sweeping views of the mountains and city enjoyed from each living room and backyard terrace.

Try to imagine the circular driveways filled with expensive cars and limousines on evenings in the Roaring Twenties, when party-goers celebrated (probably with bootlegged liquor) the good life in this exclusive, secret neighborhood of Reno. Be sure to stop and appreciate the elegant gardens and groves of trees on both sides of the street, for the homes that lacked a panoramic view certainly made up for it in their landscaping.

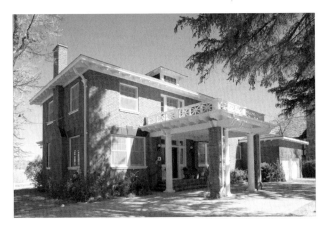

Parsons/McGinley residence, 761 California Avenue.

Mansions on the Bluff

Large homes line both sides of the street, but it was the north side of California Avenue that attracted the most wealthy clients to Senator Francis Newlands's new subdivision. The Newlands Heights lots were very large and afforded a spectacular view over the Truckee River, downtown, and mountains beyond. This row of distinguished houses now bears the nickname "mansions on the bluff."

The most historically significant house is at 631 California Avenue, built by Senator George Nixon in 1906.

This spacious Spanish Colonial Revival home rises grandly from one of the two largest lots on the street. Currently undergoing restoration by new owners, after a disastrous fire in the 1970s and vacancy thereafter, the Nixon Mansion will re-emerge soon to take its place as one of the most spectacular homes ever built in Reno.

The other estate-sized lot is at the far west end of the avenue, at 775 California. This Georgian Revival was built in the 1930s by a lumber baron who made his fortune in mahogany from the Philippines. The home has a matching guest house with swimming pool set back from its immense lawn.[1] In 1943, it was purchased by one of the FBI agents sent to Reno to investigate the lucrative money laundering rackets in town. Vacant for many years, the house's new owners have restored the home and grounds to their former grandeur; the new garage blends in perfectly with the original design of the house.

Between these two estates on the north side of the street, you will see several other beautiful homes, such as the Parsons/McGinley residence at 761 California. This house figured significantly in the careers of two prominent Reno architects, Fred Schadler, who designed it in 1920, and Edward Parsons, Sr., who lived in the house for 50 years. Jack Dempsey once rented the house and erected a sparring ring in the yard to get in shape for an important boxing match.

Nearby, at 725, is the Kinder/Muller "manse," a fine example of Spanish Colonial Revival style so popular in the 1920s. Mary Ruth "Maizie" Kinder, a celebrated London stage actress, left behind her British home, Checquer's Court, to sue for divorce in Reno. Here she met Dr. Vinton Muller in 1922, and they constructed this beauti-

Memorial to Francis Newlands at Newlands Circle on California Avenue.

ful home graced by a huge London plane (sycamore) tree on a circular driveway.[2]

The Payne House, at 745 California Avenue, was designed in 1938 by Reno architect Edward Parsons, Sr., for J. C. Penney executive Frank Russell Payne. He married the girl next door, Hazel Steinmiller (No. 761), who became famous (as writer Greer Gay) for her flamboyant novel, *The Mystery of the Well-Dressed Corpse*, set in Reno in the early 1950s.[3]

At the end of California Avenue, visitors can enter the small Newlands Heights Park on the north side of the street and enjoy the sweeping views of Reno, Peavine Peak, and the Sierra Nevada from the bluff. Adjacent to this park (No. 826) is "the Johnston castle," a French country house built on six levels, using native stone skillfully laid by stone masons in the 1930s. Mrs. William Johnston, the daughter of Francis Newlands, was living up the street in the grand Nixon mansion (631 California Avenue), but found that she needed more room for guests for her extensive family (despite its eleven bedrooms), so she built this French-inspired house.[4] Late in her life, Mrs. Johnston moved to San Francisco to manage her family's Palace Hotel, which was rebuilt after the 1906 earthquake.

The legacy of Nevada's famous U.S. Congressman and U.S. Senator Francis Newlands is again evident here at the end of California Avenue (on the south side), where a monument stands in a small park named Newlands Circle, honoring his vision of bringing water to the arid lands of the American West. If Newlands were to visit California Avenue today, he would no doubt be proud of its elegant mansions set amongst lush lawns and towering trees, for the once-high, wind-blown bluff was home only to sagebrush and rattlesnakes when he first built his own home here and subdivided the rest into large parcels. Now some of Reno's most elegant homes and gardens stand as a testament to his vision of Reno as a beautiful green oasis in the high desert, irrigated by his beloved Truckee River.

WILLIAM J. GRAHAM HOUSE (1928)
548 California Avenue

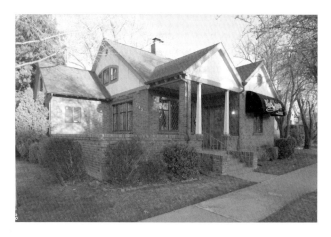

Behind the walls of this quiet, respectable-looking Tudor house lived a notorious character who played a major role in Reno's unsavory past, especially prostitution and bootlegging, in the 1930s.[1] William Graham and his partner, James McKay, opened the popular Bank Club on Center Street, Reno's first big casino, in 1931. Although some of their businesses were barely legal, the Graham-McKay partnership had a truly dark side. They owned the "Stockade" on Second Street, a tawdry complex of tiny rooms called "cribs," utilized by prostitutes. They also dabbled in bootlegging liquor across state lines, illegal racehorse betting, and using marked or stacked cards on the poker tables. Allegedly, they laundered money through the several branch banks of their good friend George Wingfield, once Nevada's most powerful businessman and politician. East Coast gangsters carried bags of ill-gotten greenbacks here, which were exchanged for worthless, illegal "securi-

ties" from Reno banks. Graham and McKay were almost caught when a Reno bank cashier, Roy Frisch, was ready to testify to the FBI about their dirty dealings, but he mysteriously disappeared one night after leaving a downtown movie theater.[2] Graham and McKay were never charged, because a body was never found, but eventually the FBI nabbed them on mail fraud charges and they spent six years in a federal penitentiary.

This house was built in 1928 by William Graham in the Newlands Heights neighborhood.[3] The Tudor Revival walls are of brick with half-timbered stucco gables, the roof is shingled with wood, and the windows are leaded glass, including the eyebrow window on the Gordon Avenue façade. Curious details have emerged about the Grahams. He and his wife lived here for over 40 years, but never used the fireplace: it was found stuffed with 1929 newspapers when the house was sold in 1969. Reportedly, there was a walled-up room in the basement filled with marked casino cards and other suspicious artifacts. Some modifications were made by the Grahams and subsequent tenants, but the house is generally in a good state of preservation. It is currently used as an office.

LUELLA GARVEY HOUSE (1934)
589-599 California Avenue

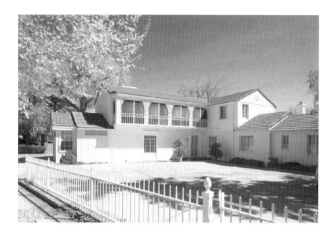

Seemingly more at home in the French Quarter of New Orleans than in Reno's Old Southwest, this house grabbed headlines in 1934 as the most expensive home built at that time.[1] But that wasn't the only history-making news about the $50,000 Colonial Revival residence, with its French Regency grillwork, ornate fireplaces, and large walled garden.[2] Its architect, Paul Revere Williams, was an African American and a masterful designer of buildings and mansions, primarily in southern California. All of his Nevada projects incorporated designs and motifs found here in the Garvey House: different ceilings and crown moldings in each room, including the tile-covered vaulted kitchen ceiling in this house, fireplaces faced with marble and granite, intricate ironwork, and elaborately landscaped grounds. Williams also designed the First Church of Christ, Scientist on Riverside Drive (now the Lear Theater)[3], where his unique classical style is on full display.

Mrs. Garvey, a wealthy widow from Los Angeles, designed the house as a duplex; she lived on one side and rented the other side to her lawyer friend Edward Lunsford. After she passed away in 1942, the house was bought by gaming pioneer Nathan Abelman, who had made a fortune in the mines of Goldfield before becoming a trusted partner of George Wingfield, Nevada's most powerful businessman.[4] Abelman managed several Wingfield properties, including the Riverside Hotel and the Christmas Tree Lodge. The current owner purchased the house in the 1970s, and has updated it while carefully preserving its original beauty and fine craftsmanship. The house is no longer a duplex. One distinguished guest was Carol Channing, who stayed here while starring in "Hello, Hollywood, Hello" at the MGM Grand in 1985.

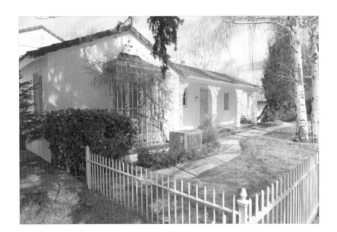

NIXON MANSION (ca. 1906)
631 California Avenue

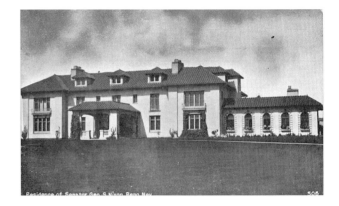

Long before Senator George Nixon built this imposing Spanish Colonial Revival home in 1906, he was at work one day in the First National Bank of Winnemucca when it was robbed by the Sundance Kid (real name: Harry Longabaugh), supposedly a member of the famous Wild Bunch.[1] In the September 1900 bank heist, the bandits ran off with $32,640, and legend has it that Nixon ran after them, firing his revolver. He never caught them, nor was Butch Cassidy among the robbers at the time, contrary to popular belief.

Nixon later moved to Reno, where he became very active in civic affairs, including helping to build an opera house and a theater. He was best known for championing the free and unlimited coinage of silver, Nevada's most important product, to protect it from being eliminated in favor of gold-only coinage (which eventually failed). In 1904, he was elected to the U.S. Senate, where he served for seven years. As historians Russell Elliott and William Rowley note, Nixon "was an example of the new breed of

Nevada politician who had earned a fortune in Nevada, invested it in Nevada, and then chose to maintain his permanent residence there," compared to previous Nevada politicians who actually lived next door in California.[2] Nixon Avenue and the town of Nixon on the Pyramid Lake Paiute Reservation are named for this distinguished Senator and community leader.

The Nixon Mansion encompasses 15,099 square feet, distributed among 11 bedrooms, 7 bathrooms, and other large rooms. When it was built on this 2.03 acre lot, it was set back from the street on the edge of the bluff, so that the Truckee River below could easily be observed from the back terrace. In 1979, a tragic fire caused by Christmas tree lights destroyed much of the first floor. Fortunately, in 2002 new owners took over the landmark home, and are in the process of restoring it to its previous grandeur.

CALIFORNIA BUILDING (1927)
1000 Whitmore Lane
Idlewild Park

The California Legislature funded the construction of this building to house exhibits intended to lure tourists westward during the Reno Transcontinental Highway Exposition.[1] The completion in 1927 of the transcontinental Lincoln and Victory highways across America spurred California politicians to join Reno city fathers in extolling the attractions of both states at an event planned and attended by prominent politicians and movie industry executives. The California Building was the center of the highway exposi-

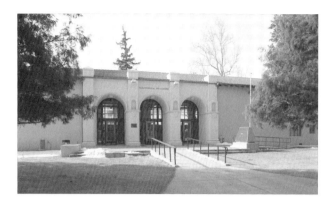

tion, housing booths for nearly all California major cities. A separate tent annex featured San Francisco's port and tourist attractions.[2] The new 43-acre site had belonged to Senator Francis Newlands' estate. Since 1927, the parks' attractions have included a fish hatchery and "Mark Twain's cabin" (both gone), fish ponds, a playground, miniature train for children, a municipal swimming pool, baseball fields, a rose garden, a peace officer memorial, and, most recently, a skateboard park. The California Building is a popular venue for square-dancing and folk-dancing clubs, weddings, conferences, and meetings.

Appropriately, the California Building echoes the style of the 21 missions established along the Pacific Coast in the 1700s by Spanish priests. The Mission Revival style is characterized by simple stucco walls, tile roofs, and Roman-arched doorways; the exterior stucco is applied to wood lath, resulting in walls at least a foot thick. Remodeled by prominent Reno architect Edward Parsons, Sr., in the 1950s, a system of tie rods was constructed, which transferred the weight of the roof onto the walls, freeing up the grand hall from interior columns. A 1970s-era

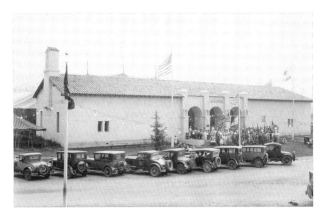

California Building, opening ceremonies, 1927.

drop ceiling covered up this inverted truss structure, but it was brought to light once again in the mid-1990s, after asbestos removal. Parson's daughter, Alice Parsons, has been involved in the restoration effort for several years, pleased to be involved in uncovering her father's additions to the building.

Funding sources for its ongoing renovation include the First Ward Advisory Board, the City of Reno, and the state Commission on Cultural Affairs.

≈ Chapter Five ≈
OLD SOUTHWEST

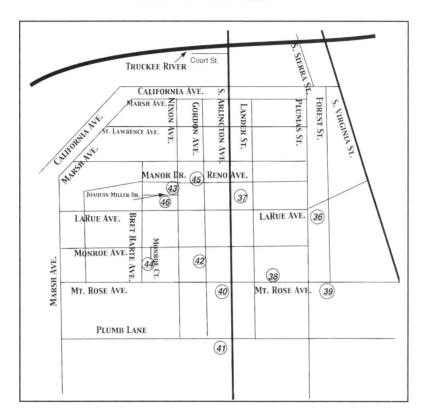

36. McCarthy/Platt House (ca. 1900)
37. Mount Rose School (1912)
38. El Reno Apartments (1930s)
39. Hill/Redfield Mansion (ca. 1930)
40. Wanamaker/Mapes "Chateau" (1938)
41. Phillips/Arlington Nursery (1876)

42. Patrick Ranch (ca. 1901)
43. Russell Mills Cottage (1928)
44. Hart House (1938)
45. Cantlon House (ca. 1939)
46. Barnard House and
 Greystone Castle (ca. 1930)

⇜ OLD SOUTHWEST RENO ⇝

Reno's "First Preferred Neighborhood"

Old Southwest Reno, as it is defined today, stretches (roughly) southward from the Truckee River, west of Virginia Street to Hunter Lake Drive and south to Moana Lane. Countless architectural masterpieces are found within this neighborhood, many of which were, and still are, home to prominent doctors, lawyers, politicians, and community leaders.

This area was "Reno's first preferred residential neighborhood."[1] Virginia Street was, and still is, an important dividing line. The east side of Virginia Street was populated primarily by Reno's working class, although there were a few large, expensive homes there. To the west of Virginia Street, town lots were usually bigger and, consequently, larger and more expensive homes were constructed.

The first developers of Southwest Reno were Myron Lake (founder of Reno) and Washington J. Marsh (the builder of the Lake Mansion, Chapter 3), who began developing this area on a grand scale in 1876: "They offered two-and-a-half acre lots for the rather high price of $1,000. There were few takers because streets had not yet been developed and the high bluff over now-Wingfield Park had the 'ominous name 'Rattlesnake Point.'"[2]

Not until 1890 did the area become popular. In that year, wealthy ex-San Francisco millionaire and future Congressman and Senator Francis Newlands built a showpiece Queen Anne house on the high bluff, visible from all over Reno. Having been the developer of Chevy Chase in Maryland, Newlands knew a thing or two about developing a high-priced neighborhood. He had acquired a large parcel of land adjacent to his house, naming it Newlands Heights, and had subdivided it into large lots that he then sold to Reno's first millionaires. Suddenly, Newlands Heights became the most fashionable place to live. The West Court Street area, around the Newlands Mansion on Elm Court, is the location of these fine mansions, and is covered in Chapter 2. Newlands also developed an area to the south of California Avenue, known as Newlands Manor.

By 1900, Marsh's Addition was also becoming a popular choice for new homes, as construction pushed west of Virginia Street and south from California Avenue to Taylor Street and east to Belmont Street (now Arlington Avenue). Soon modest homes were erected on Plumas, St. Lawrence, Humboldt, and Lander streets, to the east of Arlington Avenue. This neighborhood today offers prime examples of the many styles of homes, from Queen Anne to Craftsman/Bungalow and English Cottage, built here in the 1920s through the 1940s.

West of Arlington Avenue, however, the lots were larger and a distinctly different tone can be detected: Numerous interesting and unique houses are found here, designed by Reno's most prominent architects, and many of the streets bear historic or literary names: Nixon, Sharon, Donner, Mark Twain, Bret Harte, Joaquin Miller, and John Frémont. Several streets have undergone name changes: Monte Rose became Mount Rose, Belmont and Chestnut coalesced into Arlington, Neuschwander became Swan Circle, and Ross Skyline Drive became Skyline Drive.[3]

Truly unique houses are found in the Old Southwest, such as the Oriental-inspired Hart House, the all-river-

rock Hill/Redfield Mansion, the castle-like Mapes Mansion, and several of the little metal houses known as the El Reno cottages. While searching out the houses featured in this chapter, be prepared to spend several hours driving around these streets, marveling at the large number of unique, charming, and beautiful old homes found on these tree-shaded avenues.

The Old Southwest is a fascinating blueprint of the life and times of Reno in the first half of the 20th century.

High Desert Challenges

Take time to admire the lush landscaping surrounding the residences in this district, but try to picture this place as it once was: a dry, rock-filled plateau hosting nothing more than sagebrush, rabbitbrush, and an occasional rattlesnake. The 20,000 acres of irrigated farmland in the lowest parts of the Truckee Meadows contributed to the success of early Reno as a cattle and sheep ranching center, but Reno could not grow without a dependable source of drinking water for its citizens. The wetlands were excellent for hay pastures and alfalfa, but not for houses. Reno's town center was dry as a bone. Covered verandas and porches gave the only relief from the brutal summer sun.

Fortunately, blessed with (usually) plentiful water flowing down from the Sierra Nevada, Reno boomed in the 1860s through the 1880s, as ditches were dug, capturing life-giving water from the Truckee River and other major streams.[4] The ditches and canals that still crisscross Southwest and Northwest Reno are now nearly invisible, bridged with roads or hidden by foliage, but they were—and still are—extremely important for household

water as well as for irrigating vegetable gardens, trees, alfalfa fields, and flower gardens. Look anywhere beyond the benefits of irrigation and you will see what our pioneering gardeners faced as they built their homes and planted tiny trees. It would be decades before those trees would reach full height and arch over these leafy lanes.

While much of Reno's urban forest includes trees familiar to all visitors, such as maples and cottonwoods, look for unusual specimens, such as the tall, conical Giant Sequoias (found in most older neighborhoods as well as down the middle of West Plumb Lane) and the deciduous Dawn Redwoods found just south of Morrill Hall on the University of Nevada campus.

Stones and Bricks

As you drive the streets of Old Southwest Reno, you will notice the abundant use of river-smoothed cobbles for chimneys, walls, and entire houses. Over many millennia, the Truckee River and other Eastern Sierra Nevada streams have spread granitic and volcanic boulders and stones, nicely tumbled and rounded, across the vast alluvial fan upon which Reno is built. You only need to dig a few inches in any part of town to discover this plentiful natural resource, which some curse and others use creatively.

Most of these houses are made of brick instead of wood, especially those built after some devastating fires in the 1870s, which burned many blocks of wooden houses and buildings. In many of the brick Craftsman/Bungalow houses, you can see the mark of Italian masons, who were responsible for these intricate patterns of brickwork. In addition, Native American masons created many of the

natural rock walls and chimneys found in other styles, such as the English Cottage or Cotswold Cottage styles.

Where to Start the Tour

California and Arlington avenues are the boundaries for this area, making it easy to zig-zag in through the streets from virtually any angle. Since there are some pesky one-way streets (Marsh, Nixon, and Gordon), it may be necessary to back-track and circle around as you seek out these architectural gems. Those side trips will expose you to even more fascinating houses, and you might end up spending several hours exploring these fascinating streets.

No matter how much time you have to spend on this journey into Reno's past, it will be well worth your time, especially on a hot summer day, when the cool, shady streets are a perfect spot for a leisurely stroll, this book in hand.

MCCARTHY/PLATT HOUSE (c.1900)
1000 Plumas Street

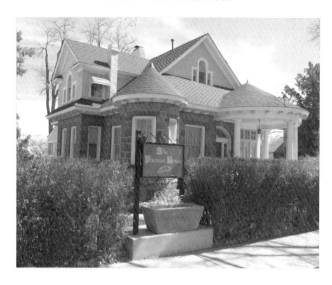

The McCarthy/Platt house is a good example of the remodeling skills of Reno architect Frederic DeLongchamps. Whatever its style was prior to the major renovation in 1925, the house emerged as a fashionable Colonial Revival home with many Classical elements, including Palladian windows.[1]

In 1923, Charles H. McCarthy bought this house and a large parcel of land surrounding it. Several months later he filed a subdivision map for the land, naming it "McCarthy's Addition." McCarthy apparently was successful in developing his subdivision, evidenced by his hiring of DeLongchamps to do a major—and rather expensive—reconfiguration of the floor plan of the house, as well as its exterior. On the first floor, a new entrance and front portico were added, which included a sun porch. The

portico became the house's predominant feature, with its semi-circular plan and four Tuscan columns supporting the conical roof. A small, rounded turret with a conical roof was added to the northerly corner of the façade. The front door is composed of six panels topped with a fanlight, flanked with fluted pilasters and four side-lights, set within a semi-circular surround, embellished with quoins.

Inside, the entrance hall and main staircase were moved, and the rest of the first floor was remodeled at the same time. Six large, multi-pane windows were added to the second floor, where the four gables are pierced by Palladian windows. Cameo windows were placed on each side of the rear Palladian windows. The roof has an interesting combination of shapes: a hipped roof is seen over the façade, then a large and a small conical roof, and finally a rear shed roof. In addition, two shed-roofed dormers arise from the slopes of the main roof. The main roof line is trimmed with a boxed cornice, brackets, and a frieze board.

In 1931, Samuel Platt purchased the house. He was a Carson City native, son of one of the pioneer merchants of the Capital who arrived in 1861, three years before statehood. Platt had an illustrious political career in the Republican Party. Starting out as a mining lawyer, he served in many important positions in the Nevada Legislature and state government. He and his family lived in this house for many years, which remains virtually unchanged on the exterior since 1925.

MOUNT ROSE SCHOOL (1912)
915 Lander Street

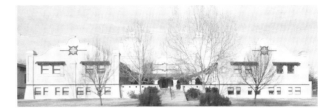

This school is one of the four "Spanish Quartet," the name given to four nearly identical elementary schools built in the Mission Revival style in the early 1900s. These schools were built in response to the growing population in the Truckee Meadows. While the Catholic, Methodist, and Episcopal churches offered instruction to children of their members, the need for more public schools became acute by 1900, when the city's population reached 4,500.[1] Two bond issues were passed for the construction of four new elementary schools: Mount Rose, Mary S. Doten (now gone), Orvis Ring (also gone), and McKinley Park (now utilized as a city park and recreation headquarters; see Chapter 6).[2]

The 3.28 acres of land for this school cost $7,500 in 1911, a fairly large sum for those days. Two well-known Reno architects—father and son—were involved in the design of the schools and their later additions: George Ferris did the school's design, while his son Lehman "Monk" Ferris did the addition of two classrooms on the south side of the building in 1938. The Spanish-inspired floor plan is a basic "Y" shape, with major axes running east-west and north-west through the two symmetrical wings. Originally, the entry patio featured a Moorish-style fountain, as

well as false beams, or vigas, projecting from the walls, but all of these have been removed. Instead of Spanish tile for the roof, as one would expect for this design, composition shingles were utilized from the beginning.

Faced with pending demolition of the old school in the 1970s, a coalition of community leaders and parents pushed for its inclusion in the National Register of Historic Places, and funds were raised for its restoration and earthquake-readiness. As young families now move back into the older homes built here in the 1920s and 1930s, a rejuvenation of the neighborhood has occurred. The school serves as a meeting hall for various groups, including the Historic Reno Preservation Society.

EL RENO APARTMENTS (1930s)
711 Mount Rose (and 11 other sites)

This "little metal house" once was part of the El Reno apartment complex at 1307 South Virginia Street. Built in the mid-1930s with prefabricated board-and-batten metal siding, each of the 12 existing houses at the complex contained two bedrooms, a kitchen with metal cabinets, a living room, and 1-1/2 baths, all in only 900 square feet! The inside walls were insulated with fabric-covered panels fitting into channels which could be removed for cleaning. Radiant heat warmed the structures, and electrical wiring was enclosed in conduit (innovative at the time). Separate garages were available for tenants' cars, and the conveniently located laundry house had new automatic washing machines instead of wringer wash-

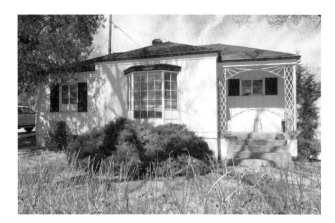

ers. According to El Reno expert Karl Breckenridge, the apartments were a great place to live until well after the Second World War.[1]

When owner Louis Giroux wanted to raise the rents, with approval of all the tenants, the rent control board (dating from the war years) refused to allow it. Apparently, Mr. Giroux was so angry that he sold all of them for about $800 apiece. They can now be found all over Reno (see Appendix for addresses). Most retain the original white walls with green trim, decorative wrought iron porch trim, front bay window and a unique eyebrow vent on the roof.[2]

Further, the houses are even more interesting because it has now been confirmed that they were designed by renowned African American architect Paul Revere Williams, who had designed similar buildings in California. Williams also designed the ranch house at Rancho San Rafael, the Garvey House[3] and the First Church of Christ, Scientist (now Lear Theater[4]), in addition to many important residences and buildings in Hollywood and Los Angeles. The connection with Williams probably stems

from the fact that Louis Giroux was a wealthy southern California developer, and may have contacted Williams in Los Angeles for the apartment complex design and construction.[5]

HILL/REDFIELD MANSION (ca.1933)
370 Mount Rose

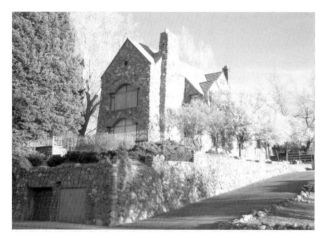

Many old-timers remember LaVere Redfield driving his battered truck around Reno in the 1960s, looking like one of the local ranchers. Only a few people knew that he was a multi-millionaire who acquired countless houses and vacant land by paying only the back taxes. By the time Redfield died in 1974, he was the largest private landowner in Washoe County and was worth nearly $100 million. Part of his wealth was a huge collection of Morgan and Peace silver dollars. His basement and garage were filled with bags of 1,000 dollars each, over $400,000 in all, mostly in mint

condition.[1] The street-level garage was out of sight of the main house, and therefore an easy target for burglaries, so he disguised his stash as trash and hid it around the house and in the basement (he distrusted banks).

LaVere and Nell Redfield bought this spectacular native-stone house in 1936, after moving from Los Angeles. It had been built by August and Bill Hill as a duplicate of a New York City brownstone house they had once lived in.[2] Hill and Son, as they were known here, had built the Hill and Sons Motel, which was where the Peppermill Hotel-Casino now stands. They had built other Reno houses, including the three identical red brick Craftsman homes on Mount Rose Street east of Watt Street. But they had their eye on the vacant bluff down the street.

This choice parcel on the hill above Mount Rose Street had a great view of Reno and the then-pastureland to the west, a perfect site for a grand, six-story house. Two of the three above-ground floors are identical, with two complete living quarters: one floor for Mr. and Mrs. August Hill and one for son Bill and his new family. The house is the "most grandiose river rock, Period Revival house in Reno [and] the most impressive, competently executed river rock example" of the dozen or so that are found in Reno.[3] The prominent, steeply pitched roof, sharply pointed gables, and the irregular rocks embedded in concrete are characteristic of the English Cottage design. Note the small stone house across the street: It was the caretaker's house. The Redfield family still owns this spectacular, well-known house, and the Nell J. Redfield Trust has been very generous to educational and philanthropic causes.

WANAMAKER/MAPES "CHATEAU" (1934)
1501 South Arlington Avenue

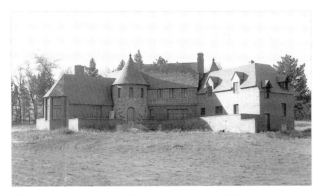

Wanamaker house just after construction in 1934.

Probably Reno's only true castle-like structure, this replica of an elegant French chateau, similar to those found in up-scale neighborhoods on the East Coast, was designed by Frederic DeLongchamps for department store magnate John Wanamaker.[1] Wanamaker insisted on a Pennsylvania slate roof, but it was so heavy that 12-square-inch supporting beams were necessary. Six bedrooms and five full bathrooms fill the large structure, including two master suites, formal and informal dining rooms, bar, and trophy room. The 3.17-acre parcel contains a guest house, a swimming pool, and a long driveway lined with hundreds of rose bushes, all surrounded by a substantial rock wall (made of stones probably gathered on site).

Charles Mapes, Jr., was born in Reno in 1920 and attended the University of Nevada. After returning home from duty in the U. S. Navy in World War II, he and his family decided to build a "dream hotel" on the north bank of the Truckee River in downtown Reno.[2] For many years the Mapes Hotel and Casino were popular venues for divorcees, movie stars, and locals enjoying a night out on the town. (See Chapter 1 for further information on the Mapes Hotel.)

After Charles Mapes bought the mansion, he hosted the rich and famous from all over America: Marilyn Monroe, Clark Gable, John Huston, Bobo Rockefeller, and Henry J. Kaiser joined many other celebrities who walked through the turreted entryway during the 1950s and 1960s. The Mapes family owned the house for more than 45 years, before it was sold in July 2000.

PHILLIPS RANCH/ARLINGTON NURSERY (1876)
1907 South Arlington Avenue

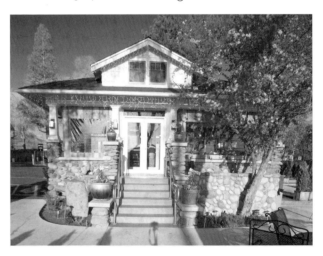

One of Reno's first businesses was, strangely enough in this unpredictable and often disappointing climate, a nursery. Veteran nurseryman R. P. Chapin arrived in the newly-established town in 1876 and saw an opportunity to sell trees, bushes, and plants.[1] On 40 acres protected by small hills, Chapin raised commercial trees, flowering shrubs, over 80 varieties of roses, berries, and fruit trees. A natural spring provided water. He even built a greenhouse for orchids and other exotics. Perhaps Chapin settled in Reno because Washoe Valley, south of Reno, had at that time a flourishing apple and berry economy, shipping produce all over the West. Chapin had three salesmen covering sales throughout the Great Basin, but local ladies rode out the dusty lane now called Arlington Avenue in their buggies to purchase house plants and starts for their vegetable gardens. After about ten years of unforgiving Nevada weather, however, Chapin moved to San Diego. Jane Lake, Myron Lake's ex-wife, purchased the "Arlington Nursery Ranch" for $8,000 and converted it to a dairy, complete with fields of clover.

In 1906, Dr. Fred Phillips arrived in Reno from Kansas, via San Francisco, and opened a dental office. He married a miner's daughter from Gold Hill, and he and Mattie bought this property in 1915. By 1918, they had built this stone house in the Craftsman/Bungalow style, plus outbuildings, a barn, milk house, sheds, low walls, and a fountain, all from river rock found on the property. Most of these early buildings remain today. In 1945, Dorothy Phillips and her husband John Benson opened Arlington Nursery, continuing her father's long fascination with horticulture, which had included a World War II "victory garden." Several new buildings were added

to the site, made of brick and granite. The nursery was Reno's largest and most prestigious for 35 years. Dorothy Benson donated numerous plants and trees to the University of Nevada, for which she was named a "Distinguished Nevadan."[2] In 1979, she donated the site to the Junior League of Reno, which still operates the Arlington Gardens shopping mall and nursery. The family's stone house is currently utilized as a restaurant.

PATRICK RANCH (c. 1901)
1225 Gordon Avenue

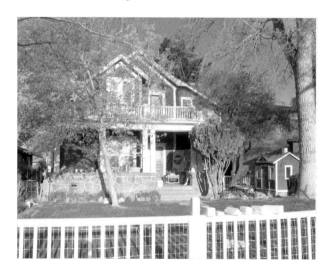

"This house will still be around when the new houses are gone," says owner Lyndi Cooper-Schroeder, who raised five children here with husband Jack Schroeder.[1] "When you scratch the surface, there's substance behind it:

These old homes have good bones. [Workmen] marvel at the quality of the workmanship that's gone before… When I drive up to my house, I'm just so glad I live here. It makes me feel good." The original owner of the property, when it was known as the Arlington Ranch, was Jane Lake, Myron Lake's wife, who passed it on to her daughter, Florence Thompson. When the Patrick family (Frank and Fannie) bought the farmhouse in 1904, it sat in the middle of 90 acres, which the family turned into a successful dairy farm. The Patricks were involved in Nevada politics for many years, especially the Democratic party. Fannie Patrick was a charter member of the Twentieth Century Club of Reno (featured in Chapter 1).

In 1923, the ranch was subdivided, and new homes filled the former dairy cow pastures, many on the newly-named Patrick Avenue. Local developer William Barnard built several of those new homes in the Tudor/English Cottage style, which he also utilized in designing Greystone Castle and the Barnard House on nearby Joaquin Miller Drive (featured in this chapter).

The Patrick Ranch House is a good example of the Folk Victorian style, which was popular between 1870 and 1910, and utilized many Italianate or Queen Anne details. Note the porch supports of square posts with beveled corners, boxed roof-wall junctions, decorative bracket along the cornice, and windows with a simple pediment above.[2] The asymmetrical façade with a full-width porch on the northwest corner of the porch also echoes the Folk Victorian style, but the classical columns on the porch are a Free Classic variation on the Queen Anne style. Most of the glass in the windows is original, as is the rough-hewn stone foundation. In the 1940s, the house was modified

into several apartments, to house military officers, but those alterations have now been eliminated as the current owners continue to restore the house to its prior configuration. Most of the glass in the windows is original, as is the rough-hewn foundation.

RUSSELL MILLS COTTAGE (1928)
803 Nixon Avenue

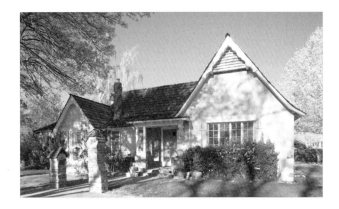

This landmark home in the heart of Reno's Old Southwest exemplifies the exuberance of the late 1920s in America, when home builders and architects enjoyed reaching back into the past for imaginative, almost mythological designs. Not only is this charming English Cottage style nearly-perfect in its story-book details (note the twisted chimney), but it was the first house designed by a young man who would become famous in Reno for his sense of style and great attention to detail.[1] Russell Mills had begun his architecture career apprenticing with

Reno's most prolific and best-known architect, Frederic DeLongchamps, in the early 1920s. This was the first house he designed in Reno as an independent architect, and his wife lived in it for twenty years after his death in 1959. This design turned out to be his favorite type of residential project: an English cottage-style family home decorated with imaginative brickwork and creative fascia cuttings, contrasted with his more modern commercial buildings.[2] He was very handy with various kinds of saws and power equipment, and did much of the decorative trim on the cottage-style houses himself. Indeed, in this neighborhood are several Russell Mills houses, all of which embody the English cottage style, sometimes combined with Tudor elements.

Mills career as an architect spanned 30 years, during which time he was an active member of the community and his profession. Among the many boards and commissions on which he served were the National Housing Administration Advisory Board, the Reno City Council, and the Reno Control Board, the city's board of adjustment. In 1949, he was appointed the first president of the new State Board of Architecture. Russell Mills' contributions to the design of schools and other public buildings are listed in the Appendix.

The Russell Mills cottage is one of the city's architectural treasures, lovingly cared for over the years by its owners. It continues to serve as a residence.

HART HOUSE (1938)
1150 Monroe Court

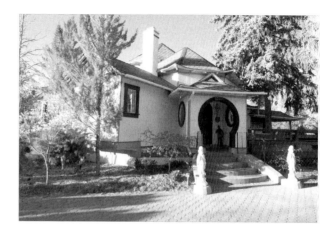

George Hart was a 1930s nightclub entertainer whose fans would call him long distance to hear him play his piano and belt out popular songs.[1] After he married a wealthy divorcée, they purchased eleven suburban acres for their new home. The Harts commissioned an up-and-coming architect, Russell Mills, a former employee of Frederic DeLongchamps, to build this totally unique house. Mills designed this house himself after opening his own business. No one is sure who came up with the Oriental design for the Hart House, but Japanese and Chinese designs were popular in the 1920s and 1930s. While some Reno houses have slightly upturned eaves, pagoda-style, nothing compares with the Hart House in its complete adoption of Asian lines and forms. Incorporated in the house are round windows, Chinese "moon gate" arched doorways, multilevel roofs, and red and black trim. The cedar siding was milled on site to replicate bamboo. One

of the many custom features of the house is the turn-table for the bed in the master bedroom. Hart was a day-sleeper due to his nightclub career, but with the flick of a switch, he could rotate the bed out of the morning sun.

The house was featured as the background for a 1938 book, *No Hands on the Clock,* written by Geoffrey Homes. The action takes place in a "pagoda-style bungalow in the desert with a hexagonal living room," where a Reno piano player is murdered. The piano player in the story was known for raising alligators in his pond, as well as customizing songs for his fans. A movie based on the book debuted in 1941, starring Chester Morris as the detective who solves the crime.[2] The Hart House was never identified officially in the book or movie, but local historians assert that the author had visited Reno in the 1930s, and no doubt saw this house.

Most of the house's unique features, such as the octagonal living room, pocket doors, and built-in cabinets and niches, were unaltered during its renovation in the 1990s. The kitchen was enlarged and the bathrooms were modernized. The house now holds five bedrooms and 4.5 bathrooms in 4,100 square feet, including a 1,200 square foot guest house. A tea house with an arching bridge over a koi pond and a walking path adorn the beautiful grounds.

CANTLON HOUSE (ca. 1939)
565 Reno Avenue

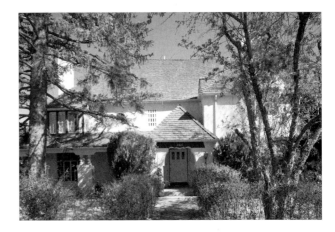

This unusual house has figured prominently in Reno's medical history, as the home of one of the city's most venerated doctors, Dr. Vernon Cantlon.[1] In 1962, Dr. Cantlon, one of the town's most well-known surgeons and community leaders, purchased the home. Vernon and his equally well-regarded brother Edwin grew up in Sparks and attended the University of Nevada.[2] Both attended Harvard Medical School in the 1930s; Vernon completed his internship at Massachusetts General Hospital in 1941. He then returned to Reno and practiced medicine with his brother until shortly before his death in 1972. Vernon's brother Edwin served as a military surgeon in World War II, saving the lives of many American soldiers in North Africa, Italy, and France. After he returned from the war, Edwin was chief of staff at both Washoe Medical Center and Saint Mary's Hospital, and was active in many professional groups. Edwin, who lived close-by on Nixon

Avenue, passed away in 2004.

The Cantlon house, and the duplex across the street, undoubtedly designed by the same architect, are examples of the French Eclectic style.[3] This style is somewhat unusual in Reno. The steep gables over the windows echo the steep pitch of the roof. The massive hipped roof and formal façade are loosely patterned after farmhouses in Normandy, which influenced English houses after the Norman invasion in 1066 AD. After World War I, this style became popular in the United States, carried across the Atlantic by American soldiers familiar with the farmhouses dotting the French and British countryside.

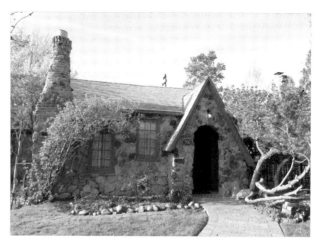

Barnard House

BARNARD HOUSE
AND GREYSTONE CASTLE (ca. 1930)
950 and 970 Joaquin Miller Drive

These side-by-side quaint English cottages add unique charm to the historic Newlands Manor neighborhood. Both were built by local developer W. E. Barnard, who came to Reno in 1925, and probably used designs from a pattern book.[1] The cottages are excellent examples of the "Cotswold Cottage" style, which utilized Tudor and English motifs during the Period Revival era, a "time when architects were responding to Victorian fussiness while embracing the ideal of simple homes that were dignified, full of charm and good taste."[2]

Greystone Castle has only 1,200 square feet, but customized fixtures and built-ins utilize every square inch of space. The house was advertised in 1930 as having

"the charm of an old English castle and all the modern conveniences of the very latest American home," which included a built-in Hotpoint range, central heating, a recessed bathtub, and "plenty of cupboard room and stor-

Greystone Castle

age and space." [3] The Gothic window and high vaulted ceiling extend the interior living space. The prominent brick and stone chimney appears very large in relation to the overall house, while the use of natural local materials, such as native stone, wood, half-timbers, and brick echoes the style's roots in the Cotswold Hills of England in the 11th century.

The Barnard House is smaller and less lavish in design, with symmetrical windows and exposed beams inside, giving a more rustic feel to the cottage. The bowed fireplace and beehive chimney add a distinctly quaint, old English touch to the house.

The English garden-style of the landscaping and the excellent condition of the two cottages are excellent examples of the dedication of past owners to preserving these picturesque, romantic little cottages.

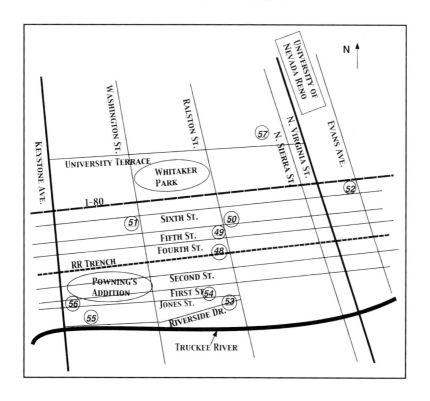

⮞ Chapter Six ⮜
OLD NORTHWEST

48. Borland/Clifford House
49. Humphrey House
50. Twaddle Mansion
51. Francovich House
52. B. D. Billinghurst House
53. First Church of Christ, Scientist/ Lear Theater
54. Lora J. Knight House
55. McKinley Park School
56. Upson/Arizabalaga House
57. ATO House

᷍ OLD NORTHWEST ᷍

C. C. Powning Develops the Neighborhood

In the 1880s, Reno began to expand westward from downtown, along the north bank of the Truckee River. A young man named Christopher Columbus (C. C.) Powning was responsible for the initial development of this unique neighborhood. At the age of 18, Powning was already running the *Nevada State Journal*, one of Reno's first morning newspapers, and was Nevada's youngest senator in the Legislature.[1]

Before he died at the early age of 46 in 1898, he helped organize the Nevada State Fair, and facilitated the transfer of the state mental hospital to Reno from Carson City, and the University of Nevada location from Elko to Reno. He donated land for McKinley Park School on Riverside Drive, as well as for Powning Park, in front of the Pioneer Theater and Auditorium.

Some of his business projects included the construction of the Odd Fellows Building/Washoe County Bank (see Chapter 1), the Powning Building on Virginia Street, and the Bank of Nevada Building. He was also one of the owners of the Reno Water, Land and Light Company, which was involved in a decade-long legal battle over the incorporation of the city of Reno and the supply of water to Reno homes.

In 1886, Powning subdivided 122 acres of land into 250 lots, 50 x 140 feet each, advertising them as being on the "Aristocratic Riverside Avenue Driveway" and having "splendid sewerage ... healthy location and safe from fire." The destructive fire of 1879 in downtown Reno made this new location more desirable. In addition, the new

Ginocchio House, 19 Winter Street.

sewage system built for this neighborhood was certainly a great improvement over the practice of letting raw sewage run down the streets into the Truckee River, as still happened in some older neighborhoods at the time. The north-south boundaries of Powning's Addition were the railroad tracks and the north bank of the Truckee River, between Arlington and Keystone avenues.

Unlike the high, rocky bluff on the south bank of the river, where Reno's first millionaires built their large homes, the north bank was flat and covered with "gravelly loam ... susceptible of the highest state of cultivation."[2] This rich soil appealed to Reno's Italian families, who promptly planted vineyards and vegetable gardens in their yards, thereby earning the name "Little Italy" for the neighborhood.

The lots facing the river had beautiful views, but they were also subject to periodic flooding. Eventually, a much higher bank was constructed, which protects the area during all but the worst floods.

Powning's Addition Architecture

The first buildings in Powning's Addition were elegant Queen Anne-style homes, mostly of brick and stone laid in place by local Italian masons. Two fine examples are the Dow House, at 935 Jones Street, and the Pearl Upson/Arrizabalaga House at 937 Jones Street, both built c. 1902. Others are at 641 Jones (c. 1910), 629 Jones (c. 1904), and 3 Washington Street (c. 1908).

Interesting combinations of styles can be found in this neighborhood, such as the little Queen Anne cottage built in 1914 at 32 Vine Street. Originally quite plain, it was decorated much later, in the 1970s, with "gingerbread trim" (i.e., Carpenter Gothic) salvaged from the old Mapes House at Fifth and Ralston streets, which burned down in 1976.

Several larger brick residences were converted to rooming houses for Reno's growing divorce trade in the 1930s; the house at 18 Winter Street is a good example of an early rooming house, now used as offices.

By the 1940s, many Craftsman/Bungalows had been built by Italian families; two especially fine examples are the Gardella House at 120 Keystone Avenue and the Ginocchio House at 19 Winter Street. The Dondero House at 96 Winter Street is a classic Craftsman/Bungalow, while the Donderos' two-story rooming house next door, which housed Italian railroad workers, has a more Italianate style.

Lincoln Highway

Automobile traffic wound through Powning's Addition on the Lincoln Highway (Fourth Street and later Highway 40) in the early 1900s, creating a need for accom-

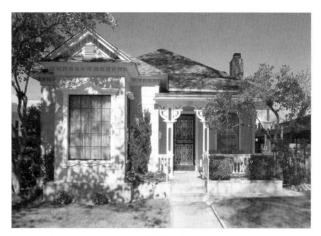

Queen Anne style cottage, 32 Vine Street.

modations for travelers. Service stations and auto camps, and later motels and hotels, sprang up along these streets. History buffs can still find a vestige of early 1900s automobile travel on the Lincoln Highway in this neighborhood: At 100 Winter Street, near First Street, is the Rocovits gas station, complete with old gasoline pump, built around 1914.

Powning's Addition Architects

Reno's most notable architects designed homes in Powning's Addition, including:

- Frederic DeLongchamps and his partner George O'Brien: Lora J. Knight House, 615 Jones Street, and the St. Thomas Aquinas school and rectory, 310 West Second Street;
- George Ferris and his son Lehman "Monk" Ferris: McKinley Park School, 925 Riverside Drive, and El Cortez Hotel, 239 West Second Street;

- Paul Revere Williams: Loomis Manor Apartments, 1045 Riverside Drive, and the Lear Theater, 501 Riverside Drive;
- Hewitt C. Wells: office building, 601 West First Street;
- Fred M. Schadler: 20th Century Club, 335 West First Street.

The Western Addition

As Reno grew westward, it expanded north across Fourth Street, later called the Lincoln Highway. One of the first subdivisions was the Western Addition, which comprised many Carpenter Gothic, Queen Anne, and Craftsman/Bungalow homes. Successful merchants and other professionals began to build new homes here, especially after the city's first concrete sidewalks lined the new streets. Houses from other parts of town were moved into the Western Addition, some coming from as far away as Virginia City, as mining declined after 1900.

Since the 1930s, however, scores of old houses in this area have been demolished to make way for commercial buildings and schools along the busy Fourth Street corridor. Some antique houses remain: A good example is the Nystrom Guest House at 333 Ralston Street, built in 1875. Originally a Carpenter Gothic house built by Washoe County Clerk John Shoemaker, it is now covered by two layers of stucco dating to the 1930s. For many years, was utilized as a divorce-trade guest house (holding up to 30 tenants at a time!) by Estelle Nystrom.[3]

Three significant houses in this neighborhood are highlighted in this chapter: (1) the Borland/Clifford House at 339 Ralston Street, which has been carefully

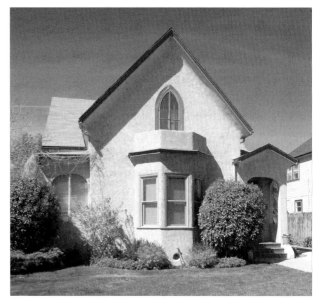

Nystrom Guest House, 333 Ralston Street.

preserved, showing off its Gothic Revival style since its construction in 1875; (2) the magnificent two-story brick Queen Anne house built by the Francovich brothers in 1900 that once sat across the street from the Nystrom House and was moved to 557 Washington Street in 1983 to save it from demolition; and (3) the Twaddle Mansion at Fifth and Ralston streets, an imposing Colonial Revival structure constructed with California redwood brought over the Sierras on the railroad. Built by one of Reno's most prominent citizens in 1905, it served as a well-known arts and crafts gift shop in the 1970s and is now an office building.

University of Nevada Neighborhood

As Reno grew northward above Fourth Street, new streets were platted near the University of Nevada campus, surrounding it on all sides except the north. Established in 1886, the university originally sat on a hill overlooking downtown, amidst the hay fields of the Evans Ranch. As the town's population and university enrollment increased, the Evans Ranch was absorbed into the growing neighborhood, its new streets filling with fine homes for professors and modest cottages for students and other university employees. Many of those homes disappeared when the wide, deep corridor for Interstate 80 was completed through Reno in 1975.

The architectural trends of the older parts of Reno continued on the new streets near the university: Craftsman/Bungalow, Queen Anne, English Cottage, and Carpenter Gothic styles flourished, especially after the Italian population increased in number. Another "Little Italy" emerged along Washington Street, north of Whitaker Park on University Terrace.

There are even a couple El Reno apartment/homes in this neighborhood, moved up from their original site on South Virginia Street (see Appendix for addresses).

Whitaker Park on University Terrace is a beautiful asset to this neighborhood, but in its former iteration, it occupied a very interesting chapter in Reno's history: Bishop Whitaker's private seminary for girls, which opened in 1875. Touted as the "Athens of Nevada," the Whitaker Academy accepted only girls from wealthy Comstock and Reno families, who were sternly taught the "three Rs" along with heavy doses of ladylike manners, art, and music.[4]

Plagued by jealousy and outright hostility from local

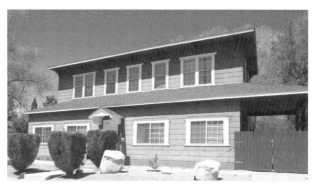

Original Whitaker Academy building, 643 University Terrace.

"hoodlums" who continually vandalized the school, the Whitaker Academy closed after only 15 years. The house at the northeast corner of Washington and University Terrace is one of the Whitaker Academy buildings. It was moved there and is now apartments. Stately rows of trees delineate the former driveways and garden pathways of the park, overlooking I-80 freeway and downtown.

Meanwhile, construction of large sorority and fraternity houses for university students added to the diversity of Old Northwest. Two notable examples are the ATO House at 205 University Terrace, designed by "Monk" Ferris, and the Sigma Nu House at 1075 Ralston, designed by Frederic DeLongchamps. The imposing Colonial Revival ATO House, built in 1929, can be seen for miles around, gracing the top of a hill overlooking University Terrace.

At the north end of the university neighborhood is an immense county park, which was once a cattle ranch belonging to the Pincolini brothers, who built the Pincolini/Mizpah Hotel on Lake Street. Located between North McCarran Boulevard and Putnam Street, the original

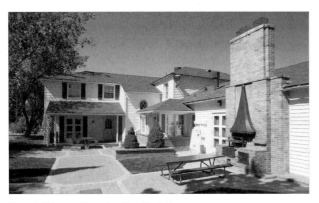

Ranch House, Rancho San Rafael.

gate of Rancho San Rafael is on Sierra Street, while other entrances are found on Putnam Street and Keystone Avenue. The original ranch house was designed by Paul Revere Williams, also responsible for the Luella Garvey House on California Avenue and the Lear Theater on Riverside Drive.

Located inside the park are the Wilbur D. May Museum and Arboretum and the Great Basin Adventure, all popular venues for learning about Nevada history.

Other interesting sidelights to this neighborhood include the old Hillside Cemetery, between 11th Street and University Terrace. Dating to 1879, the burial plots for the nearly 1,500 souls buried here are segregated by religion—e.g., Jewish and Catholic—as well as for the Grand Army of the Republic, a Civil War memorial society. While appearing disheveled and forgotten, the cemetery has been the subject of much controversy for many years as to who owns it, who should maintain it, and whether the remains should be removed so that the land can be developed for new homes. The issue has not yet been resolved.[5]

Where to Begin this Tour

The Old Northwest district of Reno covers several square miles, and will take more than a day to appreciate fully. Walking through Powning's Addition along Riverside Drive is a good place to start. Looking south across the river toward the high bluff, you can see the "back yards" of the large homes built by Reno's first millionaires, which cannot be seen otherwise.

On the north side of the river, Jones Street branches off Riverside Drive and will lead you through the tree-shaded streets of "Little Italy." You can zig-zag through this area, doubling back to the path along Riverside Drive, or you can continue on into Idlewild Park and visit the California Building (see Chapter 4).

A paved jogging path extends for several miles along the Truckee River in this area, beginning at West McCarran Boulevard, passing through Idlewild Park, following Riverside Drive, and ending at the Arlington Avenue bridge in Wingfield Park.

To appreciate the northern sector of the area and to get a feel for this old section of town, you can park at Whitaker Park and walk through the adjacent streets. Many interesting houses are found here.

A few hours at Rancho San Rafael Park on another day would be well-spent, touring the animal and history exhibit at the Wilbur D. May Museum (May's Double Diamond Ranch once filled much of the vast ranchland south of Reno), taking part in the real-life science experiences at the Great Basin Adventure Center, and strolling through the Arboretum.

All in all, Old Northwest Reno is truly a slice of local history at its best.

BORLAND/CLIFFORD HOUSE (1875)
339 Ralston Street

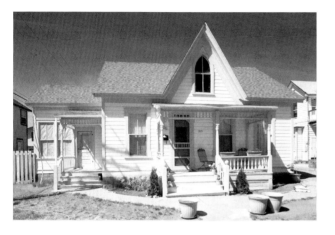

Undoubtedly the best-preserved Carpenter Gothic-style house in downtown Reno, the Borland/Clifford house is also one of the city's oldest remaining residences.[1] Built by James Borland in 1875, this small house has the traditional steep central gable enhanced by a modest lancet window, trademarks of the Carpenter Gothic style. Borland held several jobs in Reno, Central Nevada, and Northern California. He rented out this house when he was out of town, and eventually sold it in 1902. In 1907, O. J. Clifford, a pharmacist from Austin, Nevada, bought the house and lived here until his death in 1932, after which his son kept the house until his death in 1984.[2] It was previously thought that a former owner had been John Orr, but that has been disproved.

This distinctive style was widely adopted by Americans and Canadians for residences, farmhouses and churches built in the 1840s through the 1880s. The tall spires and steep roofs of European Medieval churches and castles inspired the design, while the invention of steam-powered scroll saws facilitated the cutting of the intricate "gingerbread trim" of the barge boards, porch railings, and window mouldings. Early Nevada and Northern California examples were clad with clapboard or shiplap siding, although many old houses have had asbestos siding or even stucco (see the house at 333 Ralston) placed over the original wooden boards.

The house is essentially a gabled rectangle lying parallel to the street, with a smaller gabled extension projecting from the south. Another gable intersects the center, facing the street. A shed-roofed porch covers the entrance, under the main gable with the lancet window. The porch is supported by turned posts, and cut brackets hold the spindle frieze beneath the porch overhang, while turned balusters form a lacy balustrade. A beautiful radial vent is found in the end gables of the attic.

The owners have taken excellent care of this picturesque little house for the past 130 years, maintaining its integrity and 19th century image.

HUMPHREY HOUSE (1906)
467 Ralston Street

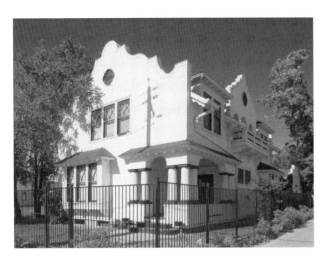

One of the few remaining Mission Revival houses in Reno, the Humphrey House echoes the style of the "Spanish Quartet," four elementary schools that were built during the same time period. The Mission Revival style was popularized in Reno by George Ferris, the architect hired by the Reno School District for the new schools. Another well-known Reno architect, Fred M. Schadler, designed this house in the same style, similar to the one he built for the Steinmillers at 761 California Avenue.[1] Originally built for the Frank E. Humphrey family, the house stayed in the family until the 1960s. The Humphreys were prominent in Nevada politics, and their guest list included two Nevada governors, Tasker L. Oddie (1911-15) and Emmet Boyle (1915-23), as well as other important politicos.

This house is an outstanding representative of Mission Revival design, with the skilful manipulation of design motifs to achieve an interesting and varied composition. Note the parapet's scroll design, which is the signature look of the Mission Revival style, still found today in houses, and Mexican food restaurants. The scrolled shape is emphasized by a strip of banding, interjecting a different decorative element into the composition. Further, the parapet creates an alternating counter point with the projecting window bays. Also adding interest is the arch motif in the windows and the entrance. The curved diamond shapes in the window panes create another pattern and texture that contrast with the smooth stucco surface of the building.

The stucco-surfaced, two-story house has a gabled roof, beneath which two sets of paired windows project like dormers from the second floor roof on the north, and flank the central parapet section holding three arched windows from a second floor balcony. A wide shallow arch is flanked by paired columns that support the projecting porch roof and solid balustrade.

On the interior, the original paneling was intact as of 1983, when it was listed in the National Register of Historic Places. An elaborate staircase leads to an upstairs sitting room separated from the main circulation by a trellised partition, all of the original wood. The entrance hall features built-in seating and the dining room features wood paneling, brick and stained glass.

TWADDLE MANSION (1905)
485 West 5th Street

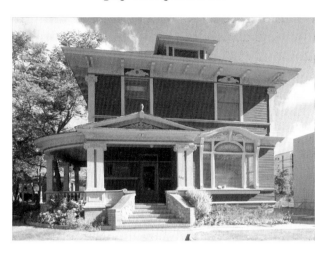

Originally a mansion built by Eben Twaddle, a Washoe Valley rancher and Reno Fire Marshall, this Colonial Revival structure is the "finest representative of its style remaining in the city."[1] Constructed by contractor Benjamin Leon on a prominent corner in Ward's Addition, once a purely residential neighborhood of fine homes, the Twaddle Mansion has served in various capacities since its construction in 1905. During the divorce-trade years, it served as a rooming house, then as a religious center for the Baha'i faith, and later, the Norfolk Arts and Crafts gallery and store in the 1970s. It currently serves as an office building.

The imposing two-story structure with its large curved porch and Classical ornamentation was placed on a river rock foundation, with brick insets beneath the porch columns. The richness and scale of the house add to its dominating presence. The hipped roof and small dormer windows with diamond shaped panes are enhanced by the brackets under the eaves encircling the building. The ornamentation of the corners with clusters of fluted square posts, capped by Ionic capitals, matches the fluted posts that flank the stairway leading to the entrance. The posts support a decorative frieze and pediment, whose gable is also ornamented with a foliated design and a finial on its peak. Note the shell pattern beneath the projecting pediment.

Around the curved porch is a balustrade of turned posts, and square fluted posts support the porch roof. A large window with a highly decorative hood molding brings light into the first-floor parlor to the east of the entry. Architecturally, these details "are unmatched in Reno in dramatic elegance" and express a "flamboyance to opulence rarely seen" in such a vernacular building.[2]

A kitchen was added to the structure in the 1940s, and other alterations were made to comply with local building code requirements, but overall the Twaddle Mansion has been carefully maintained and preserved by its many owners.

FRANCOVICH HOUSE (1899)
557 Washington Street

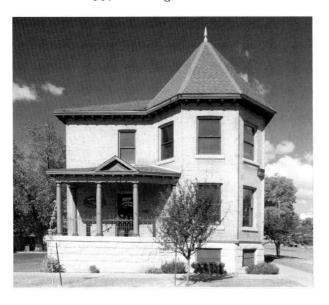

This classic Queen Anne-style house is significant for many reasons: It was once the home of a prominent Yugoslav immigrant family that has made many contributions to local history since Eli Francovich first arrived in Virginia City, in 1859. Eli operated the first three-story gambling hall in Nevada, the Old Wine House on Commercial Row in downtown Reno. The Francovich family home also happens to be the "earliest and most intact domestic example of the early change in the use of building materials traditionally associated with the Queen Anne style," i.e., the use of brick rather than wood.[1] Of further significance, it is proof that a two-story brick house can be moved intact for at least three blocks, which occurred in 1983, when it was transferred here from its former loca-

tion on Ralston Street. Lastly, while some of the Francoviches continue to be prominent in the legal profession, others are involved in a unique new business: selling homemade spiked eggnog (Francovich Holiday Nog), based on a secret family recipe.[2]

In 1899, the construction industry in Reno underwent a dramatic transition when Reno Press Brick Works opened on West Fourth Street. Good-quality brick was now readily available and highly preferred due to its relative safety from fire. If it were not for this new supply of bricks, many of Reno's fine Queen Anne homes would have been built of wood instead, and might have perished in Reno's periodic fires.

This two-story house has a typical Queen Anne-style polygonal tower projecting from one corner of the façade, which is topped by a polygonal peaked roof decorated by a pointed finial. The living room occupied the first floor of this tower, while the master bedroom was on its second level. A porch with a gable roof above the entrance is supported by simple, turned Tuscan columns, and a decorative iron balustrade extends between the columns. The house originally had five bedrooms, five fireplaces, a large dining room, and kitchen, all with 11-foot ceilings and 8-foot doors.

The house is currently utilized for law offices.

B. D. BILLINGHURST HOUSE (1910)
729 Evans Avenue

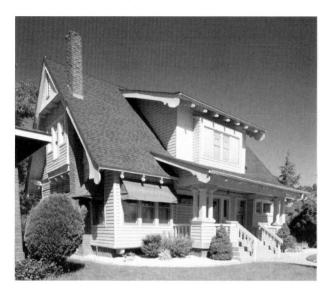

This home, which once belonged to Reno's nationally known superintendent of schools (from 1908 to 1935), Benson Dillon "B. D." Billinghurst, came perilously close to being torn down to make way for Interstate 80 in the early 1970s.[1] If it were not for two "crusaders"—Billinghurst's daughter, Florence B. Flagg, and prominent Reno architect Edward S. Parsons—the six-year-long battle would not have had this happy ending. The trench required for the new highway had already wiped out many antique homes just south of the original gates to the University of Nevada campus, including most of Eighth Street, once called "professors' row" for its fine houses.

After several extensions of time from the Nevada Highway Department and a last-minute reprieve from Governor Mike O'Callaghan, the home was temporarily saved in 1974 by placing it in the National Register of Historic Places, but someone had to buy it first. At the January 1977 auction, the highest bidder ($48,000) was Abbas Lebastchi, a preservationist who worked with Billinghurst's daughter to restore the home. After a special use permit was granted, the building was approved for commercial use, and a law firm occupies it today.

Billinghurst was an innovative leader in school architecture and education, bringing to Reno such modern ideas as industrial, home, and commercial studies, free textbooks for children, compulsory attendance, the design of the Spanish Quartet and better methods of school finance.[2] A junior high school bearing his name was demolished in the 1970s, but a new middle school built in the 1980s bears his name in tribute to his contributions to Reno.

The house is a "perfect example of the bungalow style of architecture developed at the turn of the (twentieth) century," with extensive use of highly polished hardwood throughout.[3] The exterior is lap cedar and shingle siding, the roof is composition shingle, and the foundation is part stone and part concrete. The glass in the built-in bookcases, doors, and mirrors is beveled.

FIRST CHURCH OF CHRIST, SCIENTIST/
LEAR THEATER (1939)
501 Riverside Drive

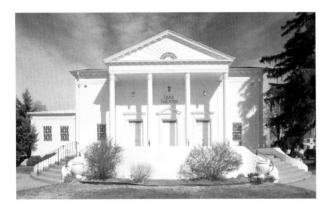

A graceful example of the work of African-American architect Paul Revere Williams, this Neo-Classical Revival structure has beautified this corner since 1939. The site had once housed a home for "orphans and foundlings" before the First Church of Christ, Scientist, was built.[1] Starting as a small congregation of only 180 members in the early 1930s, the Christian Scientists in Reno had increased their membership enough by 1938 to support a large church and a reading room.[2]

As fund-raising began, a major benefactor stepped forward for the construction of the church, a wealthy former resident of Los Angeles who was not even a member: Luella Garvey, who had hired Los Angeles-based architect Williams in 1933 to design her elegant French Regency-style house on California Avenue (see Chapter 4), offered to contribute funds for the construction and the design by Williams. By 1931, Williams had designed

many large residences, schools, and public buildings in Southern California, including the 32,000-square-foot E. L. Cord mansion in Beverly Hills. Automobile magnate Cord later moved to Reno and became one of the state's outstanding citizens and public benefactors.

Georgian and Regency details abound in this structure: twin curving balustrades, over-sized urns, slender columns with subtle foliate capitals, square pilasters with fluted capitals, pediment trimmed with dentils, and a sunburst fanlight with radiating molding, and dentils lining the cornice. The three sets of paneled double doors trimmed with simple casings and crowns carefully match the entablature of the structure. A diagonal-patterned transom light is located above each door, and the double-hung windows also have diagonal-patterned grilles.

In 1998, the congregation sold the church to the Reno/Sparks Theater Community Coalition, which is still in the process of restoring the building. The late philanthropist Moya Lear (whose husband Bill invented the Lear Jet) contributed substantial funds towards its restoration.

LORA J. KNIGHT HOUSE (ca. 1931)
615 Jones Street

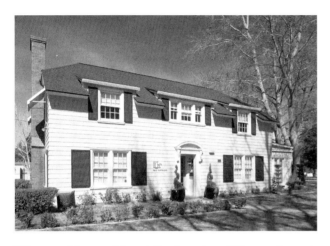

Why would a wealthy philanthropist of Norwegian origin call this her "winter house"? The answer is simple: As cold as Reno can be in mid-winter, it was still warmer than Mrs. Knight's other home: a Scandinavian-style stone castle named Vikingsholm on the shores of Emerald Bay at Lake Tahoe, California. For this reason, Mrs. Knight spent many Sierra Nevada winters in the relative warmth of this Colonial Revival house. In the summer, it was the "stopping off" point for visitors on their way to and from Vikingsholm. A busy hostess, she had a staff of 15 to attend to guests' needs, which included those staying in small houses she owned on nearby Bell Street and along the alley behind this house.[1]

Mrs. Knight's deceased husband had been a major stockholder in several major companies, including National Biscuit, Continental Can, Diamond Match, and Union Pacific Railroad.[2] Consequently, Mrs. Knight was a generous donor to the Christian science church at 501 Riverside Drive, as well as other worthy causes.

However, she is best known for her purchase of 239 scenic acres at Emerald Bay in 1928 for $250,000. It was there that she built her dream home: the Norwegian-designed masterpiece, Vikingsholm, which is now a California state park with guided tours. She also constructed the stone tea house on the island in the middle of Emerald Bay. Lora J. Knight passed away at Vikingsholm in 1945, at the age of 82.

The Reno house has been extensively remodeled and is currently owned by an advertising firm.

MCKINLEY PARK SCHOOL (1910)
925 Riverside Drive

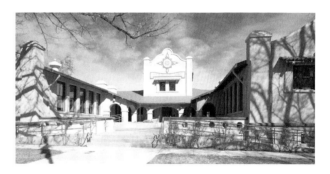

This school is one of the four "Spanish Quartet," i.e., four similar elementary schools built simultaneously after a bond issue in 1908.[1] George Ferris (no relation to the George Ferris who invented the Ferris wheel) designed

McKinley Park School, ca. 1920

all four schools. (Only one other school remains: Mount Rose Elementary School in Reno's Old Southwest, highlighted in Chapter 5.) The Spanish Quartet were lauded for their modern convenience and technology: Their mechanical fan system of heating and ventilation was innovative, and the nearly free-standing classrooms provided a maximum of light through their tall windows.

The Mission Revival style was known for its unique type of parapets and bell towers, modeled after the façades on old Spanish missions in California. The parapet design suddenly appeared on Santa Fe and Southern Pacific railway depots and station hotels that sprang up across the nation in the early 1900s, and also found its way to these four Reno schools.[2]

This school is built in the typical Spanish U-shaped style, with the central open court facing south. It is made of brick covered with concrete stucco, trimmed with concrete. A two-story tower stands at the center of the U, with a one-story wing extending to the north behind it. The name of the school is written on a scrolled panel above

paired windows in the south façade, and a raised design decorates the parapet above the name panel.

In 1976, the school was purchased by the City of Reno to prevent its demolition because of earthquake weakness, but enough funds for restoration and strengthening were not available until 1995. During restoration, the original wood floors were restored to their former shining beauty, and the building reopened in 1999 as an excellent example of adaptive reuse, for offices for non-profits organizations and the city parks and recreation department.[3]

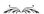

UPSON/ARRIZABALAGA HOUSE
(ca. 1902)
937 Jones Street

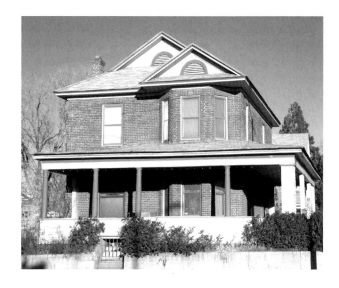

Many Renoites admire this magnificent Queen Anne house perched high on the corner of Jones Street and Keystone Avenue. Sited prominently on two lots in Block R of the Powning Addition, the tall house and its near-twin next door (Dow House) still dominate the neighborhood of mostly modest Craftsman/Bungalows and mark the transition from Queen Anne to the Arts and Crafts movement of the 1920s.[1] Beginning life as a home for Mr. Pearl Upson, who ran Upson Brothers' Transfer Company, the large home has served as a boardinghouse for several families as well as a fraternity house for University of Nevada students, from which it emerged amazingly well-preserved.[2]

As the culminating style of the Victorian Age, the Queen Anne-type profiles and details found in this home are easily identified: The exterior consists of two primary façades, facing west and south, with a gable-on-hipped roof, complete with vents. A large wrap-around porch is supported by four Doric columns on the west side, and by four square, shingle-clad columns on the south side. Typical Queen Anne-style two-story bay windows grace the west side of the front façade. The entire roof is covered in composition shingles, hiding four old exterior flues that once marked the locations of former chimneys.[3]

The interior has a distinctive Victorian feel with its traditional entry, a formal sitting room that can be closed off by sliding pocket doors, and a staircase of Victorian-style turned balusters and newel posts. Generously sized rooms include the family/living room, three bedrooms, two bathrooms (one with original wainscoting), a full-sized unfinished attic, and an unfinished basement, part of which was utilized for coal storage. An original screen porch was converted into a laundry/breakfast room years ago. An artist's studio occupies the former site of an old garage.

ATO FRATERNITY HOUSE (1929)
205 University Terrace

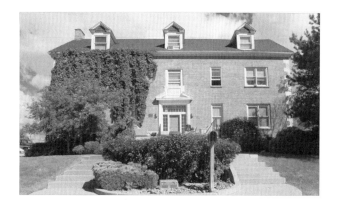

High on a hill overlooking Northwest Reno and Interstate 80, the ATO (Alpha Tau Omega) Fraternity House dominates the West University neighborhood. Designed by architect Lehman "Monk" Ferris, the large Colonial Revival structure was built to house one of Nevada's oldest fraternities.[1] The fraternity started out as a local group, named Phi Delta Tau, in 1912, but by 1921 it had become the Delta Iota Chapter of the ATO National Fraternity. (Sigma Alpha Epsilon dates to 1917, while Sigma Nu dates to 1914.) The cornerstone was laid in April 1929; the construction and furnishing costs were $32,000; it was the first build-

ing constructed to house a fraternity at the University of Nevada. The total membership had reached 150 men by that time, but the house was designed to hold no more than 20. During World War II, the ATO House was renovated to accomodate women, due to the use of the dormitories on campus to house soldiers and military trainees. The coeds were duly supervised by the Dean of Women.

Notable alumni include former Governor Grant Sawyer, former Governor and U. S. Senator Richard Bryan, State Senator Bill Raggio, former Congressman Jim Santini, and the late Robert Laxalt. Architect Lehman "Monk" Ferris was also an alumnus of the ATO Fraternity, and lent a personal touch to the design details.

The ATO House is a side-gabled Colonial Revival-style building modeled after the Georgian style popular in Eastern America during the early 1800s. This style is exemplified by the corner quoins, the gabled dormers on the main roof, the centered front door with its upside-down pedimented crown supported by decorative pilasters, sidelights, and a double row of small windowpanes beneath the crown. The building has three stories plus a full basement (for the kitchen), with a single-story wing projecting off the northeast side of the building. A "rough house" room was an integral part of the building, as were dumb waiters between the basement kitchen and the first floor pantry. In 1988, the house was renovated to meet stringent fire codes, at a cost of more than $500,000, but its original appearance and interior remain mostly intact.[2]

☞ Chapter Seven ☜

UNIVERSITY OF NEVADA, RENO

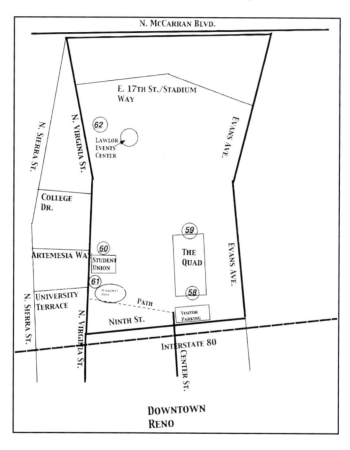

58. Morrill Hall (1886)
59. Mackay School of Mines (1908)
60. Lincoln Hall (1896)
61. Manzanita Hall (1896)
62. Fleischmann Planetarium (1963)

☙ THE UNIVERSITY OF NEVADA ❧
HISTORIC DISTRICT

In 1983, a portion of the campus of the University of Nevada, Reno was listed in the National Register of Historic Places as a historic district.[1] The 40-acre district contains 18 structures, 13 of which are historic, each representing a national style of campus architecture, dating from 1886. The map on page 81, shows the layout of the campus as of 1908.[2]

The university was designated a State Arboretum in 1986, due to the value of many historic and specimen trees found on campus (including three Dawn Redwoods near Morrill Hall). Thanks to the attentive care of the university's buildings and grounds workers in the 1960s, the 50-year old American Elm trees planted around the perimeter of the Quadrangle ("Quad") avoided falling victim to the devastating Dutch Elm disease, which killed millions of American Elms across the nation.[3]

The descriptions of the UNR campus, its buildings, and its history in this chapter are based on information on the 1986 nomination form for the National Register of Historic Places, as well as from university historic researcher and volunteer tour guide Leanne Stone.[4]

The Nevada State University

Having been moved from Elko to Reno in 1885, Nevada State University, as it was called then, began with one building, Morrill Hall. Perched on a hill overlooking downtown Reno and surrounded by ten acres of hay fields purchased from the Evans Ranch, the elegant French Second Empire structure contained the office of the president, classrooms, the dormitories, the library,

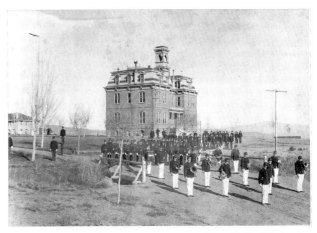

Cadets march at the campus entrance. Morrill Hall is in the background.

and the Normal School (teacher preparation).

Morrill Hall was named for Vermont Senator Justin Morrill, who invented the idea of land grant universities in America. Hoping to compete with the agricultural and mechanical advances being made in European universities, in 1862 Congress allotted federal funds to states for construction of four-year institutions that would teach agriculture, mechanics, and, in Nevada's case, mining.

By coincidence, the architect of this building was also named Morrill: Mr. Morrill John Curtis, who also designed the Mizpah Hotel in Tonopah, Reno City Hall, and the White Pine County Courthouse in Ely.

The facilities available to the 75 students enrolled in the first academic year, 1886-87, consisted of Morrill Hall, a woodshed and stable, and an abandoned alfalfa field where the military cadets practiced marching and using firearms (one of the requirements of the Morrill Act's land grant law).

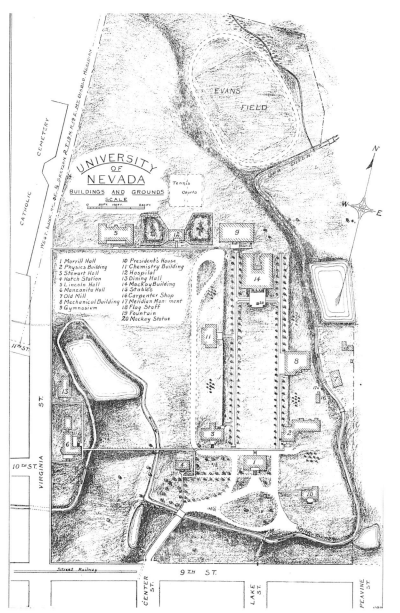

Clarence Mackay and the New University of Nevada

By 1894, an additional fifteen acres had been purchased from the Evans family, extending the newly named University of Nevada campus boundaries west to what is now Virginia Street. Two dormitories were constructed on that land, Manzanita and Lincoln halls, in 1896.

Then, in 1906, a major shift in campus design and university objectives occurred, when Clarence Mackay, son of John Mackay, a prosperous Irish miner who had made a huge fortune in Virginia City, became interested in the new campus. Clarence ended up funding a magnificent statue of his father as well as the beautiful Mackay School of Mines building, the beginning of 30 years of dedication to the Nevada campus.

John Mackay's legendary climb from rags to riches had enthralled Americans and British alike for many years. Mackay had turned his silver ore into capital that he invested in ventures such as the Commercial Cable Company, which used specialized ships to lay cables across the floor of both the Atlantic and Pacific oceans, combining cable, radio, and telegraphic services under one management (the company was bought by Western Union in 1943). Despite his great wealth, he was a modest man. While dining at the lavish Mackay mansion in London, the Prince of Wales called John Mackay "the most unas-

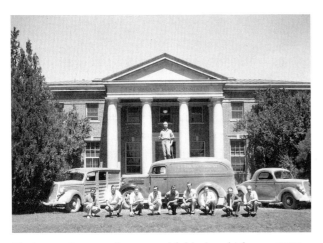

Mackay students, professors, and field trip vehicles, ca. 1938

suming American I have ever met."[5]

Clarence Mackay continued the London tradition of his father, entertaining yet another Prince of Wales (the future Duke of Windsor and King of England) at his immense Long Island estate. As a world-renowned financier, industrialist, and arts patron, he nonetheless chose the sparsely-populated state of Nevada as the focus of his philanthropy for several decades.[6] Clarence Mackay funded both the statue of his father and the new Mackay School of Mines building to honor the Comstock miner who had amassed a great fortune from the silver mines, as well as to provide high quality instruction for future miners.

Clarence Mackay brought his personal architect to Reno to see the new campus, the flamboyant Stanford White of the prestigious New York firm, McKim, Mead and White. State funding for the campus at the time was very low, due to a mining recession and loss of population in the state. But Mackay and White predicted a much brighter future for the state and its new university, with Mackay financing the major portion of the construction. The duo launched a plan to modify the campus layout and construct new buildings. In fact, Mackay's involvement in the university was so important that Mackay, not the president of the university, had the final say on the design and cost of at least eight of the buildings, as well as the campus landscape plans, between 1906 and his death in 1938.

Influenced by the ideas of the trendy new "Jeffersonian Revival" movement in academic architecture circles, Mackay and White envisioned a Nevada campus resembling the University of Virginia, designed by Thomas Jefferson in the early 1800s. The Quad would be turned from its then-east-west axis behind Morrill Hall to a new north-south axis uniting Morrill Hall with a new School of Mines on its north end. New buildings would line up along both sides of the rectangle, facing each other. Four older buildings that faced downtown Reno were eventually demolished as the Quad was redesigned.

Part of the Mackay plan also included replacing Morrill Hall, still a relatively young building, with a massive, domed rotunda-style structure that would serve as a combination library and administration building. Fortunately, a nationwide fundraising campaign by Mackay and the university president failed to raise sufficient money for the project, and the idea of destroying Morrill Hall was dismissed.

Suddenly, a major disruption occurred early in the design process, in June 1906: Stanford White was gunned down at Madison Square Garden, ironically a building that he had designed. A jealous husband shot him, angry over White's previous treatment of his new wife, initiating a scandalous affair that rocked New York society for

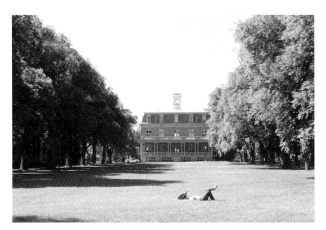

The Quad, looking south toward Morrill Hall.

years.[7] The case dragged on in the courts, but the killer avoided the death penalty via an insanity plea. Two movies based on the murder were made years later: *The Girl in the Red Velvet Swing* and *Ragtime,* the latter based on E. L. Doctorow's novel of the same name.

Another architect from the McKim firm, named W. S. Richardson, took over the Nevada university project. Richardson continued drawing up plans for the Quad as well as for the new mines building. By 1908, the building was completed and dedicated by Mackay, who traveled to Reno for the formal ceremony.

The Mackay School of Mines building is believed to be the only remaining example of McKim, Mead and White design west of Kansas City. Recently, the building was reinforced to withstand earthquakes, in a complicated process which involved digging out a basement underneath and installing rubber and steel pads under the weight-bearing walls and pouring a new concrete floor to allow for lateral movements.[8]

Borglum Statue

The bronze statue of Clarence Mackay's father, John Mackay, that stands in front of the Mackay School of Mines building, is a graphic depiction of the hardworking miners of Nevada. The statue also represents the spirit of John Mackay himself: Of all the miners and bankers who made their fortunes in Nevada's mines, and then left quickly to build their mansions in New York City and San Francisco, only John Mackay and his heirs looked back at Nevada and said, "Thank you." John Mackay was worth at least $100 million when he died in 1902; a generous portion of the Mackay fortune was dedicated to supporting mining and science programs at the University of Nevada. His family is still the university's most generous donor in its history, whose name can be found on numerous

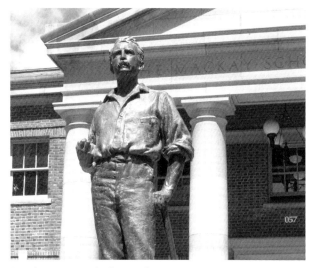

Borglum statue of John Mackay.

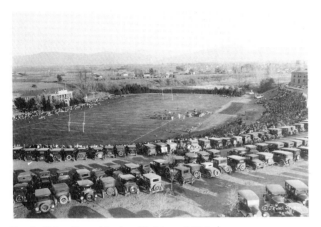

Football Stadium, Mackay Field, ca. 1930s.

structures and programs across the campus.

The sculptor of the John Mackay statue was an artist named Gutzon Borglum, who would soon become famous for carving the presidential faces into M. Rushmore. Borglum's daughter, Mary Ellis, stayed in Reno and married Reno architect David Vhay, who designed Ross Hall (1957), the Church Fine Arts building (1960), and the Getchell Library (1962).

Continuing Mackay Support

Additional acreage was purchased and donated by Mackay in 1908, a ten-acre natural hollow that served as the setting for the first sports stadium and athletic buildings. Old photographs of the show cars lined up along the ridge above Evans Field, the best seating at the time for watching the football game below.

A new Mackay Stadium was eventually built in 1966, on the north side of the campus, leaving room for the new buildings in the bowl-like location behind the School of Business.

Meanwhile, in 1911, Manzanita Lake was developed where an old pond had once provided water for the Evans Ranch cattle. Using water from the Orr Ditch (dug in 1870), which crosses the campus at its southern boundary, the lake filled up behind the dam, and a walkway was constructed that still connects the center of campus with Virginia Street.

Clark Administration Building was built in 1926 with Clarence Mackay's approval, using San Francisco architect Robert Farquhar. The money was donated by William A. Clark, Jr., of Los Angeles, who had married a young lady from Virginia City. He was the founder of the Los Angeles Philharmonic Orchestra. Clark's father was the Montana U. S. Senator who developed much of the land in Clark County, Nevada, for whom it is named. This building was the university's second library, and now serves as the president's office.[9]

The Quad, looking north toward the Mackay Mines Building.

Frederic DeLongchamps's Influence

Local architect Frederic DeLongchamps was called into service to design the new buildings on the campus. Following the McKim, Mead and White firm's Beaux-Arts

Jones Visitor Center, originally the first library building on campus.

principles used in the design of the Mackay School of Mines, DeLongchamps created drawings for several buildings, including the first library on campus (1914; now Jones Visitor Center), the Agriculture building (1918, now Frandsen), the Education building (1920, now Thompson), the Federal Mining Experimental Station (1921), the "old" Virginia Street Gymnasium (1943), and Mackay Science Hall (1930).[9] Each is described in detail below, based on research by Leanne Stone.[10]

The Mackay School of Mines building launched the Neo-Classical Revival style on the campus, which DeLongchamps continued to follow for over 30 years. His designs complemented the original Jeffersonian style, which at the time was a template for the type of architecture found

across America, not only on university and college campuses, but also in government buildings and banks.

The solid Greek-temple façade signified both democracy and advanced learning, two concepts held dear by the country's citizens. As a result, many buildings on American campuses in the late 1800s and early 1900s were built along Neo-Classical lines, with Ionic columns, pediments, and pilasters.

The University of Nevada's architects, especially DeLongchamps, followed the Neo-Classical tenets for many years, producing a campus setting around the Quad which closely resembled Jefferson's University of Virginia, that is, until modern buildings were added in the 1960s. Indeed, several Hollywood movies in the 1940s and 1950s were filmed on this campus, taking advantage of the "Ivy League" atmosphere. Jeanne Crain starred in two movies on campus, *Margie* and *Apartment for Peggie,* while Shirley Temple was featured in *Mr. Belvedere Goes to College.*[11]

Ornamental design of book, Jones Visitor Center

Jones Visitor Center

The Jones Visitor Center was the first library (note the open book motifs in the medallions), in 1914. In 1983, the building was dedicated to two of the university's most generous donors, Clarence and Martha Jones, who were associated with the two major local newspapers. When the *Reno Evening Gazette* and the *Nevada State Journal* were purchased by Spiedel Newspapers, the Joneses shared their windfall profits with the university, contributing to nursing, computer science, journalism, the planetarium, and the Alumni Association.

Frandsen Building

The Frandsen building (1918) was originally the agriculture building, named after Peter Frandsen, a renowned biologist from Denmark who grew up on a ranch in Verdi. After graduating from Harvard, "Bugs" Frandsen returned to Nevada and taught here for 42 years. After the Fleischmann Agriculture building opened, Frandsen Humanities held the offices of the English and foreign languages departments. Note the two large Ionic columns flanked by brick and limestone pilasters. Terra cotta garlands and soffits with rosettes adorn the portico.

Thompson Building

The Thompson building (1920) was the first Education Building, designed by DeLongchamps in his oft-used Classical style, exemplified by the four large Ionic columns. Reuben Thompson was a professor of ancient languages, literature, and philosophy; he founded the Department of Philosophy and also served as Dean of Men.

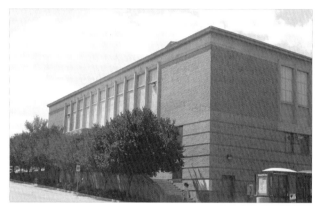

Virginia Street Gymnasium, known as the "Old Gym" today, designed by Frederic DeLongchamps.

Federal Mining Experimental Station

By 1919, the university and the Nevada Legislature had succeeded in lobbying Congress to transfer the duties and work of Colorado's Federal Mining Experimental Station to Nevada. The Station's methods are still the standards used for recovering gold, silver, and other precious metals from ore. In 1954, the new U. S. Bureau of Mines took over the work of the Station, and this building was purchased for $1.00.

Virginia Street Gymnasium

The Virginia Street Gymnasium was first designed in 1940, but when World War II began, the plans were revised because of delays in finding heating and ventilation system parts. It was finished in March 1943, but immediately became a barracks for American airmen stationed in Reno. In 1944, it opened for athletic events.

Dedication of the Mackay Science Hall, October, 1931. Clarence Mackay, center and university President Walter Clark.

Mackay Science Hall

This building was the final major gift to the university from Clarence Mackay, who died in 1938. In tribute to the source of his father's fortune, in laying the cornerstone, he used a trowel made from wood and one part silver and two parts gold from the mines in Virginia City. The main entrance on the west side has a five-bay, two-story limestone portico with six Ionic columns. It has a limestone cornice, dentils, and a patterned brick frieze. The south side of the Neo-Classical structure is surprisingly quite elaborate, with four Ionic pilasters between two pilaster strips, and an entablature and a frieze around the sill of the water table. Since this side of the building does not face the Quad, where such an ornate entry would normally be found, many believe that it was designed this way so that the university president could see it from the window in his house. The building now houses the geography department and several centers.

Palmer Engineering

This building was designed by Russell Mills in 1941, who continued the DeLongchamps Classical style. It was named for Stanley G. Palmer, a former graduate who returned to Reno in 1915, and eventually became Dean of Engineering in 1941. Stanley's brother Walter graduated with a degree in mining, returned here to teach in 1910, and almost single-handedly catalogued all the minerals and specimens in the Keck Minerals Museum, located in Mackay School of Earth Sciences and Engineering.

Buildings of the 1950s and 1960s

Several modern buildings are contained within the historic district, to the east of Morrill Hall. The university president's house also occupied this site at one time. Constructed in 1901, it was a Colonial Revival structure with a gambrel roof and decorative pediment supported by slender white columns on either side of the entry. Then-university president Joseph Stubbs funded the leasing of the land for the house and then raised funds statewide for its construction. The San Francisco firm of Bliss and Faville designed the house, and later assisted the McKim, Mead and White firm in the design of the Quad and the Mackay School of Mines.

President Minard Stout was the last president to occupy the president's house, which was demolished when the new Fleischmann buildings were constructed in the 1950s. Since then, university presidents use their own homes and receive housing allowances.

The Sarah Fleischmann Building, built in 1957, now houses the Human and Community Science College, while the Fleischmann Agricultural Building (1957), is

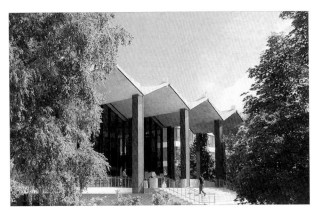

Getchell Library

home to the Agricultural Biotechnology and Natural Resources College. Both buildings, as well as the Planetarium/Atmospherium on the north end of the campus, were funded by the Max Fleischmann Foundation, named for the wealthy yeast-company executive who was enticed to move to Reno in the 1930s by real estate magnate Norman Biltz. His foundation donated funds to educational and humanitarian causes for several decades.

Ross Hall, on the west side of the Quad, was built in 1957 and named for Silas Ross, a 1909 graduate and owner of the Ross-Burke and Knobel Mortuary. He was a member of the Board of Regents for over 20 years. The building's 1950s architecture is in stark contrast to the Neo-Classical buildings around the Quad.

Two historic, but structurally unsafe, buildings on the Quad, the Mechanical Engineering and the Electrical Engineering building, were replaced in the 1980s. The two new buildings, both dedicated to former Nevada Governor and U. S. Senator Paul Laxalt, hold laboratories and classrooms for mining and geological studies.

Exploring the Campus

The University of Nevada campus today is very large, covering over 250 acres. It is still expanding, as evidenced by the new buildings under construction. But the historical district is quite compact, and by following this walking guide to a select few of the important buildings, you can appreciate the Ivy League atmosphere of the original campus and learn about its interesting history. If you are doing this tour during normal business hours, you will be able to enter the buildings and appreciate their interior design as well as their exterior features.

MORRILL HALL (1886)

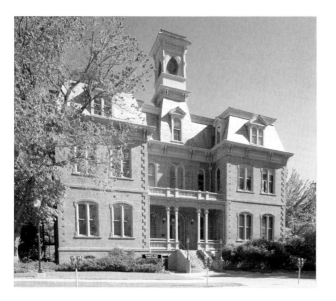

This beautiful French Second Empire building was the first to be constructed on the new "Nevada State University" campus. Originally it housed everything, from the president's office to classrooms, dormitories, and the library. The building was named after Vermont U. S. Senator Justin Morrill, the father of the land-grant federal program for American universities in 1862. Coincidentally, another man from Vermont with the name Morrill designed the building: Morrill John Curtis. The elegant French Second Empire hall came close to being demolished by the Clarence Mackay team of architects, but it was thankfully spared, becoming the southern anchor-point of the Quadrangle (the "Quad"), while a new Mackay School of Mines building came to dominate the north end in 1908. After that year, all new buildings faced

each other across the rectangle, rather than downtown Reno, as the campus had originally been designed. Over the years, the Quad was lined with Jeffersonian-inspired, Neo-Classical buildings.[1]

When a severe earthquake rattled Reno in 1959, many feared that Morrill Hall was unsafe and called for its destruction.[2] Years of bickering over what to do happily resulted in a fund-raising campaign in the 1970s, which brought in enough for restoration and strengthening of the venerable building. The process included shoring up sagging floors and adding fire escapes, an access ramp, and an elevator. By 1974, restoration was finished, and Morrill Hall was placed on the National Register of Historic Places. The building recently received new shingles on its mansard roof, and is being carefully maintained and preserved. If the building is open, be sure to go inside to appreciate the antique furniture and ambiance of this architectural gem.

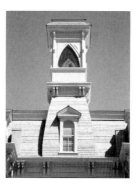

MACKAY SCHOOL OF MINES (1908)

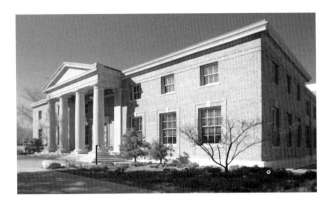

The most visible symbol of the importance of mining in Nevada's early history, this elegant Neo-Classical Revival building has dominated the north end of the Quad since 1908.[1]

The brick exterior walls are of the Flemish bond pattern, while the decorative, glazed brick in the ceiling of the front portico was set in a herringbone pattern by a Mr. Guastavino, a Spaniard who invented the process. Limestone brought in from Indiana was used in the pediment, columns, cornices, wall bases, door frames, chimney caps, keystones in the arches, and window sills. Originally, the weight-bearing walls were placed on a rubble foundation, but fears of earthquake damage led to a complete restructuring of the building's foundation. In 1991, a basement was dug out under the building (large enough for a bulldozer!) and rubber and steel pads were placed under the weight-bearing walls and the columns.[2] The pads support the building and allow it to move laterally, if needed.

Be sure to visit the Keck Museum inside on the first floor. It is a world-famous minerals and mining museum with samples of minerals and fossils from around the world. The displays also offer an excellent lesson in Nevada's mineral history, showing how the Comstock mines were dug, the type of equipment utilized for ore extraction, and how the tunnels were supported for safety. The DeLaMare Library on the north side of the building has a fine research collection and is particularly strong in maps.

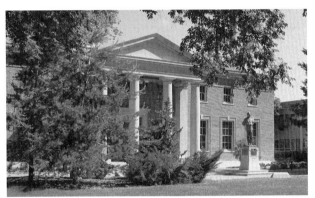

LINCOLN HALL AND MANZANITA HALL
(1896)

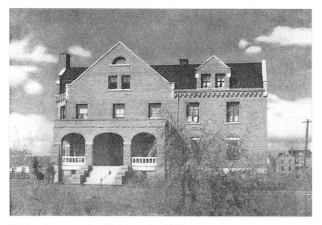

Early photograph of Manzanita Hall.

These two student dormitories were the first structures built after fifteen acres were purchased to expand the campus toward Virginia Street, in 1894. Morrill Hall served as the only location for offices, classrooms, and dormitories, an overcrowded situation that needed to be remedied as enrollment grew. The dormitories were part of a cluster of buildings called a "cottage system," where home-like buildings were placed in a less-formal, more naturalistic setting, to make students feel more comfortable as they spent their first years away from home. After the dormitories were built, a dining hall was placed between them, in 1905, and then in 1907 the three buildings were connected by boardwalks. Only the dormitories remain today.[1]

Lincoln Hall was the designated men's dormitory, while Manzanita was the women's. Both buildings are similar to many Eastern campus dormitories, with their eclectic blend of Colonial, Flemish, and Romanesque Revival styles. Lincoln's hipped roof, central cupola, three gabled dormers, common red brick, and rusticated granite block foundation have remained basically unchanged for over 100 years. Lincoln Hall holds the distinction of being the oldest continuously occupied university residence hall west of the Mississippi.

Manzanita Hall was originally called the Cottage, and the living arrangements were unusual: University president Stubbs and his family lived on the first floor, with the women above. The south end was built first, followed by a north wing in 1910, with parapet gable walls. The roof has red asphalt shingles, while brick dentils band the

Lincoln Hall, 2007.

roof line, and red brick and rusticated sandstone accents complete the exterior walls. The entrance has a one-story semi-elliptical arcaded porch, flanked with semicircular brick arches, supported by rough, dark-rose sandstone piers adorned with white granite capitals.[2]

FLEISCHMANN ATMOSPHERIUM/ PLANETARIUM (1963)

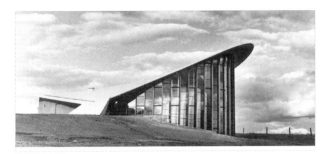

Widespread interest in technology and science and space exploration in the late 1950s and early 1960s (stimulated by Russia's 1958 launch of its space satellite, Sputnik), led to the construction of a new type of building called a "atmospherium."[1] Reno was one of the first cities to build this intriguing type of building, a design which was actually created in 1923 to simulate the night sky and show star and planetary movements. A special projector had just been invented in 1963, which could replicate the sky during daylight, so that weather and climate could be explained. This new projector was called an "atmospherium" and instantly became part of this structure, propelling the University of Nevada campus to national prominence for its modernistic "Atmospherium/Planetarium."

Initially, the building's most famous feature was an experimental solar heating and cooling system designed by the Desert Research Institute in Reno, making this the only structure in the western states to have such a system at the time.

The abstract-form building is one of three local examples of the trendy Populuxe architecture style (the other two are the Washoe County Library downtown and the Getchell Library on campus). Populuxe-inspired objects took their shapes from boomerangs, flying saucers, parabolas, and atoms and applied them to products for America's middle class, with its love of streamlined cars, houses, and appliances.

Faced with demolition to make way for a parking lot in 2004, supporters raised funds to preserve the building and install state-of-the-art equipment that fosters collaboration with the National Weather Service, the Desert Research Institute, the Jones Observatory at Rancho San Rafael, the Washoe County School District science pro-

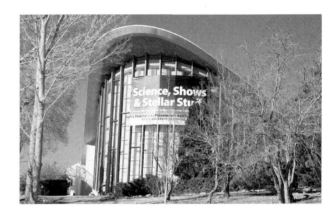

gram, the Raggio Science, Technology and Mathematics Center, and the College of Science.[2] A new Digistar 3 digital theater audiovisual system gives high-definition viewing of science movies, while meteorological data sensors, and interactive NASA exhibits attract visitors of all ages to the continuing schedule of events.

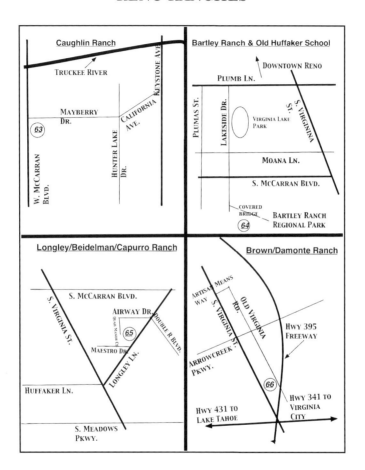

✤ Chapter Eight ✤
RENO RANCHES

63. Caughlin Ranch (1897)

64. Bartley (Buscaglia) Ranch (ca. 1876)
 Old Huffaker School (1867)

65. Longley/Beidelman/Capurro Ranch (1865)

66. Peleg Brown Ranch (1864)

⤞ THE GILDED AGE IN RENO ⤝
Ranching in the Truckee Meadows

Those of us who grew up catching a whiff of newly-mown hay from a near-by ranch are saddened by the disappearance of most of them, but we should be somewhat comforted to know that there are still a few vestiges of that lifestyle around the Truckee Meadows. Thanks to efforts by preservation groups such as Truckee Meadows Remembered, which has published an excellent pictorial and historical record of the area's ranches (*Truckee Meadows Remembered*, by Jack Hursh, Jr. and Loren Jahn, 2004), as well as the Bartley Ranch's Western Heritage Interpretive Center at the base of Windy Hill in Southwest Reno, several ranch buildings have been spared the wrecking ball (and are on display there). Just as important is the large collection of antique tools and farm equipment that has been saved from the garbage dump, also on display at the park. The Hursh/Jahn publication is an excellent, in-depth guide to the ranches that still exist, with abundant pictures and drawings, and is a great complement to (and source for) the ranches highlighted in this book.

Historian John Townley summed up ranching's importance in the "gilded age," i.e., between 1861 and 1900:

"When all is said and done, nature must take credit for Reno's Gilded Age prosperity. The raw materials for that wealth – location, land and water – waited for anyone to appropriate and exploit. No entrepreneur of genius forged new industry from the valley or its water power; men simply used obvious resources to route railroads, raise alfalfa or sell beef. Three railroads – all built by outside interests – and twenty thousand acres of hay eventually enabled the town to outgrow those more dynamic mining camps which to most contemporaries typified Nevada. Local residents grabbed opportunity enthusiastically, and deliberately pyramided their advantages into the state's largest community. " [1]

Townley further noted that Reno's first "super-rich" residents were not professionals: "Those fortunate few were still self-made, land-poor stockmen who arrived early and squatted on whatever they could hold, or those who made a fortune on the open range elsewhere and moved to Reno to enjoy it." The names of those early ranchers are found all over the valley, memorialized as street names and parks: Jones, Lake, Holcomb, Oddie, Mayberry, Raffetto, Lombardi, Pecetti, Pincolini, Questa, Casazza, Plumb, Longley, Capurro, Farretto, Feretto, Curti, Bartley (formerly Buscaglia), Quilici, Brown, Huffaker, Caughlin, Frey, Peckham, Damonte, and Zolezzi, among others.

Although the first ranchers were of English extraction, many settlers of Italian background began to arrive in the Meadows in the 1880s, first working in the logging industry, and then branching out to ranching after saving up their earnings to buy land. Initially, they were met with widespread prejudice and suspicion, and tended to cluster together and not learn English. But their intensive agricultural methods learned in Europe, such as collecting manure from corrals and barns and plowing it into the alfalfa fields, soon brought them respect and admiration for the spectacular results. They soon branched into fruit and vegetables.

By 1900, Italians owned the largest portion of the croplands in the western half of the Truckee meadows, from Steamboat Springs to Verdi (note its Italian name), and have been valued community leaders ever since.

The most prosperous aspect of Reno's ranching economy in the early days of the railroad was the winter feeding of cattle brought from all over northern Nevada to fatten up for transport to California and Chicago. The lush grass hay of the Truckee Meadows was Reno's first cash crop, which easily fed countless thousands of cattle spending the winter here, gaining valuable weight prior to shipment on the railroad.

The old barns and ranch houses that you will see by following this book and the Hursh/Jahn book were mostly built by teams of barn builders who came from Europe and added their own style to each structure. Hand-hewn beams made from the large trees in the near-by Sierras provided strength, while wooden shingles on the roof and square nails in the walls provided the finishing touches.

Often the barns were repaired with "board and batten" to cover the gaps made by the shrinkage of the original wood panels on the exterior. The bunkhouse in the collection of old ranch buildings at Bartley Ranch Regional Park was constructed with cut nails in this manner. It is believed to be very old, because wire nails replaced the square ones in 1870. That display includes out-buildings that were moved from the Joe Ferretto Ranch in the Huffaker area on South Virginia Street. It includes a chicken coop with a pigeon loft, a cook house, a carriage house, bunkhouse, and a granary/tool shed. Surrounding the old buildings are old ranch artifacts ranging from tractors and wagons to a spindle seat run-about buggy.

The four ranches in this chapter represent a broad spectrum of styles dating from early Truckee Meadows ranch architecture. The oldest one is the Peleg Brown Ranch, on Old Virginia Road, near the intersection of the Mt. Rose highway and the road to Virginia City. The Greek-Revival-style house was built in 1864, and fortunately has been protected from the encroaching freeway and shopping center. The 1869 Longley/Beidelman/Capurro Ranch off Longley Lane is a beautiful example of Carpenter Gothic style. The Caughlin Ranch house on Mayberry Drive was built as a city home in Virginia City sometime in the 1880s and brought down on a wagon on the old toll road in 1895. The Buscaglia/Bartley ranch is somewhat younger, and now serves as a county park with horse facilities. The Old Huffaker School is included in this chapter, because of its importance in the education of the children living on the many ranches in the South Truckee Meadows. Some old-timers still tell stories about riding their horses to school and tying them up to the hitching rail while they attended classes.

Where to Start the Tour of the Ranches

Because the ranches are scattered across the valley, ranging from the extreme western end of Reno to the most southern point of the city, a car is necessary. Maps to help visitors find the ranches are included in this chapter.

As you tour the four ranch sites, try to think back to a time when the entire valley was covered with over 20,000 acres of lush grasslands, watered by springs and ditches. Reno was the center of the livestock industry of the Great Basin for many years because of this abundant water and fertile cropland.

CAUGHLIN RANCH (1897)
3636 Mayberry Drive (at West McCarran Blvd.)

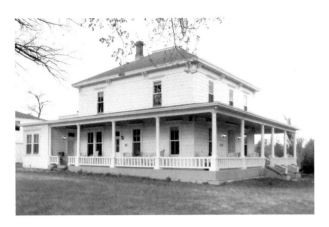

Once the centerpiece of a sprawling 6,000-acre cattle ranch, this elegant ranch house is a beautiful testament to the legacy of Crissie Andrews Caughlin, a pioneer of Nevada ranching history. Originally part of Crissie's family ranch, the Andrews acreage was renamed Caughlin Ranch after she married Washoe County sheriff William Caughlin in 1895.[1] This house was moved down from Virginia City and placed on what was known as Verdi Road. A bunkhouse was already on the ranch, which served as the family home until the new one arrived. Crissie's father, George Andrews, had received some acreage (as well as water rights) in exchange for designing the Steamboat and Last Chance canals that brought much-needed water to Reno's outlying ranchlands. Water also came from Alum Creek, which is now a trickle compared to its former volume.

Originally encompassing a vast panorama of pastures along the river, stretching below the tree-covered Sierra foothills, the Caughlin Ranch has changed with the times: A rocky pasture where the Caughlin children once played is called Stonegate, and Mayberry Meadows homes fill the fields where hay stacks once extended from today's River Run neighborhood for over a mile eastward to Ferris Street. The upper parts of the ranch once reached Skyline Boulevard and to the southwest beyond what is known now as Eagle's Nest. High inheritance tax and property tax bills in the 1950s and again in the 1980s forced the heirs to sell off large portions of the ranch, which eventually became the site of the Caughlin Ranch development, directed by financial backer Sam Jaksick, engineer Alan Means, and Don Lonie, who was married to Crissie's granddaughter Shiela. That carefully planned community preserves the wide-open spaces-feel of the original ranch through walking and jogging trails and ponds; a herd of cattle still grazes in the pastures surrounding the ranch house.[2]

A four-year restoration project was completed in 1997, earning the family a historic preservation award for a Residential Structure from the City of Reno's Historical Resources Commission. Crissie Caughlin Park along the Truckee River memorializes Crissie's desire to preserve her family's homestead and the ranching way of life.

BUSCAGLIA/BARTLEY RANCH (ca. 1876)
Bartley Ranch Regional Park
6000 Bartley Ranch Road
(off Lakeside Drive at Windy Hill)

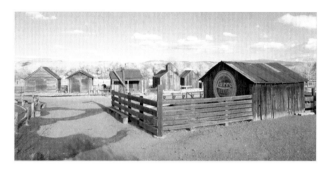

In the 1870s, a group of South Truckee Meadows farmers dug two ditches to bring water from the Truckee River to the fields south of Reno: the Last Chance Ditch and the Lake Ditch.[1] The two new irrigation sources, whose take-out points are near the California border along Interstate 80, spurred the planting of new alfalfa fields and grassy pastures for the growing cattle and sheep industry. Prosperous new ranches sprang up south of Reno, including the Wheeler Ranch, which eventually became the Bartley Ranch, and through which both ditches flowed. In 1912, an Italian immigrant, Demetrio Buscaglia, who had been very successful in agricultural pursuits in the Truckee Meadows, bought part of the Wheeler estate. He and his son Gus operated a small dairy, but after World War II they transformed the ranch into a horse-boarding and training facility. Gus was a well-known rodeo performer, who later changed his last name from Buscaglia to Bartley, and eventually sold the ranch to the Washoe County

Parks Department in 1988 before retiring in California.

When the new park opened in 1995, the Bartley family home was converted to an office (the white brick structure), while a new building now houses the Western Heritage Interpretive Center.[2] Many conferences and cowboy poetry events are held here. Not to be missed inside the Center is the large mural of one of Reno's most picturesque ranches, the Longley/Beidelman/Capurro Ranch (highlighted in this chapter) created by artist Loren Jahn, the illustrator of this book's cover.

Note the outdoor horse training arena, the fascinating exhibit of old barns and out-buildings rescued from the Ferretto Ranch, the collection of old ranch vehicles and machinery, the old Huffaker School, and the perfectly-acoustical outdoor amphitheatre: All add up to an outstanding regional park with something for everyone.

OLD HUFFAKER SCHOOL (1867)
Bartley Ranch Regional Park
6000 Bartley Ranch Road

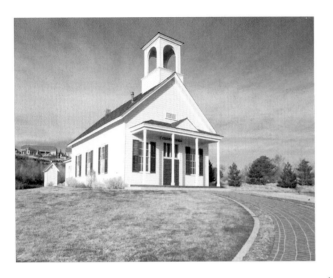

The Huffaker School was built for the children who lived on the many ranches and farms dotting the Southwest Truckee Meadows.[1] It was built in 1867, at the site of the "second" Huffaker School on South Virginia Street (a red brick school building). It was moved from that site in 1951 and used as a storage shed for fish food and equipment at the Neil Road Fish Hatchery in southeast Reno. Because of its importance in the history of the valley, the Huffaker Restoration Committee and the Friends of the Old Huffaker School raised funds for moving the school to the new Bartley Ranch Park in 1996. Many prominent Renoites, especially of Italian descent, were once students here, some riding their horses from home several miles away and tying them up at the hitching rail. Genders were kept apart in those days: Boys entered through one door, girls through another, keeping their coats and lunch buckets in separate cloakrooms.

The school gets its name from the little settlement called "Huffaker's," located near the junction of the now-Virginia City and Mt. Rose highways. The town once had 300 citizens, a U. S. Post Office, a flume, and a general store; today no trace remains of the once-important town, but Huffaker Lane and the new (i.e., third) Huffaker School adjacent to Bartley Ranch Park remind us of its historical significance.[2]

The architectural style of Huffaker School is Greek Revival. The exterior has been restored to its early 1900s appearance. In 1878, the belfry was added, and another classroom was added to the back; a third classroom was added to the south side during the 1930s (now gone). The color scheme of the exterior dates from the early 1900s. The school bell was cast of solid brass and was rung so accurately and loudly that farmers miles away could set their watches by it. The main classroom has been restored to the 1930s time period; the "Little Room" in the back has been restored to the Victorian era. The Huffaker Schoolhouse is a popular venue for weddings and meetings.

LONGLEY/BEIDELMAN/
CAPURRO RANCH (ca. 1869)
6450 Quail Manor Court (off Longley Lane)

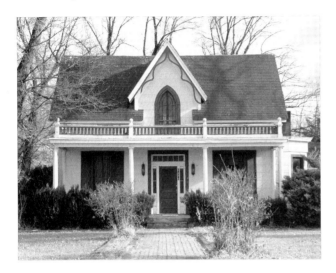

One of the area's most beautiful examples of the Carpenter Gothic style, this ranch house has managed to survive the demolition that leveled most of the ranch's outbuildings and barns.[1] Constructed from a classic pattern book design, the house was considered cutting edge when it was built: it had indoor plumbing and carbide gas illumination. Other than candles and kerosene lamps, carbide gas was the only way to light and heat houses in the 1700s and 1800s, when there was no natural gas to be found, or before the production of gas by a municipality. Wealthy American landowners far from city services often constructed separate buildings on their property for the somewhat dangerous production of carbide gas. The gas was piped into homes for use in gas lamps and chande-

liers. Indoor plumbing in Nevada at that time was also a marvel, signifying that this ranch house was not only beautiful, but thoroughly modern for its day.

The campus of the ranch was once very large, including several barns and other outbuildings set among towering cottonwoods that are probably as old as the house. Everything but the ranch house was torn down in October 2001 to make way for warehouses. The Hursh/Jahn book shows photographs of the ranch outbuildings prior to their demolition, and its current appearance.

Fortunately, a large full-color mural depicting the original ranch house and its outbuildings was created by Loren Jahn in the Bartley Ranch's Western Heritage Interpretive Center, where visitors can view an accurate depiction of what was once a major ranch in the Truckee Meadows. The carefully preserved ranch buildings can allow visitors to appreciate the different types of structures that were built on 19th century ranches, from chicken coops to hay barns. A collection of old plows, tractors, and other heavy equipment gives a glimpse into what was once a hardworking way of life on the area's ranches.

A visit to the site of the ranch, off Longley Lane, should also be made, to see the lovely house sitting among ancient trees, still preserved and, hopefully, protected forever.

PELEG BROWN RANCH (1864)
12945 Old Virginia Road

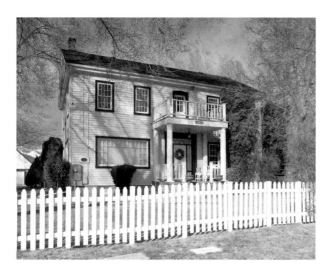

Only the rear part of this large Greek-Revival style ranch house can be seen from U.S. 395, near the junction of the Virginia City and Mt. Rose highways. The front of the house actually faces Old Virginia Road, which leads to the old Brown School. Built in 1864, the same year that Nevada entered the Union as a state, the venerable home has been carefully protected from an adjacent freeway and a new near-by shopping mall. Peleg (from an old Hebrew word meaning "geological division between large continents") Brown established this ranch on 620 acres at the very important junction of the stagecoach and wagon roads to Virginia City, Carson City, and Lake Tahoe.[1] His ranch's milk cows provided butter and cheese for hungry miners on the Comstock, while his beef cattle supplied meat, and his gardens provided fruit and vegetables.

He divided the second floor of this house into fourteen small bedrooms to rent to travelers. When the Virginia and Truckee Railroad pushed south from Reno to Carson City, the Brown Station siding was constructed for loading hay, lumber, and stock from Brown's companies. An acre of land for Brown School was donated to the school district in 1878.

In 1940, the ranch passed from the Brown family heirs to the Damonte family. One of many Italians of Genovese heritage in Reno, Louis Damonte began as a sharecropper, growing grain and potatoes on rented land. Eventually, the Damontes owned several ranches (over 7,000 acres), including the Brown Ranch and Wilbur May's Double Diamond Ranch.

The Brown/Damonte Ranch is still owned by a descendant of Louis Damonte, surrounded now by only eight acres. The main house and outbuildings date to the 1860-1890s, although the house was remodeled in 1940 and 1955. The 14 bedrooms on the second floor were joined to form larger rooms, and modern conveniences have been added. However, the house retains its outward Greek Revival appearance, including its original windows and doors, and is a welcome reminder of Reno's early ranching days.

❧ APPENDICES ❧

≈ Appendix A ≈
Glossary of Architectural Terms
with Local Examples

TERM AND DEFINITION **RENO EXAMPLE**

arch – half-circle of stones or bricks supporting a wall, window, or door

arcade – a series of arches supporting a roof

Roman arch (rounded, with keystone in middle): *California Building* (Idlewild Park)

Gothic arch (pointed at top): *Trinity Episcopal Church* (200 Island Ave.)

Chinese Moon or horseshoe arch (circular top and sides): *Hart House* (1150 Monroe Court)

baluster – upright vase-shaped post or spindle supporting a stair railing or banister

balustrade – a handrail across the top of the balusters

Nortonia Boarding House (150 Ridge St.)
Gibbons/McCarran Mansion (401 Court St.)
Twaddle Mansion (485 West Fifth St.)

bargeboard (verge board) – stylized rafter attached to the bottom edge of a gable (fascia), usually decorated with carved designs, especially on Victorian houses

Russell Mills House (803 Nixon Ave.)
Longley/Beidelman/Capurro Ranch (6450 Quail Manor Court)
Borland/Clifford House (339 Ralston St.)

belt course – horizontal ledge of masonry, bricks, wood, or stone on a wall, used for decoration or for deflecting water

El Cortez Hotel (239 West Second St.)
Gibbons/McCarran Mansion (401 Court St.)

board-and-batten – vertical siding composed of wide, flat boards with narrow strips nailed over the spaces between the boards; common in old farm and ranch buildings

Old barn and outbuildings, *Bartley Ranch Regional Park* (6000 Bartley Ranch Road)

buttress – thick, slanted section of wall supporting main wall on outside, typical of Gothic churches in Europe

Trinity Episcopal Church (200 Island Ave.)

clapboard siding – from Dutch, "to split a board," i.e., boards are thinner at one edge, laid horizontally and overlapped for weatherproofing (typical form of siding in wooden houses)

Howell House (448 Hill St.)
Twaddle Mansion (485 West Fifth St.)

TERM AND DEFINITION	**RENO EXAMPLE**

Corinthian columns – tallest and most richly-embellished column utilized by Roman architects, it is fluted and contains acanthus leaf motifs at the capital (top)

Washoe County Courthouse (117 South Virginia St.)

cornice – typical detailing of classical architecture, in which the upper section of an entablature or ornamental molding project along the top of a building or wall

Washoe County Courthouse (117 South Virginia St.)
Gibbons/McCarran Mansion (401 Court St.)
Howell House (448 Hill St.)

dentil – small rectangular blocks placed in a row, like teeth, as part of cornice or molding under a roof or Classical cornices

Levy Mansion (121 California Ave.)
Howell House (448 Hill St.)

Doric column – heaviest, most massive Greek-style column, fluted but unadorned and simple, with plain saucer-shaped capital and bold cornice
Tuscan column – same as Doric, but unfluted

Doric: *Hawkins House* (549 Court St.)

Tuscan Doric: *Gibbons/McCarran Mansion* (401 Court St.)

dormer – a shed-like structure with own roof that projects from main roof, usually enclosing a small window or opening for a vent

Morrill Hall (UNR campus)
Twaddle Mansion (485 West Fifth St.)

egg and dart – decorative repetitive molding containing egg-shaped motifs separated by pointed darts, found in friezes on Classical buildings under the cornice

Reno National Bank (204 North Virginia St.)
Washoe County Courthouse (117 South Virginia St.)

frieze – a flat, horizontal band, often decorated with dentils or egg and dart motifs, usually placed just below a cornice; in Greek or Roman temples, a frieze contains figures and other large, elaborate features

Reno National Bank (204 North Virginia St.)
Washoe County Courthouse (117 South Virginia St.)
Howell House (448 Hill St.)

TERM AND DEFINITION	RENO EXAMPLE
gable – a triangular portion of a wall defined by the sloping edges of the roof and a horizontal line between the eaves **cross gable** – is set parallel to the roof	Cross gable with dormers: *Hawkins House* (549 Court St.)
side gable – is an additional gable added onto the side of a building **jerkin-head clipped gable** – has a truncated point, cut off so that it slants backwards (like the hood on a robe, or jerkin)	Side gable: *Russell Mills House* (803 Nixon Ave.) Jerkin-head gable: *Jahn House* (842 Nixon Ave.)
shaped gable – has a decorative edge, such as a scroll in the Mission Revival style, or steps as in the Flemish style	Shaped gable: *Mount Rose School* (915 Lander St.), *Humphrey House* (467 Ralston St.) and *Lincoln Hall* (central campus, UNR)
gingerbread trim – named for its similarity to sugar frosting on German gingerbread houses, this decoration of the Victorian era features pierced or carved curvilinear ornamentation on bargeboards, fascia boards, and around windows and doors	*Borland/Clifford House* (339 Ralston St.) *Longley/Beidelman/Capurro Ranch* (6450 Quail Manor Ct.) *Lake Mansion* (250 Court St.)
half-timber - timber-framing on Tudor-style building where the supporting beams are left exposed; also may be applied as pure decoration to exterior of house	*Graham House* (548 California Ave.)
hipped roof – characterized by four or more sloping planes that all start at same point or level, extending outward	*Upson/Arrizabalaga House* (937 Jones St.) *Gray Mansion* (457 Court St.) *El Reno homes* (711 Mount Rose St.)
Ionic columns - column with a fluted style originating in Turkey (Ionian Greece), distinguished by thick, flaring scrolls (volutes) at the capital	*Reno National Bank/Harrah's* (204 N. Virginia St.) *Twaddle Mansion* (485 West Fifth St.)
mansard roof - roof with two slopes on all four sides, often with dormers for an attic set into each side; often seen in Second Empire style buildings	*Morrill Hall* (UNR, near South Entrance)
Palladian – named after Palladio, 16th century Italian designer of classical sets of windows and doors in villas, consisting of central, top-arched portion flanked by rectangular windows	*McCarthy-Platt House* (1000 Plumas St.) *Howell House* (448 Hill St.) *Twaddle Mansion* (485 West Fifth St.)

TERM AND DEFINITION	RENO EXAMPLES
parapet – extension of a masonry or frame wall above the roof line on the front of a building.	*Lincoln Hall, Manzanita Hall* (UNR) *Mt. Rose School* (925 Lander St.) *McKinley Park School* (925 Riverside Dr.) *Artists' Co-Op* (627 Mill St.)
pediment – a triangular gable defined by the crown molding at the bottom edge of a gabled roof and the horizontal line between the eaves, often used over doors and windows in Classical Greek or Queen-Anne Style homes and grand public buildings	*Tyson House* (242 West Liberty St.) *Levy Mansion* (121 California Ave.) *Howell House* (448 Hill St.) *Washoe County Courthouse* (117 South Virginia St.) *Twaddle Mansion* (485 West Fifth St.) *Lear Theatre* (501 Riverside Dr.)
pilaster – a flat column attached to surface of a building, often as a doorway or window frame	*Howell House* (448 Hill St.) *Twaddle Mansion* (485 West Fifth St.)
porte cochère – from French for "coach door," a covered area attached to a house at the front door for protection from rain or snow when exiting a carriage or car	*Cantlon House* (565 Reno Ave.)
portico – a covered porch, with a small roof projecting over a door, supported by columns or posts	*Washoe County Courthouse* (117 South Virginia St.) *Lear Theater* (501 Riverside Dr.) *Howell House* (448 Hill St.) *Giraud/Hardy House* (442 Flint St.) *Lear Theatre* (501 Riverside Dr.)
quoin – dressed or finished stones (or facsimiles thereof) at the corners of a masonry building, often used in Classical and Mediterranean designs	*Riverside Hotel* (17 South Virginia St.) *Lear Theatre* (501 Riverside Dr.) *Washoe County Courthouse* (117 South Virginia St.) *Reno National Bank* (204 N. Virginia St.) *Cantlon House* (565 Reno Ave.) *St. Thomas Aquinas Cathedral Complex* (301 West Second St.) *Lear Theatre* (501 Riverside Dr.) *Morrill Hall* (UNR)

TERM AND DEFINITION	RENO EXAMPLES
terra cotta ornamentation – baked, lustrous clay material similar to brick but usually shaped in form of decorative tiles, garlands, friezes, soffit, rosettes, etc.	*Reno Main Post Office* (50 South Virginia St.) *El Cortez Hotel* (239 West Second St.) *Southside School Annex* (190 E. Liberty St.) *Riverside Hotel* (17 South Virginia St.)
vernacular – indigenous, characteristic of a locality; refers to homes or buildings typical of a certain geographical area but not representative of a particular formal style; also refers to buildings not designed by a trained architect	*Bartley Ranch Regional Park* (6000 Bartley Ranch Rd.): old barn and outbuildings, old Huffaker School, including the new Western Heritage Center, which represents the green-roofed, white ranch houses once found all over the Truckee Meadows *Caughlin Ranch House* (3636 Mayberry Dr.) & Lake Mansion (250 Court St.), representing 18th century homes typically built in western mining towns *Hill/Redfield House* (370 Mount Rose St.) and other cobblestone homes in Old Southwest, showing use of unique materials found on site

⁂ Appendix B ⁂
Reno's Unique Architectural History

The 1995 publication, ***City of Reno Historic Structures Handbook***,[1] contains an excellent overview of the evolution of Reno's unique architectural history, which is quoted here in its entirety:

General Reno History

"The City of Reno has a very colorful, albeit curious past. Settled as a river crossing in 1860 by Myron Lake, Reno has served as a link between Nevada's rich mines and Northern California's generous supply centers. The area has been characterized by a pattern of slow, even growth which responded to the housing needs of residents involved in mining and ranching throughout the late 19th and early 20th centuries. In the early 1900s, Reno, experienced a stronger growth pattern as two new industries, gambling and divorce, gained popularity.

The families who had relocated to Reno began to settle permanently. They opened businesses and entered new professions. The growing city complemented the strong economic base provided by the gambling and divorce industries. This, in turn, enabled the city to develop in an orderly fashion. The architectural heritage of Reno demonstrates the growth, evolution, and change experienced for more than one hundred years.

There are many Period Revival buildings throughout the city which showcase Reno's inherent character. These buildings include various architectural styles, such as Tudor, European Cottage and Colonial and Mission/Spanish Revival.

Buildings constructed between 1900 and 1950 are characterized by features that appear to be indigenous to Reno. The primary exterior building material for historic structures of this period is masonry, such as brick, river rock and stone. Reno's architectural diversity varies in size from small, simple buildings like bungalows to large complex structures. The result was a type of stylistic evolution that was atypical of architectural styles in the rest of the country. This transformation is represented by the Queen Anne, Bungalow, Craftsman, Mission/Spanish and Colonial Revival styles. The use of brick, coupled with variations to window treatments, appears to have been a characteristic trademark of local builders.

Reno Architects

The unique architectural heritage in Reno is attributed not only to the local builders, but also to the local architects who were responsible for the design of its rich architectural diversity.

Finally

Turn of the century buildings still exist today and provide a glimpse of an earlier time in contrast to the styles of today. These buildings defined Reno's character long before Reno was known for gambling and quick divorce. Changing economic patterns and commercial zoning

have transformed many residential areas. The preservation of the remaining historic buildings is important because of their contribution to the rich historical character of Reno.

Historic structures are, by their very nature, non-renewable because the craftsmanship and fabrication processes that created these treasures are no long available or are cost prohibitive. These resources should, therefore, be maintained for future generations whenever possible. Owning an historic building is like owning an important piece of Reno's history. Each individual historic resource is an integral part of the heirloom patchwork quilt that has made Reno "The Biggest Little City in the World." Please take good care of your piece of our history."

The following descriptions of the diverse historical architectural styles to be found in Reno's houses and buildings are excerpted from the City of Reno handbook just cited, as well as from Virginia and Lee McAlester's, *A Field Guide to American Houses* (Knopf, New York, NY, 1984). [2]

❧ Appendix C ❧
Major Architectural Styles Found in Reno

NAME	DESCRIPTION	LOCAL EXAMPLE
Art Deco **Art Moderne** **Modernistic**	Based on artifacts discovered in an Egyptian king's tomb in the 1920s, this style was popularized at the Exposition des Artes Decoratifs in Paris, France. It soon became common in American public and commercial buildings in the 1920s-1930s (e.g., New York's Empire State and Chrysler buildings). Walls are smooth, usually of stucco, and carry zigzags, chevrons, and other stylized geometric motifs, of brushed metal. Glass block and round windows are common, and roofs are streamlined.	*Reno Main Post Office* (50 South Virginia St.) *El Cortez Hotel* (239 West Second St.) *Southside School Annex* (190 East Liberty St.) *El Reno Apartments* (711 Mount Rose St.)
Beaux Arts	This elaborate, eclectic style includes quoins, pilasters, paired columns, symmetrical façades, rusticated stonework with exaggerated joints, and either mansard roof or hipped roof. Many American banks, stock exchanges, universities, mansions, and courthouses of the early 1900s were built in this style.	*Washoe County Court House* (117 South Virginia St.)
Carpenter Gothic **Gothic Revival**	Two of the many "Victorian" styles of houses, Carpenter Gothic and Gothic Revival use elements such as pointed arch windows and gables, Carpenter Gothic embodies "gingerbread" trim carefully crafted by master carpenters. Stone and concrete buildings resemble medieval castles, with buttresses, steep roofs, and ramparts.	*Longley/Beidelman/Capurro Ranch* (6450 Quail Manor Ct.) *Borland/Clifford House* (339 Ralston St.) *Trinity Episcopal Church* (200 Island Ave.) *First Methodist Church* (201 West First St.)

NAME	DESCRIPTION	LOCAL EXAMPLE
Classical **Classical Revival** **Greek Revival** **Neo-Classical**	Based on early Greek and Roman temples and monuments, these symmetrical styles utilize Doric, Corinthian, and Ionic columns, pilasters, and pediments to create a tall, dominant aspect for a large, prominent mansion or public building. Quoins, dentils, and closed rafters are common. Exterior siding is of brick, stucco, or clapboard. The roof is usually hipped or side-gabled.	*Levy Mansion* (121 California Ave.) *Giraud/Hardy House* (442 Flint St.) *McCarran Mansion* (401 Court St.) *Washoe County Courthouse* (117 South Virginia St.) *Nixon Mansion* (631 California Ave.) *Reno National Bank* (204 North Virginia St.)
Colonial Revival **Georgian** **Neo-Colonial**	These styles are reincarnations of America's earliest homes, characterized by hipped or Dutch gambrel roofs, large porches or porticos, Palladian windows with shutters, pediments, elaborate doorways with Ionic or Corinthian columns or pilasters, balustrades on upper porches, massive, multiple chimneys, and gabled dormers.	*Hawkins House* (549 Court St.) *Giraud/Hardy House* (442 Flint St.) *Lora J. Knight House* (615 Jones St.) *Twaddle Mansion* (485 West Fifth St.) *Peleg Brown Ranch* (12945 Old Virginia Rd.) *Howell House* (448 Hill St.) *Garvey House* (589 California Ave.) *ATO Fraternity House* (205 University Terrace)
Craftsman/Bungalow	Often combined into one style, the Craftsman and Bungalow styles both became popular in the early 1900s in California and spread widely across America through the use of pattern books and magazines. A product of the Arts and Crafts movement, these small homes are the dominant style in older neighborhoods in Reno and Sparks, where families once spent summer evenings on their generous porches, visiting with their neighbors. Low-pitched gables, deep overhanging eaves, wide front porches supported by square or tapered columns, and	*Phillips Ranch/Arlington Nursery* (1907 South Arlington Ave.) *Billinghurst Home* (729 Evans Ave.) Numerous homes in Old Southwest and Old Northwest

NAME	DESCRIPTION	LOCAL EXAMPLE
Craftsman/Bungalow, cont.	walls of clinker bricks (hand-crafted), stucco, wood, or stone accented with decorative timbers characterize this style. The front door is often centered between two large façade windows of three parts, with large panes and multiple lights. Bungalow windows and doors tend to be rectangular, while Craftsman windows and doorways are often arched. Interiors feature extensive built-in wooden bookcases, window seats, and china cabinets.	
English Cottage **Cotswold Cottage** **French Rural**	Based on small, rustic farmhouses and cottages seen by American soldiers in France and England in WWI and WWII, these Reno homes used brick and river rock and steep slate or shingle roofs to create a quaint country cottage-look. Usually a large chimney and one front-facing gable dominate the façade, often with a curve-top front door. Italian masons often created the decorated brick motifs on the chimneys and front walls.	*Russell Mills Cottage* (803 Nixon Ave.) *W. E. Barnard House* (950 Joaquin Miller St.) *Greystone Castle* (970 Joaquin Miller St.) *DeLongchamps Cottage* (4 Elm Court) *Hill/Redfield House* (370 Mount Rose St.)

NAME	DESCRIPTION	LOCAL EXAMPLE
French Eclectic	The high-pitched, massive hipped roof, symmetrical lines, and round, castle-like towers are the most characteristic elements of this style.	*Cantlon House* (565 Reno Ave.)
French Second Empire	This heavily embellished revival of French Baroque was popularized by Napoleon III, during France's "Second Empire" (1852-70). The mansard roof (usually slate or black sheets of zinc) with dormer windows on steep lower slopes and molded cornices plus towers and cupolas are trademarks of this design.	*Morrill Hall* (UNR) (also: Capitol Building in Carson City and Fourth Ward School in Virginia City)
Italianate	Typified by U-shaped hoods over windows, flat roofs, distinctive corner quoins, and ornate bracketed cornices under the roof line, this Italian-villa style was popular in the mid 1800s.	*Reno Masonic Hall* (98 West Commercial Row) *Reno Savings Bank*/Oddfellows' Hall (195 North Virginia St.) *Lake Mansion* (250 South Arlington)
Queen Anne	The last of the many "Victorian" styles of the 19th century, Queen Anne style houses are large, usually multi-storied, distinguished by their asymmetrical rooflines, classical porches, balconies, and wide verandas with column supports, often decorated with bright colors and variety of exterior wall textures (brick, stone, shingles, clapboard). Windows are large and numerous, often including stained glass accents, and include casement and as well as Palladian and bay windows and insets of	*Newlands Mansion* (7 Elm Court) *Francovich House* (557 Washington St.) *Arrizabalaga/Upson House* (937 Jones St.) *Tyson House* (242 West Liberty St.) *Nortonia Boarding House* (150 Ridge St.) *Roy Frisch House* (247 Court St.) *Patrick Ranch House* (1225 Gordon Ave.) *McCarthy/Platt House* (1000 Plumas St.)

NAME	DESCRIPTION	LOCAL EXAMPLE
Queen Anne, cont.	all shapes. Rounded turrets borrowed from French chateaux and huge, medieval-style chimneys are common.	*Wanamaker/Mapes Mansion* (1501 South Arlington Avenue)
Shingle	Another type of Victorian era style, this is a free-form adaptation of the Queen Anne style, utilizing shingles and decorative stone to cover the exterior walls and sometimes curved roofs, dormers, and turrets.	*Newlands Mansion* (7 Elm Court)
Spanish	American mixture of styles: Moorish, Byzantine, Gothic, and Renaissance, found in homes, buildings, and Santa Fe and Southern Pacific railway depots and hotels of the late 1800s. Colonnades and arcades shade walkways, while decorative insets include quatrefoil windows and motifs. Typical are low-pitched, red tiled roofs with exposed beams inside and out, curved, scrolled parapets, Roman arch doors and windows, round towers, wrought iron railings, hooded chimneys, and stucco exteriors.	*Mount Rose School* (925 Lander St.) *McKinley Park School* (925 Riverside Dr.) *Humphrey House* (467 Ralston St.) *Nixon Mansion* (631 California Ave.) *California Building* (Idlewild Park)
Stick	Known for their façades of decorative "sticks" of wood, these "Victorian" houses often have elaborate patterns covering most of the exterior walls, often in geometric designs.	*Gray Mansion* (457 Court St.)

NAME	DESCRIPTION	LOCAL EXAMPLE
Tudor	Ranging from thatch-roofed folk cottages to grand manor homes, this late Medieval English-based style typically has steep overlapping gables, parapets, casement windows with diamond-shaped mullions, stone or stucco walls with half-timbers or stones arranged in patterns, stone quoins, and multiple massive chimneys.	*Graham House* (548 California)
Victorian	See Carpenter Gothic, Gothic Revival, and Queen Anne, above.	

☙ Appendix D ❧
Prominent Reno Architects

DeLongchamps, Frederic (1882-1969)

This prominent Reno architect designed many fine private homes and notable public buildings around Northern Nevada, over 500 in all. Born in Reno and educated in mining engineering at the University of Nevada, his health required a less rigorous career. After serving a brief apprenticeship in San Francisco, he returned to Reno. His first public project was the 1910 Washoe County Courthouse, the first of seven Nevada courthouses over his lifetime, including the round Pershing County Courthouse in Lovelock. His styles included Beaux Arts, Neoclassical, Gothic Revival, and Art Deco, exemplifying a career attuned to the latest fashions in architecture while characterized by his own unique style. Note: On the cornerstone of the Washoe County Courthouse, his name is spelled slightly differently. After completing this structure, he changed the spelling of his last name when relatives discovered the correct spelling of the family name. George O'Brien was a partner in the firm.

Partial List of Designs
Buildings
Washoe County Courthouse (117 South Virginia St.)
Reno National Bank (204 North Virginia St.)
State Mental Hospital (Sparks)
Downtown Post Office (50 South Virginia St.)
Riverside Hotel/artists lofts (17 South Virginia St.)
St. Thomas Aquinas Rectory and School
 (310 West Second St.)
Nevada-California-Oregon Railroad Depot
 (325/401 East Fourth St.)
California Apartments (45 California Ave.)

University of Nevada, Reno Campus
Mackay Science Hall
Thompson Building
Jones Visitor Center
Frandsen Building

Public Buildings in Other Cities
Pershing County Courthouse (Lovelock)
The Minden Inn (Minden)
Douglas County Courthouse (Minden)
Minden Wool Warehouse/Minden Butter Mfg. Co.
 (Minden)
Supreme Court Building (Carson City;
 now offices of Attorney General)

Private Residences
"Honeymoon Cottage" (4 Elm Court)
Summerfield House (815 Marsh Ave.)
Gibbons/McCarran Mansion (401 Court)
McCarthy/Platt House (remodel; 1000 Plumas St.)
Giraud-Hardy House (442 Flint St.)
Fitzgerald House (123 Mark Twain)
Lora J. Knight Home (615 Riverside Dr.) with George O'Brien.

Erskine, Graham (1911-1991)

The only Reno architect with a doctorate from the University of Rome, Italy, Erskine came to Reno in 1946 and joined Lehman "Monk" Ferris's firm. His first project was Reno High School; perhaps the large interior dome over the main lobby echoes his classical training. Erskine (and his partner Lehman Ferris) designed many public buildings across the state. He also authored the Nevada architect licensing act of 1947.

Partial List of Designs:

Reno High School (395 Booth St.) (with Lehman Ferris)

Wooster High School (1331 East Plumb Lane)
 (with Lehman Ferris)

Hug High School (2880 Sutro St.) (with Lehman Ferris)

College of Education Building, UNR (now Edmund J.
 Cain Hall)

Harolds Club (North Virginia St., now gone)

Nevada Employment Security Division Building
 (Carson City)

Bell Telephone Administration Building (Reno)

Several First Interstate and First National Banks in Reno

Moana Municipal Pool Building (Reno)

Mt. Grant General Hospital (Hawthorne)

Department of Motor Vehicles Building (Carson City)

Sparks City Hall Complex and Fire Station (Sparks)

Ferris, George Ashmead (1859 – 1948)

Educated in Quaker schools and Swarthmore College in Pennsylvania, George Ferris emigrated to California, where he was known as a colorful character. His son Lehman described him as a "gun-slinging sign painter" in his early days who later became an architect. The Ferris family lived in California and Colorado before moving to Reno in 1906. Within a year George was awarded the job of building Nevada's first governor's mansion. He completed the elegant Classic Revival structure on Mountain Street in Carson City in 1909. He was then chosen by the Reno School District to design the "Spanish Quartet," four similar elementary schools of Spanish Mission Revival Style. George and his son Lehman formed an architectural partnership during the late 1920s, but the Depression forced its dissolution. Note: George Ashmead Ferris was not the designer of the Ferris wheel, which was created by George W. G. Ferris, Jr., a one-time resident of Carson City, Nevada.

Partial List of Designs:

Governor's Mansion (Carson City)

Mount Rose School (925 Lander St.)

McKinley Park School (925 Riverside Dr.)

Mary S. Doten School (West Fifth St., now gone)

Orvis Ring School (Evans Ave., now gone)

El Cortez Hotel (239 West Second St.)

Eureka High School (Eureka)

Austin High School (Austin)

Ferris, Lehman "Monk" (1893–1997)

Son of architect George A. Ferris, Lehman studied at UNR and was a member of Alpha Tau Omega (ATO), whose fraternity house he designed in 1929. He worked as an electrician and draftsman in Central Nevada mines before joining his father's firm in 1928. During the Depression, he served as the City of Reno building inspector, where he helped the adoption of the Uniform Building Code, and chaired the first State Architectural Registration Board in 1947. In 1945, he formed a partnership with Graham Erskine and designed many buildings; he died at age 103.

Partial List of Designs:

ATO House (205 University Terrace)
Reno High School (395 Booth St.) (with Graham Erskine)
Wooster High School (1331 East Plumb Lane) (with Graham Erskine)
Hug High School (2880 Sutro St.) (with Graham Erskine)
Nevada Legislative Building (Carson City, now remodeled)
Harolds Club (Virginia St., now gone)

Grey, Elmer (1872 – 1963)

Born in Chicago, Grey was educated in Milwaukee public schools and then served a three-year apprenticeship to architects Ferry & Clas there. By 1904, he had settled in Pasadena as an architect and partner of Myron Hunt. With Hunt, he designed Pasadena's Polytechnic Elementary School, the Beverly Hills Hotel, and the Huntington Art Gallery in San Marino. The partnership was dissolved in 1910, and Grey then was architect of several of the First Churches of Christ, Scientist, and the Pasadena Community Playhouse. He served on the United States' Art Advisory Board for the 1904 Louisiana Purchase Exposition in St. Louis. In 1911, Grey was supposed to build the house (which included the landscaping) at 549 Court Street (the plans are still preserved). The Hawkins House is Grey's only known structure in Reno.

McKim, Mead & White

This New York City firm, formed in 1878, became the largest and most important architectural office in America. Its most famous partner, Stanford White, designed Madison Square Garden, many Fifth Avenue mansions, and several buildings at the University of Virginia. Clarence Mackay chose White to help re-design the University of Nevada Quadrangle and add the Mackay School of Mines building. During the preliminary work on UNR project, the flamboyant White was murdered by a jealous husband, in 1906. Another partner, S. Richardson, completed the designs. The movies *The Girl in the Red Velvet Swing* and *Ragtime* were based on White's life.

Mills, Russell (1892-1959)

The young Russell Mills initially appreniced with Frederic DeLongchamps in the early 1920s, but by 1928 he was designing houses on his own, beginning with his own unique family home at 803 Nixon Ave. He liked the English Cottage Style, with Tudor influences, but also dabbled in other styles, such as the Asian-style Hart House and the Art Deco Veterans Memorial School (which was pre-wired for cable TV before it was even available to the general public in Reno). He served on many professional boards as well as the Reno City Council.

Partial List of Designs:

Russell Mills Family Home (803 Nixon Ave.)
Hart House (1150 Monroe Ct.)
Our Lady of the Snows Catholic Church
 (1138 Wright St.)
Sparks City Hall (431 Prater Way)
Veterans Memorial School (1200 Locust St.)
Brown Elementary School (14101 Old Virginia Rd.)

Parsons, Edward S., Sr. (1907-1991)

Parsons not only built many houses and buildings, but he was also involved in historic preservation of such structures as the Lake Mansion, Bower's Mansion, the State Capitol and St. Theresa's Church in Carson City, UNR's Morrill Hall, the Mizpah in Tonopah, and Piper's Opera House in Virginia City. Parsons also remodeled several of Bill Harrah's residences in Reno and Idaho.

Partial List of Designs:

Centennial Coliseum and Convention Hall (South
 Virginia St. and Kietzke Lane)
Fleischman College of Agriculture and Orvis School of
 Nursing (UNR)
Federal Court House (300 Booth St.)
Nevada State Prison (Carson City)
SAE Fraternity House (835 Evans Ave.)

Schadler, Fred N. (1887-1935)

A German immigrant by way of San Francisco, he designed Georgian Revival homes for several prominent Renoites, as well as public buildings.

Partial List of Designs:

Twentieth Century Club (335 West First St.)
Elks' Club (Sierra St., now gone)
Governor Oddie House (467 Ralston)
Parsons/McGinley House (761 California Ave.)

Williams, Paul Revere (1894-1980)

Williams was born in Los Angeles, studied in the New York Beaux-Arts Institute of Design, earned an engineering degree at USC, and designed over 3,000 projects in southern California, including the Airport, Shrine Auditorium, and Saks Fifth Avenue in Beverly Hills. He was the first Black American architect elected to the AIA College of Fellows. Williams designed several important buildings in Reno, including the El Reno Apartments.

Partial List of Designs:

Luella Garvey House (589-599 California Ave.)
First Church of Christ, Scientist – Lear Theater
(501 Riverside Dr.)
Raphael Herman House, Rancho San Rafael Park
(Northwest Reno)
El Reno Apartments
(originally on South Virginia St.; see Appendix for
addresses)

❧ Appendix E ❧
El Reno Apartments

The original site of the twelve (or possibly more) El Reno Apartments was in the 1200 block of South Virginia Street, where Statewide Lighting now stands. The white and green "little metal houses" were built around 1935 probably in Southern California and brought to Reno on railcars, by developer/landlord Roland Giroux. The units had individual garages along Tonopah Street, to the west. A laundry room with modern washers served the tenants. The stylish little units had board-and-batten metal walls, enclosing 900 square feet. Inside, there were two bedrooms with built-in closets, one and a half baths, a small living room, and a compact kitchen. The front porch of lacey wrought iron and the distinctive eyebrow ventilator and wind turbine on the roof make the El Reno's fairly easy to spot, unless they have been greatly modified (as has happened with a couple of them).

The units were sold and moved off the original site after Giroux tried to raise the rent, which was apparently approved by the tenants but not by the rent control board (a hanger-on from World War II). Reportedly angered by obstinate bureaucracy, Giroux decided to sell them for about $800 each.

For many years, there was a great deal of speculation that the El Reno's were designed by architect Paul Revere Williams, who designed the Lear Theater, the Rancho San Rafael ranch house, and Luella Garvey's house. Now direct proof has been found of a definitive link to Williams. Meanwhile, El Reno expert Karl Breckenridge is still at work, hoping to discover one or two others that might still exist but are now unidentifiable. It is believed that another El Reno was at 545 Skyline Drive, but it has since been demolished. Others may have existed, but the following list shows the ones identified so far.

Addresses:
1. 245 Bonnie Briar Street
2. 711 Mt. Rose Street
3. 1425 Plumas Street
4. 1461 Lander Street (two on one lot)
5. 1409 Tonopah Street
6. 100 West Pueblo Street
7. 1698 Plumas Street
8. 115 Ridge Street (original apartment of Bill and Thelma Harrah)
9. Southeast corner of College Drive and Sierra Street
10. 326 West 11th Street
11. 400 Country Club Drive

⁂ Appendix F ⁂
Chapter Notes

INTRODUCTION

[1] Skorupa, Susan, "Solid as a rock: Reno's stone houses give cool comfort to owners," *Reno-Gazette Journal*, July 9, 2005, pg. 1, 5b.

DOWNTOWN

Introduction

[1] Skorupa, Susan, "A riveting story: Ceremony to honor Reno inventor of Levi's 501 jeans," *Reno Gazette Journal*, May 12, 2006, pg. 1E. Further information can be found on the Levi Strauss website: http://www.levistrauss.com/Heritage/History.aspx

Washoe County Courthouse

[1] Washoe County Clerk's Office, Washoe County Courthouse Historical and Preservation Society, "History of Washoe County Courthouse," retrieved on April 16, 2007, from http://www.washoecountyus.clerks/historical_society.php

[2] Henderson, Mike, "Courthouse regains its color," Reno Gazette Journal, May 9, 2001, pg. 6A.

Riverside Hotel

[1] Lawrence-Dietz, Patricia, National Register of Historic Places Nomination for the Riverside Hotel, 1983, State Historic Preservation Office, Carson City, NV.

[2] Harmon, Mella Rothwell, *Divorce and Economic Opportunity in Reno, Nevada, during the Great Depression*, unpublished Master's thesis, University of Nevada, Reno, Reno, NV, 1998.

Reno Post Office

[1] Schaefer, Michelle A., *United States Postal Service, Historic, Architectural and Archaeological Significance Survey*, 1983, State Historic Preservation Office, Carson City, NV.

Pioneer Theater-Auditorium

[1] Harmon, Mella Rothwell, National Register of Historic Places Nomination for the Pioneer Theater-Auditorium, 2005, State Historic Preservation Office, Carson City, NV.

Southside School Annex

[1] Snyder, Helen, National Register of Historic Places Nomination for the Southside School Annex, 1993, State Historic Preservation Office, Carson City, NV.

National Automobile Museum

[1] "Museum History," National Automobile Museum website, retrieved on June 20, 2006, from http://www.automuseum.org/

Pincolini/Mizpah Hotel

[1] Koval, Ana, and Kathryn Kuranda, National Register of Historic Places Nomination for the Pincolini/Mizpah Hotel, 1984, State Historic Preservation Office, Carson City, NV.

Artists' Coop/French Laundry

[1] Walbridge, Sharon, "Adaptive Reuse, Artfully Done," *Footprints*, Vol. 3, No. 3, Historic Reno Preservation Society, Fall, 2000, pg. 6.

[2] Skorupa, Susan, "40 cooperative years: Artists' gallery to mark anniversary with reunion show," *Reno Gazette Journal*, January 24, 2006, pgs. 1E and 3E.

Amtrak Depot

[1] "The Age of Railroads," Chapter XVIII, History of California Railroads website, retrieved on June 20, 2006, from http://www.usgennet.org/usa/ca/state1/tinkhamch18.htm

[2] Townley, John, *Tough Little Town on the Truckee*, Great Basin Studies Center, Reno, NV, 1983, pgs. 189-208.

[3] "Reno, NV, Station," Caltrans-Amtrak California website, retrieved on June 20, 2006, from http://www.dot.ca.gov/hq/rail/depots/stops/rno.htm

Harolds Club Site

[1] Kling, Dwayne, *The Rise of the Biggest Little City: An Encyclopedic History of Reno Gaming, 1931 – 1981*, University of Nevada Press, Reno and Las Vegas, NV, 2000, pgs. 61 – 73.

Reno National Bank
[1] Rainshadow Associates, National Register of Historic Places Nomination for the Reno National Bank, 1983, State Historic Preservation Office, Carson City, NV.

Reno Savings Bank/Oddfellows' Hall
[1] Townley, John, op. cit., pg. 144.

[2] Harmon, Mella Rothwell, Nevada State Register of Historic Places Nomination for the I.O.O.F. Lodge/Reno Bank Building, 2003, State Historic Preservation Office, Carson City, NV.

Mapes Hotel Site
[1] Rocha, Guy, "Reno's Mapes rose after World War II," *Reno Gazette Journal*, January 22, 2006, retrieved on December 5, 2005, from http://news.rgj.com/apps/pbcs.dll/article?AID =/20060122/CP:17/601220304/1120/LIV.

[2] Cafferata, Patty, *Mapes Hotel and Casino: The History of Reno's Landmark Hotel*, Eastern Slope Publishers, Reno, NV, 2005, pgs. 38 – 43.

First United Methodist Church
[1] Hinman, Debbie, "The Gray Lady of West First Street," *Footprints*, Vol. 8, No. 2, Spring, 2005, pg. 4.

[2] Boghosian, Paula, National Register of Historic Places Nomination for the First United Methodist Church, 1984, State Historic Preservation Office, Carson City, NV.

[3] Hinman, op. cit., pg. 5.

Twentieth Century Club
[1] Letter to Max Fleischman Foundation of Nevada, August 15, 1961, Document No. NC 9, 34/2, Special Collections/Archives, University of Nevada, Reno, Library, Reno, NV.

[2] Boghosian, Paula, National Register of Historic Places Nomination for the Twentieth Century Club, 1983, State Historic Preservation Office, Carson City, NV.

[3] Breckenridge, Karl, "The Twentieth Century Club: Reno's first hot spot," *Reno Gazette Journal*, July 23, 2006, pg. 6A.

St. Thomas Aquinas Cathedral Complex
[1] Boghasian, Paula, National Register of Historic Places Nomination for the St. Thomas Aquinas Cathedral Complex, 1983, State Historic Preservation Office, Nevada State Museum, Carson City, NV. NOTE: The Diocese chose not to proceed with its placement on the National Register.

[2] Walbridge, Sharon, and Carole Coleman, "Reno's Catholic Churches, A Trial by Fire," *Footprints*, Vol. 9, No. 1, Historic Reno Preservation Society, Winter, 2006, pgs. 5-6.

El Cortez Hotel
[1] Coleman, Carol, "On the National Register of Historic Places: The El Cortez Hotel," Footprints, Vol. 7, No. 1, Historic Reno Preservation Society, Winter, 2004, pg. 7.

[2] Koval, Ana B., and Katharine Boyne, National Register of Historic Places Nomination for the El Cortez Hotel, 1984, State Historic Preservation Office, Carson City, NV.

[3] Rowley, William, *Reno: The Hub of the Washoe Country*, Windsor Publications, Inc., Woodland Hills, CA, 1984, pg. 70.

Trinity Episcopal church
[1] "A Tour of Our Church Home," Trinity Episcopal Church, undated brochure.

[2] Check the Church's website for schedules: http://www.trinity-reno.com

WEST COURT STREET/ARLINGTON AVENUE

Gibbons/McCarran Mansion
[1] IntoHomes Mortgage Services, "The McCarran Mansion," brochure, 2005.

[2] Hopkins, A. D., "Pat McCarran: Perennial Politician; The First 100," *Las Vegas Review-Journal*, retrieved on December 2, 2005, from http://www.1st100.com/part2/mccarran.html

Gray Mansion
[1] Kuranda, Kathryn, and Ron James, National Register of Historic Places Nomination for the Joseph Gray Mansion, 1984, State Historic Preservation Office, Carson City, NV.

[2] Truckee-Donner Historical Society, Inc., "Uncle Joe's Cabin: Truckee's First Building," retrieved on December 2, 2005, from http://truckeehistory.tripod.com/history9.htm

Hawkins House
[1] Delaplane, Gaye, "Restoration: The stately Hawkins House has found yet another identity," *Reno Gazette-Journal*, September 11, 1998, pg. 6D.

[2] Loomis, Suzanne M., National Register of Historic Places Nomination for the Hawkins House, 1979, State Historic Preservation Office, Carson City, NV.

Newlands Mansion

[1] Snell, Charles W., National Survey of Historic Sites and Buildings Nomination for the Senator Francis G. Newlands Home, 1962, National Park Service, U. S. Department of the Interior, State Historic Preservation Office, Carson City, NV.

[2] Townley, John, op. cit., pg. 184.

[3] *Reno Gazette Journal*, "Surprises accompany mansion's restoration," December 31, 1985, pg. D1.

Frederic Delongchamps's Honeymoon Cottage

[1] Delaplane, Gaye, "One man's cottage is…Another man's castle," *Reno Gazette-Journal*, Sierra Living Section, March 22, 1996, pgs. 1, 6, & 7.

[2] Personal interview with Mr. High, June, 2006.

LIBERTY STREET

Frisch House

[1] Land, Barbara and Myrick, *A Short History of Reno,* University of Nevada Press, Reno, NV, 1995, pgs. 40 – 42.

[2] Rowley, William D., op. cit., pg. 57.

[3] Personal interview, Theresa Frisch, August, 2006.

Lake Mansion

[1] VSA Arts offers art workshops and camps, plus exhibits. The Mansion is open for tours or special events (go to http://www.VSAnevada.org).

[2] O'Malley, Jaclyn, "Truck tows historic home to its new neighborhood," *Reno Gazette-Journal,* July 12, 2004, pgs. 1A & 8A.

[3] Zimmer, Ethel, "The Turrillas home, constructed in '77, still remains as one of Reno's finest," *Nevada State Journal,* March 10, 1957, pg. 8.

Nortonia Boarding House

[1] Harmon, Mella Rothwell, "Housing Reno's 1930s Divorce Trade," *Footprints*, Vol. 9, No. 2, Historic Reno Preservation Society, Spring, 2006, pg. 103.

[2] Boghosian, Paula, National Register of Historic Places Nomination for the Nortonia Boarding House, 1982, State Historic Preservation Office, Carson City, NV.

Howell House

[1] Handout furnished by current owners David P. Sinai and Theodore J. Schroeder.

[2] Junior League of Reno, *So this is Reno: An Invitation from the Junior League of Reno to take a walking or driving tour through the historic Newlands Heights District*, brochure printed by Dickson Realty, Reno, NV, undated.

Giraud/Hardy House

[1] National Register of Historic Places, "Joseph Giraud House: Three Historic Nevada Cities: Carson City, Reno, Virginia City: A National Register of Historic Places Travel Itinerary," retrieved on December 2, 2005, from http://www.cr.nps.gov/nr/travel/nevada/jos.htm.

[2] Boghosian, Paula, and Pat Lawrence-Dietz, National Register of Historic Places Nomination for the Giraud/Hardy House, 1985, State Historic Preservation Office, Carson City, NV.

[3] Simone, Anne, Joan Collins, and Helen Hardy Mills, "The Giraud-Hardy House, 442 Flint Street, Reno," *Footprints*, Vol. 6, No. 1, Winter, 2003, pg. 3.

[4] Glass, Mary Ellen, *Nevada's Turbulent 50s,* University of Nevada Press, Reno, NV, 1981, pgs. 61 – 71.

Levy House

[1] Boghosian, Paula, National Register of Historic Places Nomination for the Levy House, 1983, State Historic Preservation Office, Carson City, NV.

[2] Breckenridge, Karl, "The Levy Mansion finale," *Reno Gazette-Journal,* September 1, 2001, pg. B8.

Nevada Museum of Art

[1] See Bruder's website at http://www.willbruder.com, for further details.

[2] Sonner, Scott, "Reno gambling on allure of mysterious black box," retrieved on December 3, 2005, from http://www.HonoluluAdvertiser.com.

[3] There's also an elevator.

[4] Ingf, Steven, "A new art landmark for Nevada," retrieved on December 3, 2005, from http://www.tahoequarterly.com.

[5] Nevada Museum of Art, "Mission and History: Nevada Museum of Art," retrieved on June 20, 2006, from http://www.nevadamuseumofart.org.

[6] See Chapter 2.

Tyson House

[1] Boghosian, Paula, National Register of Historic Places Nomination for the Tyson House, 1983, State Historic Preservation Office, Carson City, NV.

CALIFORNIA AVENUE

Introduction

[1] Willis, Glee, "Family Bike Tour of the Historic Buildings of Downtown Reno," retrieved on December 2, 2005, from http://unr.edu/homepage/willis/longhistoric.html

[2] Historic Reno Preservation Society, *725 California Avenue*, brochure produced for Mansions on the Bluff Open House Event, 2002.

[3] (a) Willis, op. cit.; (b) Historic Reno Preservation Society, *761 California Avenue*, brochure produced for Mansions on the Bluff Open House Event, 2002.

Graham House

[1] Rowley, William, *Reno: The Hub of the Washoe Country*, Windsor Publications, Inc., Woodland Hills, CA, 1984, pg. 57.

[2] See the history of the Roy Frisch home in Chapter 3.

[3] Leland, Joy, National Register of Historic Places Nomination for the William Graham House, 1983, State Historic Preservation Office, Carson City, NV.

Luella Garvey House

[1] Harmon, Mella Rothwell, National Register of Historic Places Nomination for the Luella Garvey House, 2003, State Historic Preservation Office, Carson City, NV.

[2] See KNPB, Channel 5's "House with a History" program regarding the Garvey House for a close-up look at the home's architectural details, available in DVD format at http://www.knpb.org/productions/house/default.asp

[3] See Chapter 6.

[4] Historic Reno Preservation Society, "On the Historic Register, theLuella Garvey House," *Footprints,* Vol. 7, No. 3, Summer, 2004. pg. 4.

Nixon Mansion

[1] Rocha, Guy, and Dennis Myers, "The Wild Bunch in Winnemucca," Historical Myth a Month Series, Nevada State Archives, Carson City, NV, retrieved on December 18, 2005, from http://www.dmla.clan.lib.nv.us/DOCS/NSLA/archives/myth

California Building

[1] Skorupa, Susan, "75 years in Idlewild Park: Built to honor the Golden State, the California Building now symbolizes the history of Reno," *Reno Gazette-Journal,* October 29, 2002, pg. E1.

[2] Earl, Phillip, "The California Building," State Historic Preservation Office, Carson City, NV, 1992.

OLD SOUTHWEST

Introduction

[1] Townley, John, op. cit., pg. 236.

[2] Townley, John, op. cit., pg. 237.

[3] Hinman, Debbie, "A street by any other name," *Footprints,* Vol. 9, No. 1, Historic Reno Preservation Society, Winter, 2006, pg. 8.

[4] Harmon, Mella Rothwell, "Bringing water to the Truckee Meadows: The Ditches," *Footprints,* Vol. 7, No. 2, Historic Reno Preservation Society, Spring, 2004, pg. 2.

McCarthy/Platt House

[1] Koval, Ana, and Patricia Lawrence-Dietz, National Register of Historic Places Nomination for the McCarthy/Platt House, 1984, State Historic Preservation Office, Carson City, NV.

Mount Rose School

[1] Elliott, Russell R., and William D. Rowley, *History of Nevada*, University of Nebraska Press, Second Edition, Revised, 1987, Lincoln, NE, pgs. 404 – 405.

[2] Wood, Kimberly, National Register of Historic Places Nomination for the Mount Rose School, 1977, State Historic Preservation Office, Carson City, NV.

El Reno Apartments

[1] Breckenridge, Karl, *You're Doing WHAT to the Mapes?* Jack Bacon & Company, Reno, NV, 2005, pgs. 93 – 100.

[2] Sievers, Linda, and Debbie Hinman, "Reno's El Reno Apartments," *Footprints,* Vol. 7, No. 3, Historic Reno Preservation Society, Summer, 2004, pg. 1.

[3] See Chapter 4.

[4] See Chapter 6.

Hill/Redfield Mansion

[1] Lynn Coins, "La Vere Redfield: The Secret Stash of Silver Dollars," retrieved on December 2, 2005, from http://lynncoins.com/redfield.htm

[2] Breckenridge, Karl, "South Virginia's Nevada Stock Farm," *Reno Gazette-Journal,* Homefinder Section, January 28, 2006, pg. 10.

[3] Koval, Ana, and Patricia Lawrence-Dietz, National Register of Historic Places Nomination for the Hill/Redfield Mansion, 1984, State Historic Preservation Office, Carson City, NV. NOTE: The house was never placed on the National Register.

Wanamaker/Mapes "Chateau"

[1] Delaplane, Gaye, "Mapes Mansion sold to Kansas family for undisclosed sum," *Reno Gazette-Journal,* July 22, 2000, pg. 1C.

[2] Cafferata, Patty, *Mapes Hotel and Casino: The History of Reno's Landmark Hotel,* Eastern Slope Publisher, Reno, NV, 2005, pg. 9.

Phillips Ranch/Arlington Nursery

[1] Townley, John, op. cit., pg. 237.

[2] Loomis, Suzanne, Barbara Moreland, and Betty Hendrickson, National Register of Historic Places Nomination for the Phillips/Arlington Nursery, 1981, State Historic Preservation Office, Carson City, NV.

Patrick Ranch

[1] Delaplane, Gaye, "Our Old House," *Reno Gazette-Journal,* July 20, 2000, pgs. D1-2.

[2] Southerland, Cindy, National Register of Historic Places Nomination for the Patrick Ranch House, 2003, State Historic Preservation Office, Carson City, NV.

Russell Mills Cottage

[1] Simone, Anne, "Architect Russell Mills," *Footprints,* Vol. 9, No. 1, Historic Reno Preservation Society, Winter, 2006, pg. 4.

Hart House

[1] Carr, Marla, *The Hart House,* "House with a History" series produced by KNPB Television, Reno, NV, retrieved on January 23, 2006, from http://www.knpb.org/productions/house/default.asp

[2] KNPB Television, "No Hands on the Clock," "House with a History" series produced by KNPB Television, Reno, NV, retrieved on January 23, 2006, from http://www.knpb.org/productions/house/default.asp.

Cantlon House

[1] De la Garza, Mercedes, Scott Gibson, and Anne McCarty, *A walking tour of the Newlands Neighborhood* by HRPS Members, brochure, Historic Reno Preservation Society, ca. 2000.

[2] Sage, Roderick D., "Cantlon, Edwin: A surgeon cowboy rides down memory lane," Oral History Interview, Oral History Program, University of Nevada, Reno, 1998, Special Collections, University of Nevada, Reno, Reno, NV.

[3] McAlester, Virginia and Lee, *A Field Guide to American Houses,* Knopf, New York, NY, 1984, pgs. 388-89.

Barnard House and Greystone Castle

[1] KNPB Television, "Greystone Castle/Barnard House." "House with a History" series produced by KNPB Television, Reno, NV, retrieved on January 24, 2006, from http://www.knpb.org/productions/house/default.asp.

[2] Harmon, Mella Rothwell, State Architectural Historian, quoted in Lenita Powers, "Two Reno houses granted historic registration," *Reno Gazette-Journal,* September 8, 2002, pg. C1.

[3] Harmon, Mella Rothwell, National Register of Historic Places Nomination for Greystone Castle and the W. E. Barnard House, 2002, State Historic Preservation Office, Carson City, NV.

OLD NORTHWEST

Introduction

[1] Sievers, Linda, "HRPS Focus: C. C. Powning and the Powning Addition," *Footprints,* Vol. 7, No. 1, Historic Reno Preservation Society, Winter, 2004, pg. 3.

[2] *A Walk through Time: The Historic Powning's Addition in Reno, Nevada,* Historic Reno Preservation Society, Reno, NV, 2004, pgs. 4-5.

[3] Harmon, Mella Rothwell, National Register of Historic Places Nomination for the Nystrom Guest House, 2000, State Historic Preservation Office, Carson City, NV.

[4] Townley, John, op. cit., pgs. 158-160.

[5] Hinman, Debbie, "Hillside Cemetery, 1875 – 2005," *Footprints,* Vol. 9, No. 1, Historic Reno Preservation Society, Winter, 2006, pgs. 1–3.

Borland/Clifford House

[1] Jahn, Loren, and Jack Hursh, Jr., [and Tammy Buzick], "Carpenter gothic Country Houses of Northern Nevada," *Footprints,* vol. 9, No. 2, Spring, 2006, pgs. 8 – 9.

[2] Boghosian, Paula, National Register of Historic Places Nomination for the Borland/Clifford House, 1983, State Historic Preservation Office, Carson City, NV.

Humphrey House

[1] Boghosian, Paula, National Register of Historic Places Nomination for the Humphrey House, 1983, State Historic Preservation Office, Carson City, NV.

Twaddle Mansion

[1] Boghosian, Paula, National Register of Historic Places Nomination for the Twaddle Mansion, 1983, State Historic Preservation Office, Carson City, NV.

[2] ibid.

Francovich House

[1] Boghosian, Paula, and Pat Lawrence-Dietz, National Register of Historic Places Nomination for the Francovich House, 1983, State Historic Preservation Office, Carson City, NV.

[2] Dick Eastman Online, "Yugoslavian Descendants Create Business from Family Recipe," retrieved on December 2, 2005, from http://www.ancestry.co/learn/library/article.aspx?article=65040&print=1

B. D. Billinghurst Home

[1] Historic Reno Preservation Society, "On the National Register of Historic Places: The B. D. Billinghurst Home, 729 Evans Avenue," *Footprints,* Vol. 6, No. 1, Winter, 2003, pg. 5.

[2] Historic Reno Preservation Society, "B. D. Billinghurst Junior High School," *Footprints,* Vol. 6, No. 1, Winter, 2003, pg. 4.

[3] Earl, Phillip I., National Register of Historic Places Nomination for the Billinghurst Home, 1974, State Historic Preservation Office, Carson City, NV.

First Church of Christ, Scientist/Lear Theater

[1] Harmon, Mella Rothwell, National Register of Historic Places Nomination for the First Church of Christ, Scientist/Lear Theater, 1999, State Historic Preservation Office, Carson City, NV.

[2] Walbridge, Sharon, "The story behind the Lear Theater," *Footprints,* Vol. 6, No. 2, Historic Reno Preservation Society, Spring, 2003, pg. 5.

Lora J. Knight House

[1] Scharmer, Roger P., National Register of Historic Places Nomination for the Lora J. Knight House, 1983, State Historic Preservation Office, Carson City, NV.

[2] Anglen, Robert, "Experts will have no say in landmark's alterations," *Reno Gazette-Journal,* September 11, 1998, pgs. C1,8.

McKinley Park School

[1] Townley, John, op. cit., pgs. 210- 211.

[2] McAlester, Virginia and Lee, op. cit., pg. 409.

[3] Wood, Kimberly, National Register of Historic Places Nomination for McKinley Park School, 1977, State Historic Preservation Office, Carson City, NV.

Upson/Arrizabalaga House

[1] Coleman, Carol, "Update on 937 Jones, the Arrizabalaga or Upson House," *Footprints,* Vol. 7, No. 1, Winter, 2004, pg. 8.

[2] Harmon, Mella Rothwell, National Register of Historic Places Nomination for the Upson/Arrizabalaga House, 2003, State Historic Preservation Office, Carson City, NV.

[3] Personal communication, Joan Arrizabalaga, October 2006.

ATO House
[1] Historic Reno Preservation Society, "On the Historic Register, the ATO House," *Footprints,* Vol. 7, No. 3, Summer, 2004, pg. 5.

[2] Harmon, Mella Rothwell, National Register of Historic Places Nomination for the ATO Fraternity House, 2003, State Historic Preservation Office, Carson City, NV.

UNIVERSITY OF NEVADA, RENO

Introduction
[1] Hamby, Mary Beth, et al., National Register of Historic Places Nomination for the University of Nevada, Reno, Historic District, 1986, State Historic Preservation Office, Carson City, NV.

[2] University of Nevada: Buildings and Grounds, Book of Views, 1908, Archive No. 27, Special Collections, University of Nevada, Reno, NV.

[3] Crowley, Joe, personal communication, October 2006.

[4] Stone, Leanne, "University of Nevada, Reno, Historic District Walking Tour," June, 2002.

[5] Duffy, Kevin, *Who were the Celts?,* Barnes and Noble, New York, NY, 1996, pg. 199.

[6] Stone, Leanne, op. cit.

[7] Buffalo Architecture and History Organization, "McKim, Mead & White in Buffalo, Buffalo as an Architectural Museum," retrieved on December 1, 2005, from http://ah.bfn.org/a/archs/mck

[8] Stone, Leanne, op. cit.

[9] Stone, Leanne, op. cit.

[10] Stone, Leanne, op. cit.

[11] (a) McDonnell, Patrick, "Campus on the Hill," *Nevada Magazine,* University of Nevada, Reno, September/October 1998; (b) DuVal, Gary, The Nevada Filmography, McFarland & Co., Inc., Jefferson, NC, and London, English, 2002.

Morrill Hall
[1] Hamby, Mary Beth, et al., op. cit.

[2] Simone, Anne, and Carl Coleman, "On the National Register: Morrill Hall," *Footprints,* Vol. 8, No. 2, Historic Reno Preservation Society, Spring, 2005, pg. 6.

Mackay School of Mines
[1] Hamby, Mary Beth, et al., op. cit.

[2] Leanne Stone photographed the process from beginning to end.

Lincoln Hall – Manzanita Hall
[1] Stone, Leanne, op. cit.

[2] Hamby, Mary Beth, et al., op. cit.

Fleischmann Planetarium
[1] Housely, Harold, and Julie Nicoletta, National Register of Historic Places Nomination for the Fleischmann Atmospherium/Planetarium, 1994, State Historic Preservation Office, Carson City, NV.

[2] Stewart, Brandon, "Reaching for the moon … and beyond," Nevada *Silver & Blue,* University of Nevada, Reno, Spring, 2005, pg. 13.

RENO RANCHES

Introduction
[1] Townley, John, op. cit., pg. 271.

Caughlin Ranch
[1] Fine, Linda, "Blast from the Past," *Caughlin Rancher/Reno Gazette-Journal,,* December 2, 2005, pgs. 3 & 8.

[2] Lonie, Shiela. *Crissie Caughlin – Pioneer.*

Buscaglia/Bartley Ranch
[1] Washoe County Parks & Recreation Department, *History: Bartley Ranch Regional Park,* brochure printed by Washoe County Parks & Recreation Department, undated.

[2] Hursh, Jack, Jr., and Loren Jahn, *Truckee Meadows Remembered,* Second Edition, published by Jack Hursh, Jr., 2004.

Old Huffaker School (Bartley Ranch Regional Park)
[1] Washoe County Parks & Recreation Department, *Old Huffaker Schoolhouse,* brochure printed by Washoe County Parks & Recreation Department, Reno, NV, undated.

[2] Townley, John, op. cit., pg. 55.

Longley/Beidelman/Capurro Ranch

[1] Hursh, Jack, Jr., "Truckee Meadows Remembered: A Success Story in Preserving Ranching Culture," *Footprints*, Vol. 8, No. 2, Historic Reno Preservation Society, Spring, 2005, pgs. 1 – 3.

Peleg Brown Ranch

[1] Koval, Ana, and Katharine Boyne, National Register of Historic Places Nomination for the Peleg Brown Ranch, 1994, State Historic Preservation Office, Carson City, NV.

ARCHITECTURAL TERMS

[1] McAlester, Virginia and Lee, *A Field Guide to American Houses*, Knopf, New York, NY, 1984.

[2] City of Reno, *Historic Structures Handbook*, 1995.

⁂ Appendix G ⁂
Bibliography

Anglen, Robert, "Experts will have no say in landmark's alternations," *Reno Gazette-Journal*, September 11, 1998.

Boghosian, Paula, and Patricia Lawrence-Dietz, National Register of Historic Places Nomination for the Giraud/Hardy House, 1985, State Historic Preservation Office, Carson City, NV.

Boghosian, Paula, and Patricia Lawrence-Dietz, National Register of Historic Places Nomination for the Francovich House, 1983, State Historic Preservation Office, Carson City, NV.

Boghosian, Paula, National Register of Historic Places Nomination for the First United Methodist Church, 1984, State Historic Preservation Office, Carson City, NV.

Boghosian, Paula, National Register of Historic Places Nomination for the St. Thomas Aquinas Cathedral Complex, 1983, State Historic Preservation Office, Carson City, NV.

Boghosian, Paula, National Register of Historic Places Nomination for the Twentieth Century Club, 1983, State Historic Preservation Office, Carson City, NV.

Boghosian, Paula, National Register of Historic Places Nomination for the Levy House, 1983, State Historic Preservation Office, Carson City, NV.

Boghosian, Paula, National Register of Historic Places Nomination for the Nortonia Boarding House, 1982, State Historic Preservation Office, Carson City, NV.

Boghosian, Paula, National Register of Historic Places Nomination for the Tyson House, 1983, State Historic Preservation Office, Carson City, NV.

Boghosian, Paula, National Register of Historic Places Nomination for the Borland/Clifford House, 1983, State Historic Preservation Office, Carson City, NV.

Boghosian, Paula, National Register of Historic Places Nomination for the Humphrey House, 1983, State Historic Preservation Office, Carson City, NV.

Boghosian, Paula, National Register of Historic Places Nomination for the Twaddle Mansion, 1983, State Historic Preservation Office, Carson City, NV.

Breckenridge, Karl, "South Virginia's Nevada Stock Farm," *Reno Gazette-Journal*, Homefinder Section, January 28, 2006.

Breckenridge, Karl, "The Levy Mansion finale," *Reno Gazette-Journal*, September 1, 2001.

Breckenridge, Karl, "The Twentieth Century Club: Reno's first hot spot," *Reno Gazette-Journal*, July 23, 2006.

Breckenridge, Karl, *You're Doing WHAT to the Mapes?*, Jack Bacon & Company, Reno, NV, 2005.

Buffalo Architecture and History Organization, "McKim, Mead & White in Buffalo: Buffalo as an Architectural Museum," retrieved on December 1, 2005, from http://ah.bfn.org/a/archs/mck

Cafferata, Patty, *Mapes Hotel and Casino: The History of Reno's Landmark Hotel*, Eastern Slope Publishers, Reno, NV, 2005.

Caltrans-Amtrak California, "Reno, NV, Station," retrieved on June 20, 2006, from http://www.dot.ca.gov/hq/rail/depots/stops/rno.htm

Carr, Marla, KNPB Television, "The Hart House," House with a History series produced by KNPB Television, Reno, NV, retrieved on January 23, 2006, from http://www.knpb.org/productions/house/default.asp

Coleman, Carol, "On the National Register of Historic Places: The El Cortez Hotel," *Footprints*, Vol. 7, No. 1, Historic Reno Preservation Society, Winter, 2004.

Coleman, Carol, "Update on 937 Jones, the Arrizabalaga or Upson House," *Footprints*, Vol. 7, No. 1, Historic Reno Preservation Society, Winter, 2004.

Crowley, Joseph, personal communication, October, 2006.

De la Garza, Mercedes, Scott Gibson, and Anne McCarty, *A walking tour of the Newlands Neighborhood by HRPS Members*, brochure, Historic Reno Preservation Society, ca. 2000.

Delaplane, Gaye, "Mapes Mansion sold to Kansas family for undisclosed sum," *Reno Gazette-Journal*, July 22, 2000.

Delaplane, Gaye, "One man's cottage is...Another man's castle," *Reno Gazette-Journal*, March 22, 1996.

Delaplane, Gaye, "Our Old House," *Reno Gazette-Journal*, July 29, 2000.

Delaplane, Gaye, "Restoration: The stately Hawkins House has found yet another identity," *Reno Gazette-Journal*, September 11, 1998.

Dick Eastman Online, "Yugoslavian Descendants Create Business from Family Recipe," *Ancestry.com: The No. 1 Source for Family History Online* website, retrieved on December 2, 2005, from http://www.ancestry.com/learn/library/article.aspx?article=65040&print=1.

Duffy, Kevin, *Who Were the Celts?* Barnes & Noble, New York, NY.

DuVal, Gary, *The Nevada Filmography*, McFarland & Co., Inc., Jefferson, NC, and London, 2002.

Earl, Phillip, "The California Building," California Building File, State Historic Preservation Office, Carson City, NV, 1992.

Earl, Phillip, National Register of Historic Places Nomination for the B. D. Billinghurst Home, 1974, State Historic Preservation Office, Carson City, NV.

Elliott, Russell R., and William D. Rowley, *History of Nevada*, University of Nebraska Press, Lincoln, NE, Second Edition, Revised, 1987.

Fine, Linda, "Blast from the Past," Caughlin Rancher, *Reno Gazette-Journal*, December 2, 2005.

Frisch, Theresa, personal communication, August, 2006.

Glass, Mary Ellen, *Nevada's Turbulent 50s*, University of Nevada Press, Reno, NV, 1981.

Hamby, Mary Beth, Nancy E. Sikes, and Kathryn M. Kuranda, National Register of Historic Places Nomination for the University of Nevada, Reno, Historic District, 1986, State Historic Preservation Office, Carson City, NV.

Harmon, Mella Rothwell, "Bringing Water to the Truckee Meadows: The Ditches," *Footprints*, Vol. 7, No. 2, Historic Reno Preservation Society, Spring, 2004.

Harmon, Mella Rothwell, "Housing Reno's 1930s Divorce Trade," *Footprints*, Vol. 9, No. 2, Historic Reno Preservation Society, Spring, 2006.

Harmon, Mella Rothwell, *Divorce and Economic Opportunity in Reno, Nevada, During the Great Depression,* unpublished Master's Thesis, University of Nevada, Reno, 1998.

Harmon, Mella Rothwell, National Register of Historic Places Nomination for the Luella Garvey House, 2003, State Historic Preservation Office, Carson City, NV.

Harmon, Mella Rothwell, National Register of Historic Places Nominations for Greystone Castle and the W. E. Barnard House, 2002, State Historic Preservation Office, Carson City, NV.

Harmon, Mella Rothwell, National Register of Historic Places Nomination for the First Church of Christ, Scientist/Lear Theater, 1999, State Historic Preservation Office, Carson City, NV.

Harmon, Mella Rothwell, National Register of Historic Places Nomination for the Nystrom Guest House, 2000, State Historic Preservation Office, Carson City, NV.

Harmon, Mella Rothwell, National Register of Historic Places Nomination for the ATO Fraternity House, 2003, State Historic Preservation Office, Carson City, NV.

Harmon, Mella Rothwell, National Register of Historic Places Nomination for the Pearl Upson House, 2003, State Historic Preservation Office, Carson City, NV.

Harmon, Mella Rothwell, Nevada State Register of Historic Places Nomination for the I.O.O.F. Lodge/Bank Building, 2003, State Historic Preservation Office, Carson City, NV.

Harmon, Mella Rothwell, Nevada State Register of Historic Places Nomination for the Pioneer Theater-Auditorium, 2005, State Historic Preservation Office, Carson City, NV.

Harmon, Mella Rothwell, quoted in Lenita Powers, "Two Reno houses granted historic registration," *Reno Gazette-Journal*, September 8, 2002.

Henderson, Mike, "Courthouse regains its color," *Reno Gazette Journal*, May 9, 2001.

High, Ferdinand, personal interview, June, 2006.

Hinman, Debbie, "A Street by Any Other Name," *Footprints*, Vol. 9, No. 1, Historic Reno Preservation Society, Winter, 2006.

Hinman, Debbie, "Hillside Cemetery, 1875-2005," *Footprints*, Vol. 9, No. 1, Historic Reno Preservation Society, Winter, 2006.

Hinman, Debbie, "The Gray Lady of West First Street," *Footprints*, Vol. 8, No. 2., Historic Reno Preservation Society, Spring, 2005.

Historic Reno Preservation Society, "B. D. Billinghurst Junior High School," *Footprints*, Vol. 6, No. 1, Winter, 2003.

Historic Reno Preservation Society, "On the Historic Register, the ATO House," *Footprints*, Vol. 7, No. 3, Summer, 2004.

Historic Reno Preservation Society, "On the Historic Register, the Luella Garvey House," *Footprints*, Vol. 7, No. 3, Summer, 2004.

Historic Reno Preservation Society, "On the National Register of Historic Places: The B. D. Billinghurst Home, 729 Evans Avenue," *Footprints*, Vol. 6, No. 1, Winter, 2003.

Historic Reno Preservation Society, "The Old Riverside District: North Side of the Truckee," *Footprints*, Vol. 6, No. 2, Spring, 2003.

Historic Reno Preservation Society, *725 California Avenue*, brochure produced for Mansions on the Bluff Open House Event, 2002.

Historic Reno Preservation Society, *761 California Avenue*, brochure produced for Mansions on the Bluff Open House Event, 2002.

Historic Reno Preservation Society, *A Walk through Time: The Historic Powning's Addition in Reno, Nevada*, Reno, NV, 2004.

Hopkins, A. D., "Pat McCarran: Perennial Politician," The First 100, *Las Vegas Review-Journal* website, retrieved on December 2, 2005, from www.1st100.com/part2/mccarran.html

Housley, Harold, and Julie Nicoletta, National Register of Historic Places Nomination for the Fleischmann Atmospherium/Planetarium, 1994, State Historic Preservation Office, Carson City, NV.

Hursh, Jack, Jr., "Truckee Meadows Remembered: A Success Story in Preserving Nevada Ranching Culture," *Footprints*, Vol. 8, No. 2, Historic Reno Preservation Society, Spring, 2005.

Hursh, Jack, Jr., and Loren Jahn, *Truckee Meadows Remembered*, published by Jack Hursh, Jr., Reno, NV, 2004.

Ingf, Steven, "A new art landmark for Nevada," *Tahoe Quarterly*, retrieved on December 3, 2005, from http://www.tahoequarterly.com.

IntoHomes Mortgage Services, "The McCarran Mansion," brochure, Reno, NV, 2005.

Jahn, Loren, and Jack Hursh, Jr., "Carpenter Gothic Country Houses of Northern Nevada," *Footprints*, Vol. 9, No. 2, Historic Reno Preservation Society, Spring, 2006.

Junior League of Reno, *So this is Reno, An invitation from the Junior League of Reno to take a walking or driving tour through the historic Newlands Heights District*, brochure printed by Dickson Realty Company, Reno, NV, undated.

Kling, Dwayne, *The Rise of the Biggest Little City: An Encyclopedic History of Reno Gaming, 1931-1981*, University of Nevada Press, Reno and Las Vegas, NV, 2000.

KNPB Television, "Greystone Castle/Barnard House," House with a History series produced by KNPB Television, Reno, NV, retrieved on January 24, 2006, from http://www.knpb. org/productions/house/default.asp

KNPB Television, "House with a History" series, produced by KNPB Television, Reno, NV, available from http://www. knpb.org/productions/house/default.asp.

KNPB Television, "No Hands on the Clock," House with a History series produced by KNPB Television, Reno, NV, retrieved on January 23, 2006, from http://www.knpb.org/ productions/house/default.asp

Koval, Ana B., and Katharine Boyne, National Register of Historic Places Nomination for the El Cortez Hotel, 1984, State Historic Preservation Office, Carson City, NV.

Koval, Ana B., and Katharine Boyne, National Register of Historic Places Nomination for the Pincolini/Mizpah Hotel, 1984, State Historic Preservation Office, Carson City, NV.

Koval, Ana B., and Katharine Boyne, National Register of Historic Places Nomination for the Peleg Brown Ranch, 1994, State Historic Preservation Office, Carson City, NV.

Koval, Ana, and Patricia Lawrence-Dietz, National Register of Historic Places Nomination for the Hill/Redfield Mansion, 1984, State Historic Preservation Office, Carson City, NV.

Koval, Ana, and Patricia Lawrence-Dietz, National Register of Historic Places Nomination for the McCarthy/Platt House, 1984, State Historic Preservation Office, Carson City, NV.

Kuranda, Kathryn M., and Ron James, National Register of Historic Places Nomination for the Joseph H. Gray Mansion, 1984, State Historic Preservation Office, Carson City, NV.

Land, Barbara and Myrick, *A Short History of Reno*, University of Nevada Press, Reno, NV, 1995.

Lawrence-Dietz, Patricia, National Register of Historic Places Nomination for the Riverside Hotel, 1983, State Historic Preservation Office, Carson City, NV.

Leland, Joy, National Register of Historic Places Nomination for the William J. Graham House, 1983, State Historic Preservation Office, Carson City, NV.

Loomis, Suzanne M., National Register of Historic Places Nomination for the Hawkins House, 1979, State Historic Preservation Office, Carson City, NV.

Loomis, Suzanne, Barbara Moreland, and Betty Hendrickson, National Register of Historic Places Nomination for the Phillips Ranch/Arlington Gardens, 1981, State Historic Preservation Office, Carson City, NV.

Lynn Coins, "LaVere Redfield: The Secret Stash of Silver Dollars," retrieved on December 2, 2005, from http:// www.lynncoins.com/redfield.htm.

McAlester, Virginia and Lee, *A Field Guide to American Houses*, Knopf, New York, NY, 1984.

McDonnell, Patrick, "Campus on the Hill," *Nevada Magazine*, September/October, 1998, Carson City, NV.

National Automobile Museum, "Museum History," retrieved on June 20, 2006, from http://www.automuseum.org/.

National Register of Historic Places, "Joseph Giraud House: Three Historic Nevada Cities: Carson City, Reno, Virginia City: A National Register of Historic Places Travel Itinerary," retrieved on December 2, 2005, from http:// www.cr.nps/gov/nr/travel/nevada/jos.htm.

Nevada Museum of Art, "Mission and History," retrieved on December 4, 2005, from http://www.nevadamuseumofart. org.

O'Malley, Jaclyn, "Truck tows historic home to its new neighborhood," *Reno Gazette-Journal*, July 12, 2004.

Powers, Lenita, "Two Reno houses granted historic registration," *Reno Gazette Journal*, September 8, 2002.

Rainshadow Associates, National Register of Historic Places Nomination for the Reno National Bank, 1983, State Historic Preservation Office, Carson City, NV.

Reno Gazette-Journal, "Surprises accompany mansion's restoration," *Reno Gazette-Journal*, December 31, 1985.

Rocha, Guy, "Reno's Mapes rose after World War II," *Reno Gazette-Journal*, January 22, 2005.

Rocha, Guy, and Dennis Myers, "The Wild Bunch in Winnemucca," Historical Myth a Month Series, Nevada State Archives website, retrieved on December 18, 2005, from, http://www.dmla.clan.lib.nv.us/DOCS/NSLA/archives/myth/.

Rowley, William, *Reno: The Hub of the Washoe Country*, Windsor Publications, Inc., Woodland Hills, CA, 1984.

Sage, Roderick D., "Cantlon, Edwin: A Surgeon Cowboy Rides Down Memory Lane," *Oral History Interview, Oral History Program, University of Nevada*, 1988, Special Collections Archives, University of Nevada, Reno, NV.

Schaefer, Michelle A., National Register of Historic Places Nomination for the Reno Downtown Station, 1983, State Historic Preservation Office, Carson City, NV.

Scharmer, Roger P., Nevada State Register of Historic Places Nomination for the Lora J. Knight House, 1983, State Historic Preservation Office, Carson City, NV.

Sievers, Linda, "HRPS Focus: C. C. Powning and the Powning Addition," *Footprints*, Vol. 7, No. 1, Historic Reno Preservation Society, Winter, 2004.

Sievers, Linda, and Debbie Hinman, "Reno's El Reno Apartments," *Footprints*, Vol. 7, No. 3, Historic Reno Preservation Society, Summer, 2004.

Simone, Anne, "Architect Russell Mills," *Footprints*, Vol. 9, No. 1, Historic Reno Preservation Society, Winter, 2006.

Simone, Anne, and Carol Coleman, "On the National Register: Morrill Hall," *Footprints*, Vol. 8, No. 2, Historic Reno Preservation Society, Spring, 2005.

Simone, Anne, Joan Collins, and Helen Hardy Mills, "The Giraud-Hardy House, 442 Flint Street, Reno," *Footprints*, Vol. 6, No. 1, Historic Reno Preservation Society, Winter 2003.

Sinai, David P., and Theodore J. Schroeder, "The Howell House," undated brochure.

Skorupa, Susan, "40 cooperative years: Artists' gallery to mark anniversary with reunion show," *Reno Gazette-Journal*, January 24, 2006.

Skorupa, Susan, "75 years in Idlewild Park: Built to honor the Golden State, the California Building now symbolizes the history of Reno," *Reno Gazette-Journal*, October 29, 2002.

Skorupa, Susan, "A riveting story: Ceremony to honor Reno inventor of Levi's 501 jeans," *Reno Gazette-Journal*, May 12, 2006.

Skorupa, Susan, "Solid as a Rock: Reno's stone houses give cool comfort to owners," *Reno Gazette-Journal*, July 9, 2006.

Snell, Charles W., National Survey of Historic Sites and Buildings Nomination for the Senator Francis G. Newlands Home, 1962, State Historic Preservation Office, Carson City, NV.

Snyder, Helen, National Register of Historic Places Nomination for the Southside School Annex, 1993, State Historic Preservation Office, Carson City, NV.

Sonner, Scott, "Reno gambling on allure of mysterious black box," retrieved on December 3, 2005, from http://www.HonoluluAdvertiser.com.

Southerland, Cindy, National Register of Historic Places Nomination for the Patrick Ranch House, 2003, State Historic Preservation Office, Carson City, NV.

Stewart, Brandon, "Reaching for the moon….and beyond," *Nevada Silver & Blue*, University of Nevada, Spring, 2005.

Stone, Leanne, "University of Nevada, Reno Historic District Walking Tour," June 2002.

Townley, John, *Tough Little Town on the Truckee*, Great Basin Studies Center, Reno, NV, 1983.

Trinity Episcopal Church, *A tour of our church home*, undated brochure.

Truckee-Donner Historical Society, Inc., "Uncle Joe's Cabin: Truckee's First Building," retrieved on December 2, 2005, from http://truckeehistory.tripod.com/history9.htm

Twentieth Century Club, Letter to Max Fleischmann Foundation of Nevada, dated August 15, 1961, Document No. NC-9, 34/2, Special Collections Archives, University of Nevada Library, Reno, NV.

University of Nevada Buildings and Grounds: *Book of Views, 1908*, Archive No. 27, Special Collections, University of Nevada, Reno, Reno, NV.

Usgennet.org, "The Age of Railroads," Chapter XVIII, History of California Railroads, retrieved on June 20, 2006, from http://www.usgennet.org/usa/ca/state1/tinkhamch18.htm

Walbridge, Sharon, "Adaptive Reuse, Artfully Done," *Footprints*, Vol. 3, No. 3, Historic Reno Preservation Society, Fall, 2000.

Walbridge, Sharon, "The Story Behind the Lear Theatre," *Footprints*, Vol. 6, No. 2, Historic Reno Preservation Society, Spring, 2003.

Walbridge, Sharon, and Carol Coleman, "Reno's Catholic Churches: A Trial by Fire," *Footprints*, Vol. 9, No. 1, Historic Reno Preservation Society, Winter, 2006.

Washoe County Clerk's Office, Washoe County Courthouse Historical and Preservation Society, "History of Washoe County Courthouse," retrieved on April 16, 2007, from http://www.washoecountyus.clerks/historical_society.php.

Washoe County Parks & Recreation Department, *History: Bartley Ranch Regional Park*, brochure printed by Washoe County Parks & Recreation Department, Reno, NV, undated.

Washoe County Parks and Recreation Department, *Old Huffaker Schoolhouse*, brochure printed by Washoe County Parks and Recreation Department, Reno, NV, undated.

Willis, Glee, "Family Bike Tour of the Historic Buildings of Downtown Reno," retrieved on December 6, 2005, from http://unr.edu/homepage/willis/longhistoric.html.

Wood, Kimberly, National Register of Historic Places Nomination for the McKinley Park School, 1977, State Historic Preservation Office, Carson City, NV.

Wood, Kimberly, National Register of Historic Places Nomination for the Mount Rose School, 1977, State Historic Preservation Office, Carson City, NV.

Zimmer, Ethel, "The Turrillas home, constructed in '77, still remains as one of Reno's finest," *Nevada State Journal*, March 10, 1957.

≈ Appendix G ≈

Index of Houses and Buildings

BY DISTRICT

DOWNTOWN RENO

WEST COURT ST. - ARLINGTON AVENUE

LIBERTY STREET

☙ The Author ❧

Holly Walton-Buchanan grew up in Reno, and has watched many fine old historic buildings disappear in the name of "progress." Her former elementary school, Mary S. Doten, one of the four "Spanish Quartet" schools built in the early 1900s, was demolished to make way for a bus parking lot. For many years she taught Spanish and History in the Washoe County Schools, and also worked at the Nevada Department of Education. In 2003 she completed her Ph.D. in education at the University of Nevada, Reno. Her first book, a history of the College of Education at the university (2004), was based on her doctoral dissertation.

As a member of the Historic Reno Preservation Society, she began to see the need for an historical and architectural guidebook that presents the stories of some of Reno's finest buildings and homes, along with photographic images of them. This book is the result of nearly two years of research into the history of Reno and its buildings. In October 2006, as the book was being finalized, the Mizpah Hotel was destroyed by a tragic fire. That single event not only shocked and saddened Reno's historians and preservationists, but it also clearly validated the need for this book as a permanent record of those remnants of Reno's past that could be gone forever in just one terrible night.

≈ Colophon ≈

Designed by Robert E. Blesse at the Black Rock Press,
University of Nevada, Reno. The text font is
Bulmer, originally designed by William
Martin for the Shakespeare Press, circa
1790. The display font is Mrs. Eaves,
designed by Zuzana Licko in 1996,
for the Emigre foundry.
The book was printed
by Thomson-Shore,
Dexter, Michigan.